• LOCOMOTIVES OF THE •
NORTH EASTERN RAILWAY

1841–1922

John S. MacLean

AMBERLEY

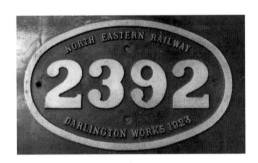

The main text of this book was originally published by the Locomotive Publishing Company, *c.* 1923.

This new edition first published 2014.

Amberley Publishing
The Hill, Stroud
Gloucestershire, GL5 4EP

www.amberley-books.com

British Library Cataloguing in Publication Data.
A catalogue record for this book is available from the British Library.

ISBN 978-1-4456-3781-5
Ebook 978-1-4456-3793-8

Typeset in 9.5pt on 13pt Sabon.
Typesetting and Origination by Amberley Publishing.
Printed in the UK.

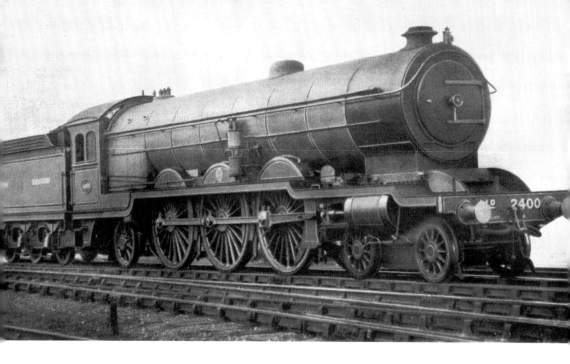

No. 2400, the first of the 'Pacific' Type 4-6-2 on the NER.

Introduction to this edition

The successor to the Stockton & Darlington, the NER was an important company and its territory included Yorkshire, County Durham and Northumberland, with outposts into Cumbria and north to Scotland. Five men held the post of Locomotive Superintendent including the Worsdell brothers. An innovative company, the NER introduced Bo-Bo type electric locos in 1905, and many of their stable of steam engines were handed over to the LNER. Today, there are eleven preserved examples of NER locos including several built by the LNER to the NER's designs.

The Locomotives of the North Eastern Railway, by J. S. MacLean, was originally published in 1923, at the dawn of the grouping of Britain's railways into the 'Big Four'. At that time the NER ceased to exist as an independent enitity when it became subsumed within the LNER. This makes this account a complete survey of the company's locomotives and the many original line drawings and photographs provide an invaluable resource for the enthusiast or railway modeller. The text of the original book has been reproduced in its entirety, with only minor editing to improve the flow for the modern reader. The drawings and photographs from the original are all here, and have been supplemented with photographs from the J. & C. McCutcheon archive.

Locomotives of the North Eastern Railway is the fourth volume in a new series from Amberley Publishing focussing on the pre-grouping railways. More will follow on the grouping and post-nationalisation eras.

Above: No. 1156, an 0-6-0, in its working days and, *below*, No. 2392 undergoing restoration. After a spell at the National Railway Museum, this NER Class P3 (classified as J27 by the LNER) has seen action on several heritage lines and is currently at Darlington awaiting a future overhaul. *(CMcC)*

Preface

The Locomotive having reached its highest point of development on the North Eastern Railway with the introduction of the gigantic Pacific express engines built by Sir Vincent Raven, KBE, at Darlington, this seems a suitable occasion to describe the gradual growth and expansion of locomotive engineering on this line from the very beginning.

Sir Vincent Raven's perfected three-cylinder system possesses many advantages over both the two-and four-cylinder arrangements, notably a more even turning movement, a continuous and easier blast on the fire, and good balance of moving parts. Experiments with the three-cylinder arrangement had been made by Stephenson on the York, Newcastle & Berwick Railway in 1847 and 1853 and by Kendal on the Blyth & Tyne in 1868, and it was only fitting that a final solution of the problem should be reached by Sir Vincent Raven, KBE, Chief Mechanical Engineer of the NER, on the railway which absorbed both these early lines.

This collection of drawings and photographs has largely been gathered together since 1906, when a little book by the author was published describing many NER locomotives, and it became apparent that certain errors and important omissions had then occurred which called for correction or amplification. The late W. W. Tomlinson gave every encouragement and much assistance towards this end. The historical portion is largely founded on notes made by William G. Brown, of York, whose detailed knowledge he has so generously placed at the author's disposal, and by Ahrons, who was well acquainted with the Southern Division between 1876 and 1892. Indeed, the scope of the work has so increased that the author would almost claim for it the dignity of a history of the locomotive engine from its infancy to modern times.

The best thanks of the author are due to A. C. Stamer, Esq., Chief Assistant Mechanical Engineer, LNER, Darlington, for kind permission to use several official photographs.

The author has also to specially acknowledge his indebtedness to the locomotive builders – R. Stephenson & Co. Ltd, Darlington, and R. & W. Hawthorn, Leslie & Co. Ltd, Newcastle-on-Tyne, for their permission to use drawings; and to Beyer, Peacock & Co., Manchester, and Neilson, Reid & Co., Glasgow, each for the use of photographs for reproduction.

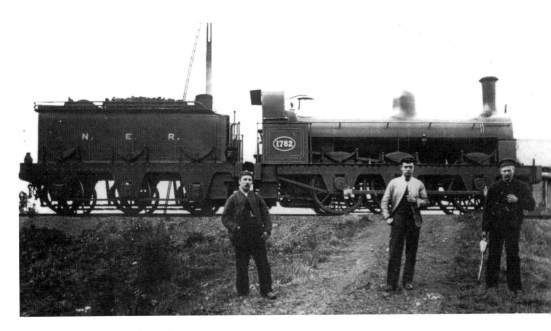

No. 1782 and No. 594, a pair of NER 0-6-0s. (CMc)

Early Locomotives

Great North of England Section

The first locomotive of their own to run on the GNER was the old *Swift*, bought in September, 1839, from the Stockton & Darlington. Railway. Originally built by R. & W. Hawthorn in 1836, it was supplied with a new round boiler with a dome and ordinary guide bars instead of the parallel motion of the original design. According to Theodore West's diagrams the driving wheels were 4-foot 6-inch diameter, the cylinders 11-inch diameter by 16-inch stroke, and the weight 8¾ tons.

Another old passenger engine, the *Planet*, No. 10, was bought about the same time by the contractors for ballasting purposes. This was one of the first engines ever to have inside cylinders, and was built by Stephenson in 1830. The driving wheels were 5-foot diameter, leading wheels 3 feet, cylinders 11-inch diameter and 16-inch stroke. Boiler, 6 feet 6 inches long. Weight, 8 tons. Both these engines had four-wheeled tenders. (The *Shildon*, No. 18, was bought at the same time.) At the opening of the line on 31 March 1841, the Company possessed altogether twenty-two locomotives, but neither the *Swift* nor the *Planet* were in the list. Ianson Cudworth, who afterwards went to the South Eastern Railway, was the first Locomotive Superintendent.

An unusual feature of the locomotives of the GNER was the fact that they all had names but were not numbered until the amalgamation.

Two trial locomotives were built by R. & W. Hawthorn in 1839: works numbers 274 and 275. These were the *Tees*, a goods engine, and the *Victoria*, for passenger trains. The latter had cylinders 12 inches by 18 inches and single driving wheels 5 feet 6 inches in diameter, the leading and trailing wheels being 3 feet 6 inches. The boiler was 8 feet long by 3-foot-3-inch diameter, and had a heating surface of 478.5 square feet. The total weight of engine in working order was 11 tons 15 cwt, and empty 10 tons 10 cwt.

The *Tees* had four coupled wheels, 4 feet 6 inches in diameter; leading wheels, 3 feet 6 inches in diameter; cylinders, 14 inches by 18 inches; and a larger boiler. This was 8 feet 6 inches long and 3 feet 7 inches in diameter. Total heating surface, 340 square feet. Weight of engine in working order 13 tons, and empty 11 tons 15 cwt. These were so satisfactory that seven more passenger engines were delivered, the names of three of them at the official

opening on 30 March, 1841, being *Leeds*, *Wensleydale*, and *Ouse*, the latter embodying certain improvements by Hawthorn; and three goods engines similar to the *Tees*. These were all dated 1840, so that at any rate part of the locomotive stock was completed some considerable time before the line on which they were to run was ready for them.

A table of the early engines published by Wishaw in 1840 mentions two passenger engines built by Tayleur & Co., Warrington, named *Harperley* and *Etherley*, with single driving wheels 5 feet 6 inches and cylinders 12 inches by 18 inches. They were numbered 32 and 33 on the YN&BR and had their cylinder diameters afterwards enlarged to 14 inches and 13 inches respectively; also six goods engines by the same makers, named *Newcastle*, *Auckland*, *Bedale*, *Edinburgh*, *Carlisle*, and *Manchester*, having 4-foot-6-inch driving wheels and cylinders 14 inches by 18 inches. These were also built in 1840. There was a series of five four-coupled goods engines by Tayleur & Co. in the YN&BR list, dated 1845, but otherwise corresponding to this set of six. There is good reason to infer that they were the self-same lot with one missing. Their numbering ran as follows: 59, 60, and 62, dated. July; 63 and 64, dated December; the year 1845 merely indicating an overhaul. No. 63 was completely re-built at Stephenson's works, Newcastle, in 1849. Two goods engines built by R. Stephenson & Co. in 1840, with driving wheels 4-foot-8-inch diameter and cylinders 14 inches by 18 inches, were followed by four goods engines from Jones, Turner, & Evans. They had 4-foot-6-inch driving wheels and cylinders 14 inches by 18 inches, and were numbered on the YN&BR 53 to 56. Altogether forty-one of this company's engines figured in the York, Newcastle & Berwick list, but special mention will only be made of the more notable ones.

The *Richmond* was a famous express engine designed by R. & W. Hawthorn (makers' number, 404) and delivered in June, 1845. This engine was in all probability the first one to figure in the gauge trials. The incident is described by Jeans in his *Jubilee Memorial of the Railway System* as follows:

> In order to show that passengers could be conveyed safely on the narrow (or standard) gauge lines at a high rate of speed Nicholas Wood obtained from the Railway Company permission to try the *Richmond*, one of their best engines, over the main line from Darlington to York. The distance of 44¼ miles was accomplished in 47 minutes, a speed of 60 miles an hour being reached during the journey, and he thus eclipsed all former achievements of the locomotive.

The train was only a light one, consisting of two first-class carriages, but Wood had the satisfaction shortly afterwards of finding that the narrow gauge system was recommended in preference to the broad gauge for British railways.

Very meagre particulars of the original engine are now preserved, but the following were the leading dimensions: The cylinders (inside) had a diameter of 16 inches; stroke, 21 inches. The engine had six wheels. The driving wheels were 6-foot-6-inch diameter and leading and trailing wheels 3-foot-6-inch diameter. The trailing pair were under the fire-box and very close to the driving wheels. Boiler, 11 feet 6 inches long, 3-foot-6-inch diameter. Fire-box, 39 inches long, 41½ inches wide, and 43 inches high. Heating surface, including tubes, about 870 square feet. Connecting rod length, 5 feet 3½ inches. Weight of engine, 18 tons.

The steam dome was on the middle ring of the boiler. The engine had a special expansion gear in addition to the eccentrics and link motion, which indicates how imperfectly were the advantages of the latter known at this time.

After being involved in an accident the opportunity was taken to have the *Richmond* re-built by the original makers in January, 1849, and it was at about this time numbered 66 by the YN&BR. As thus altered we illustrate the *Richmond* below. The new cylinders were 15½-inch diameter by 20-inch stroke. Boiler length, 10 feet 8 inches. Fire-box length, 4 feet 7½ inches. Wheel base, leading to driving, 7 feet 1 inch, driving to trailing, 7 feet 6½ inches, total, 14 feet 7½ inches.

The *Richmond* in 1852 took a 'special' from Darlington to York in 52 minutes, the average speed being 51 miles an hour. (*Vide N.E.R. History*, W. W. Tomlinson.)

No. 75, a curious little coupled engine, dated July, 1845, was built by R. Stephenson & Co., Newcastle, for passenger trains on the GNER It was one of the very few engines with a 'hay-stack' fire-box and a short boiler together. The driving and trailing wheels were 5-foot-6-inch diameter, and the cylinders originally 15 inches by 22 inches inside the frames. All the bearings were inside. The engine weighed about 21 tons.

No. 75 for a long period ran a daily trip of a service, long since discontinued, between Tweedmouth and Edinburgh *via* Kelso, Galashiels, and Falahill. The engine underwent some alteration in March, 1853, and was re-built at Gateshead, with a new boiler and flat-topped but raised fire-box, in 1863; otherwise little change was made. Afterwards No. 75 ran trains to Sunderland and Tynemouth from Newcastle. As Ahrons mentions in the *Railway Magazine*, Vol. XL., 1917, No. 75, as re-built in 1863, was the forerunner of Fletcher's 675 Class of mixed traffic engines, which were very successful in 1870.

The engine originally known as *Great A*, or the 'A' engine, as it was distinguished during the gauge trials by neither name nor number, only by a big letter 'A' on the boiler, was designed and built by R. Stephenson & Co. for the Newcastle & Darlington Junction Railway (makers' number, 493), and was finished in November, 1845, while the Gauge Commission was sitting.

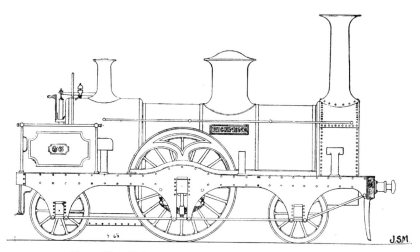

Fig. 1. The **"Richmond." No. 66.** Express Engine as re-built 1849.

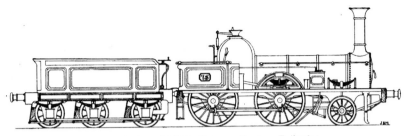

Fig. 2. **No. 75.** G.N.E.R. Passenger Engine. Built 1845.

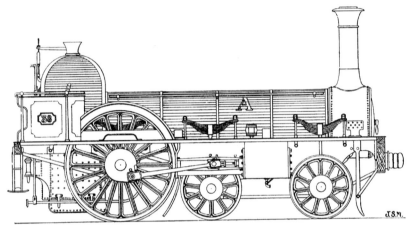

(By permission of the Council of the Institute of Mechanical Engineers.)

Fig. 3. The **"Great A"** Engine. Built November, 1845.

The GNER, over whose main line the narrow gauge trials were mostly conducted and to whom the engine was delivered, afterwards purchased the engine instead of its going to the N&DJR.

Daniel Gooch, describing this engine in his evidence before the Gauge Commissioners, remarked that every effort was made to construct a powerful engine in as small a space and with as little weight as possible. The cylinders were placed outside, and besides this a couple of additional inches in width was obtained by throwing the bosses and the spokes of the wheels out of the centre of the tyres. He quoted George Stephenson's opinion that the front and back pairs of wheels were as far apart as they could safely and properly be placed!

In spite of the assertions of Daniel Gooch and other broad gauge advocates the 'Great A' was not specially designed for this contest but happened to be the latest arrival from Stephenson's Forth Street Works for the narrow gauge, and was used in preference to any other engine on that account. In proof of this we have, of course, R. Stephenson & Co.'s statement that a precisely similar engine was supplied to the York & North Midland Railway, and both naturally had all the latest improvements. The *Engineer* has stated that the wheel base was 11 feet, but from the particulars very courteously supplied by the makers it seems clear that the total wheel base was 12 feet, and this is corroborated by the late David Joy's drawing. The principal dimensions of the 'A' engine were as follows:

Diameter of driving wheels, 6 feet 7 inches; middle and leading wheels, 3 feet 6 inches. Distance, driving to middle wheels, 5 feet 4 inches. Total wheel base, 12 feet. Cylinders, 15-inch diameter by 24-inch stroke. Boiler, 13 feet 6 inches long, 3-feet-3-inch to 3-foot-6-inch diameter, being oval in section. Working pressure, 90 lbs per sq. in. Height from rail level to top of boiler, 7 feet 4 inches. Boiler contained 139 tubes, 1¾-inch diameter outside. Fire-box, 3 feet 10¾ inches long. Heating surface, tubes 880 sq. ft. Total, 939 sq. ft. Grate area, 9¼ sq. ft. Weight of engine, 22 tons 18 cwt, and with tender, 28 tons.

D. K. Clarke recorded a speed of 48 miles an hour during the gauge trials, also an average speed of 47 mph with a load of 50 tons behind the tender; while with 80 tons 44 mph was reached.

An illustration of the 'patent long-boiler engine 'A" was shown at the Newcastle Jubilee Exhibition in 1887, but unfortunately has been lost. Our diagram is reproduced by kind permission of the Inst. Mech. Engineers from a drawing executed by the late David Joy, and differs markedly from the woodcut in the *Engineer*, 27 May, 1892.

W. G. Brown, of York, whose knowledge of the early NER engines is as reliable as it is extensive, states that the number of the 'Great A' on the York, Newcastle & Berwick Railway was 38. (NER Records state that No. 38, built by R. Stephenson & Co. for the GNER, was sent to the N&DJR for their use in February, 1846, and began running in March. As the two companies were practically then united we think this statement can be reconciled with our somewhat different version.) He knew the 'Great A' well, and as a boy moved it in steam. John Pattinson, its fireman, told him it could do 90 miles an hour on the easy ground between Belford and Beal on the main line. It is interesting to record that No. 38 was the pilot engine for the Royal Train at the opening of the High Level Bridge by Queen Victoria in 1849.

Newcastle & Darlington Junction Railway

The main line between Darlington and Gateshead was formally opened on 18 June, 1844, by three Great North of England engines: *Cleveland*, *Glasgow*, and *Edinburgh*; and four engines of the Brandling Junction Railway: the *Nathaniel Ogle*, *Brandling*, *Mountain*, and *Weir*.

Newcastle was not reached even by a temporary bridge until 1848.

During its first six months' working the Company was entirely dependent on the Brandling Junction and GNER for locomotives until they obtained delivery of their own rolling stock. On 1 July, 1845, the Newcastle & Darlington Railway took over the entire control of the GNER, and the two railways, under George Hudson's scheme, became united in 1846, when the York & Newcastle Railway was formed.

The first series of passenger engines belonging to the Newcastle & Darlington Junction Railway consisted of nine supplied by R. Stephenson & Co. The first two bore the date 1844 but began running in January, 1845. The York, Newcastle & Berwick numbers of these engines were as follows:

YN&BR No.	Began running	R. S. & Co.'s No.	Remarks
21	January, 1840	463	Renewed February, 1869.
22	January, 1845	464	Re-built as Tank 1874.
23	January, 1845	465	Re-built as Tank 1875.
24.	January, 1845	466	Re-built as Tank 1868 and re-numbered 665.
25	January, 1845	467	Scrapped 1863.
26	February, 1845	468	Scrapped 1864.
29	June, 1845	490	Re-built as Tank 1868 and re-numbered 666.
30	January, 1846	491	Re-built as Tank 1873.
31	January, 1846	492	Re-built as Tank 1874.

These were long-boiler, outside-cylinder engines, the close-coupled wheels being all in front of the fire-box – a design much favoured by certain engineers at this period. The driving wheels were 5 feet 7¼ inches and the leading wheels 3 feet 8¼ inches in diameter. Cylinders 14-inch diameter, and stroke 22 inches. The coupled wheel base was 5 feet 9 inches, and total wheel base 10 feet 11 inches. The total weight of engine was about 22 tons, made up as follows: On leading wheels, 6 tons; on driving wheels, 7¾ tons; and trailing wheels, 8¼ tons. Steam was taken from the top of the 'hay-stack' fire-box, which contained the regulator, there being no dome on the boiler, and the safety valve was located on the top of the fire-box. The engines had inside frames only, and from the first had the new 'Stephenson' link motion, a great improvement on the old valve gears.

This long-boiler plan was before its time, and would have succeeded but for the light permanent way then in use, and it required longer and more flexible wheel bases. The overhanging boilers caused a constant rocking motion at more than a moderate speed and were positively dangerous at anything above 45 miles an hour. Several accidents were directly attributable to this cause. No. 21 left the rails at Fence Houses, and No. 29 ran off the line with an express train near Bradbury. During the enquiry into the cause of the accident it transpired these engines frequently ran at the rate of 50 miles an hour! Consequently it was decided to alter several with shorter boilers, and in some cases compensating beams were fitted between the driving and trailing springs. This was tried on Nos 23, 30, and 31, but eventually they

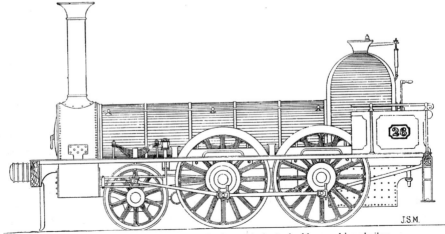

Fig 4. **No. 26.** One of the 21 Class Engines with short wheel base and long boilers.

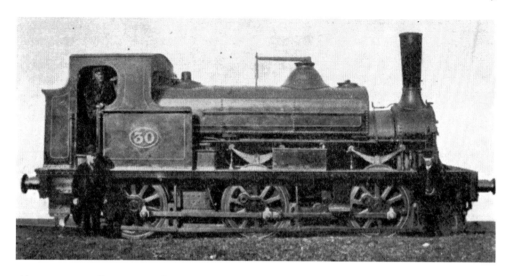

Above: No. 30, Shunting Tank Engine as re-built in 1873.

were re-constructed in a drastic fashion as six-coupled shunting tank engines; two of them, Nos 26 and 29, finishing up at Tweedmouth. No. 21 remained a passenger engine. Driven by William Smith it was stationed at Durham, in 1854, for working local passenger trains. It was 'renewed' very thoroughly in February, 1869, with double frames, coupled wheels 5 feet 6 inches in diameter, and cylinders 17-inch by 22-inch stroke. The engine and tender in working order weighed 45 tons. Little of the original No. 30 remained in the re-built engine.

The first goods engines were likewise supplied by R. Stephenson & Co. These all began running in January, 1845, but the first three were dated 1844. Their numbers on the YN&BR were 41–45 (inclusive), Stephensons' works numbers being 436, 438, 439, 447, and 448. Their wheels were 4-foot-8-inch diameter and cylinders 15-inch diameter by 24-inch stroke. Their total wheel base was 10 feet 11 inches.

A series of engines somewhat similar was supplied by Longridge & Co., of the Bedlington Iron Works. These became Nos 46, delivered in March; 47, in April; and 48 and 49, in May. They originally had a wide footboard the full length of the frames, with a protecting handrail outside to enable the driver to pass round. No. 48 is illustrated by *Fig. 5.* This engine was re-built as a saddle-tank in 1871 and afterwards shunted at Leeds for many years. It was re-numbered 1901 in 1890, and later became 1706 in 1893 and was not broken up until 1902.

Two mixed traffic locomotives were supplied by R. & W. Hawthorn in February and March, 1845, respectively, with 5-foot four-coupled wheels and cylinders 14-inch by 21-inch stroke. These two were numbered on the YN&BR 27 and 28. No. 27 was broken up in 1853, but No. 28 was re-built as a tank engine, and according to E. L. Ahrons was stationed at York and ran until 1883.

Nos 4 and 7 (YN&BR. numbers) were two interesting goods engines built by Bury & Co., Liverpool, dated June, 1845. They had four coupled wheels 5-foot-6-inch diameter; the cylinders being 12-inch diameter by 18-inch stroke. They had the well-known bar framing peculiar to this firm and seem to have been only four-wheeled engines.

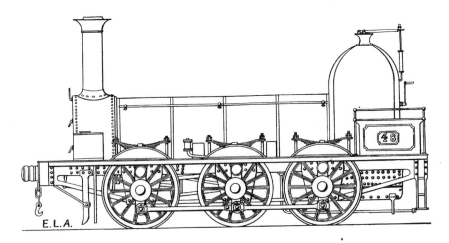

E.L.A.

Fig. 5. **No. 48.** Stephenson Goods Engine, 1844.

No. 77, the well-known three-cylinder 'patent' express passenger engine, was designed in 1846 on Stephenson and Howe's system for the attainment of greater natural stability than was arrived at in other locomotives. The engine was built at Stephenson's Forth Street Works, their number being 618, and was in outward appearance of the makers' usual long-boiler type with single driving wheels against the fire-box and the two pairs of carrying wheels in front. The driving wheels were 6 feet 6 inches in diameter and carrying wheels 3 feet 6 inches in diameter. Wheelbase, driving to middle wheels, 6 feet; total, 14 feet. The engine was delivered in 1847 to the York & Newcastle Railway and began running in June.

Only one engine of this design seems to have been built, but it continued to perform the arduous duties of an express passenger engine satisfactorily for about five years, and then the three-cylinder system was sufficiently successful to be retained when No. 77 came to be re-modelled with a new boiler and improved wheel arrangement in 1852. R. Stephenson & Co. assigned to it a new works number (737). They fitted a shorter boiler and placed the driving wheels in the middle, the carrying wheels now being leading and trailing with outside bearings.

D. K. Clark reported that, as altered, No. 77 gave unqualified satisfaction on the York, Newcastle & Berwick Railway, where it was on regular duty. The engine ran with very superior steadiness even when unassisted with balance weights in the wheels. The crank for the inside cylinder was arranged at right angles to the two outside ones, which were not opposed but set to work in unison.

The leading dimensions of No. 77 as re-built were: Driving wheels, 6-foot-8-inch diameter. Carrying wheels, 3-foot-9-inch diameter. Wheel base, leading to driving, 6 feet; driving to trailing, 8 feet. Total, 14 feet. Inside cylinder, 16 3/8-inch diameter, stroke, 18 inches; two outside cylinders, 10½-inch diameter, stroke, 22 inches. Boiler, 3-foot-8-inch diameter. Length, 11 feet. Grate area, 11.8 sq. ft, containing 170 brass tubes 11¼ feet long. Weight of engine in working order: leading wheels, 9 tons; driving wheels, 12 tons; trailing wheels, 6 tons. Total weight, 27 tons. The slide valves were worked by only two sets of link

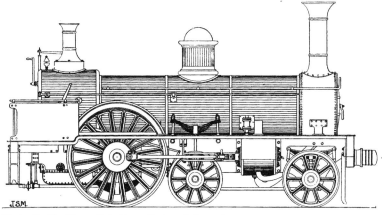

Fig. 6. **No. 77.** Three-cylinder Express Engine. Built 1847 by R. Stephenson & Co., Newcastle-on-Tyne.

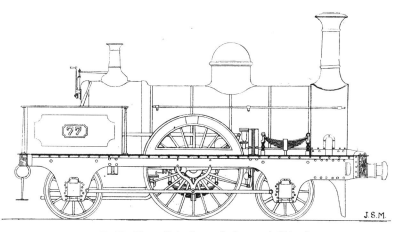

Fig. 7. **No. 77.** Three-cylinder Express Engine as re-built in 1852.

motion, one for the inside cylinder and the other working a transverse shaft for the two valves of the outside cylinders.

In October, 1850, No. 77 drew the Queen's train between Berwick and Newcastle at an average speed of 57 miles an hour.

Engine No. 77 was altered to an ordinary two-cylinder engine when it was re-built at York in November, 1860; a new boiler was fitted and two (new) inside cylinders, 16-inch diameter by 20-inch stroke, with the steam chests between them. The side frames were very substantially strengthened by square-shaped plates bolted outside the leading and trailing wheels, which were almost covered. They were connected at their bottom corners by cross-bars which stretched from one side of the engine to the other.

In 1881 J. Stephenson, the District Locomotive Superintendent at York, built an entirely new engine numbered 77, with 6-foot driving wheels. In appearance it was exactly similar to No. 190, *Fig. 19*, shown on page 24, and the first No. 77 was renumbered 1679.

After 1881 Nos 77 and 190 ran for many years as sister engines together on the Leeds and Hull fastest expresses.

York & Newcastle Railway Section

In 1847 R. Stephenson & Co. built another batch of nine long-boiler passenger engines larger than the 21 Class but on similar lines. By the courtesy of the builders No. 159 of this class is illustrated by *Fig. 9*, which will be much better remembered in its re-modelled form as a 'single.' The cylinders, outside, were 15-inch diameter and the stroke 22 inches. The four coupled wheels were 6 feet in diameter. The leading wheels were 3 feet 6 inches in diameter. Wheel base, leading to driving, 5 feet 4 inches; driving to coupled wheels, 6 feet 3 inches. Total wheel base, 11 feet 7 inches. Boiler length, 13 feet 7 inches. Weight of engine, 24 tons. The tender ran on six wheels. Tank capacity, 1,200 gallons. Owing to excessive speed No. 104 ran off the rails at Willington, on the North Shields line, causing the death of the driver. He was buried in Tweedmouth Churchyard, and full details of the accident and the number of his engine are fully recorded on the tombstone. No. 137 was blamed for knocking the road out of gauge on the main line near Benton; consequently they were prohibited by Harrison, the Chief Engineer, from further running on express trains.

No. 159 was stationed at Tweedmouth previous to 1853 and frequently ran on the main line between Berwick and Newcastle until re-built.

Numbers of the 140 class:

Engine	Began running	Renewal
103	June, 1847	Replaced 1872
104	June, 1847	Renewal 1868
108	June, 1847	Replaced 1876
137	June, 1847	Replaced 1869
139	June, 1847	Replaced 1871
140	June, 1847	Replaced 1883
142	July, 1847	Replaced 1868
159	October, 1847	Renewed 1853
168	December, 1847	Replaced 1872

Nos 103 and 168 were re-built with the trailing wheels behind the fire-box to spread the weight better.

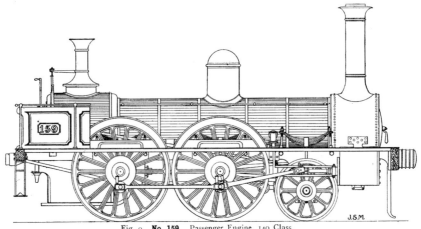

Fig. 9. **No. 159.** Passenger Engine, 140 Class.

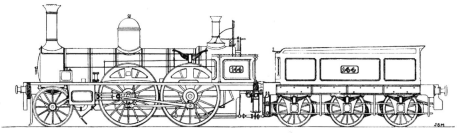

Fig. 10. One of the "Cross-legged" Express Passenger Engines. Built 1847.

The 'Cross-Legged' Engines

In 1847 R. Stephenson & Co. set about improving their design of express passenger engine. They constructed for the York & Newcastle Railway three engines, numbered 143, 144, and 145, having their leading pair of wheels placed well forward under the smoke-box, securing a long wheel base and ensuring smooth running at high speeds. The outside cylinders were placed nearer the fire-box end than usual and were connected to the rear pair of coupled wheels outside of the coupling rods. From the relative positions of the connecting and coupling rods when in motion these engines derived their nick-name of the 'cross-legged' engines. Their connecting rods were not forked as had then been usual, but were connected to the cross-head by a double eye and bolt, and were much lighter than usual. Their principal dimensions were: Driving and coupled wheels, 6-foot-1-inch diameter. Leading wheels, 3-foot-8-inch diameter. Coupled wheel base, 6 feet 3 inches. Total wheelbase, 14 feet. Cylinders, 15-inch diameter, stroke, 22 inches. Boiler pressure, 100 lbs per sq. in. For supplying the boiler the engine had two pumps worked off the driving axle, and had no steam jet in the smoke-box as in modern practice. The six brake-blocks worked on one side of the tender only.

The elevated trailing springs shown in our diagram were an alteration made to give greater flexibility, an extra joint being put in the hangers. These engines were considered fast in their time and frequently attained a speed of 60 miles an hour, and were a decided improvement on their predecessors.

Table of the 143 class:

Engine No.	Makers' No.	Began running	Date scrapped
143	585	June, 1847	1871
144	586	July, 1847	1883
145	587	September, 1847	1878

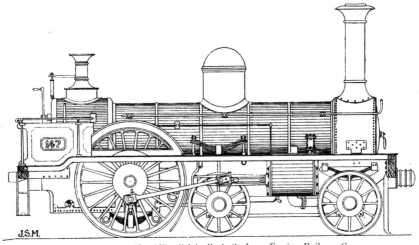

Fig. 11. Y.,N. & B.R. **No. 147.** Originally built for a Foreign Railway Company.

York, Newcastle & Berwick Railway Section

Two locomotives, designed by R. Stephenson & Co. for an Italian railway but not delivered, were put on the York, Newcastle & Berwick Railway in August, 1847. They are illustrated above, *Fig. 11*, from which it will be seen they were a development of the 'Great A' type of engine with long boiler and single driving wheels at the rear, against the fire-box, 6-foot-6-inch diameter, and having in front two pairs of carrying wheels 3 feet 6 inches in diameter. The cylinders were 15-inch diameter and 24-inch stroke. The boiler was 13 feet long and 3 feet 8 inches in diameter and contained 125 iron tubes 2-inch diameter. Their total heating surface was about 880 square feet. Boiler pressure, 120 lbs. One of these engines is said to have drawn the famous Budget express on 18 February, 1848, between York and Gateshead. Engine No. 147 was scrapped in 1869. No. 148 was re-built with the single driving wheels further forward and a pair of trailing wheels under the footplate. The leading and trailing wheels now had outside bearings. The frames were wide, partly enclosing the outside cylinders (which the engine still retained), giving a very peculiar appearance. It was regarded more or less as an experiment and was not a success. On account of its great width of frame it was unable to pass one of the roads at the Tweedmouth shed. The fire-box was divided lengthwise by a water space and had two fire-holes. No. 148 finished in 1866.

Coulthard's 'Jenny Lind'

The name 'Jenny Lind' has so long been identified with a particularly neat and successful type of express engine brought out by E. B. Wilson & Co., of Leeds, that it seems difficult to associate it with any other design. Quite a number of locomotives at this time, however, bore the name of the world-famed prima donna. One of these was a four-coupled passenger engine of small dimensions, No. 156, YN&BR, built in September, 1847, by Coulthard & Co., of Gateshead, who were proud of this latest production from their works. The

makers' number was 42. The engine is illustrated by *Fig. 12*, the name *Jenny Lind* was on both the engine and the tender sides. The principal dimensions of No. 156 were: Driving and coupled wheels, 5-foot diameter. Leading wheels, 3-foot-6-inch diameter. The middle pair of driving wheels were without flanges. Cylinders, 14-inch diameter, stroke, 18 inches. Spring balance safety valve over fire-box. Weight of engine about 22 tons. The tender ran on six wheels, 3-foot diameter. No. 156 frequently ran passenger trains.

No. 157, a single-driving-wheel passenger engine built by T. Richardson & Son, in September, 1847, had driving wheels 6-foot diameter and cylinders 15 inches by 22-inch stroke.

Nos 161 and 162, built by Nasmyth, Gaskell & Co., began running in November, 1847. They had 6-foot-6-inch single driving wheels and cylinders 15 inches by 24-inch stroke.

During 1847 and 1848 R. & W. Hawthorn delivered a class of small four-coupled passenger engines with driving wheels 5-foot-6-inch diameter and double frames, illustrated by *Fig. 13*. These engines had the well-known style of dome-cover, chimney, and six-wheeled tender usually produced by this historical firm at this period. The leading wheels were 3-foot-6-inch diameter. Tender wheels, 3-foot diameter. Wheelbase of engine, 14 feet. Coupled wheels, 7 feet 8 inches apart. Tender wheel base, 10 feet equally divided. The weight of engine and tender was about 40 tons. Boiler pressure, 80 lbs per square inch. The engines had 'grasshopper' springs under the trailing axle-boxes, and they had a pair of pumps near the fire-box worked by eccentrics off the driving axle between the cranks. The eccentrics for the valve gear were located between the wheels and the inside frames.

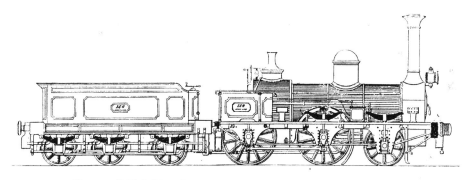

Fig. 12. Y.,N. & B.R. **No. 156.** Coulthard's **"Jenny Lind."** Built 1847.

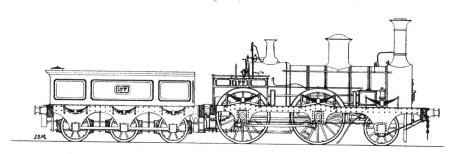

Fig. 13. Y.,N. & B.R. **No. 177.** Built by R. & W. Hawthorn & Co. in 1848.

Dates of the 165 class. Cylinder dimensions as renewed:

Engine No.	Began running	Cylinders	Altered or scrapped
165	November, 1847	15 inches x 22 inches	1875
166	December, 1847	15 inches x 20 inches	1886
176	June, 1848	15 inches x 24 inches	1871
177	July, 1848	15 inches x 22 inches	1872
178	July, 1848	15 inches x 21 inches	1875
179	July, 1848	15 inches x 22 inches	1871
181	October, 1848	15 inches x 20 inches	1877
207	April, 1849	15 inches x 20 inches	1879

No. 166 was re-built at Gateshead in 1868 with cylinders 15 inches by 22 inches and the eccentrics inside both frames. The engine ran for many years on the York and Harrogate line. The splashers had a pattern of ovals in, arranged fan-wise. At the end of 1884 she became No. 1706.

No. 207 piloted the royal train between Newcastle and Berwick on the opening of the High Level Bridge by the Queen in 1849. The photograph shows No. 207 after its renewal in 1879, with lengthened wheel base and Fletcher's boiler mountings, including chimney and dome. It had mostly been run on the Tynemouth line, with a short spell at Boroughbridge, and ended its career of usefulness on the Malton and Thirsk line at the age of well over thirty in 1883!

On 3 October, 1847, R. Stephenson & Co. offered three goods engines and tenders to the Directors of the York & Newcastle Railway. The offer was accepted, delivery to be in February, 1848. These engines were numbered 170, 171, and 173, their makers' numbers being 644, 645, and 646. They had inside cylinders 15 inches by 24 inches, six coupled wheels 4-foot-9-inch diameter, copper fire-box, and 139 brass tubes 1 5/8-inch diameter. Total wheel base of engine, 10 feet 11 inches.

Fig. 14 illustrates No. 175, one of a set of goods engines built by Nasmyth & Co., Manchester, in 1848. It was re-built at Gateshead Works in 1869. The wheels were 4 feet

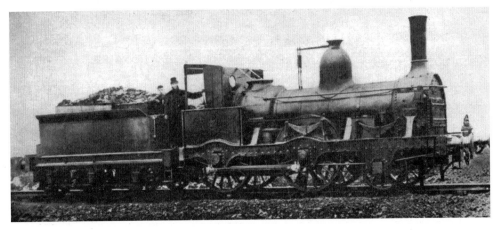

YN&BR No. 207. One of the Hawthorn Passenger Engines as re-built with new boiler.

8 inches in diameter and the cylinders 15 inches by 24-inch stroke.

In December, 1848, R. & W. Hawthorn delivered their handsome express engine named the *Plews*, after Nathaniel Plews, a director of the YN&BR. The works number was 711. The driving wheels were no less than 7 feet in diameter and other dimensions in proportion. Like several other examples on the YN&BR it was the only one of its kind, although a sister engine ran on the adjoining NBR and was reported during trials to have attained a speed of 70 miles an hour with a train of 35 tons and on an average consumption of coke of about 16 lbs per mile.

The principal dimensions of the *Plews* were as follows: Driving wheels, 7-foot diameter, of malleable iron. Carrying wheels, 4-foot diameter. Tender wheels, 3-foot-6-inch diameter. Wheel base, leading to driving, 7 feet 1 inch; driving to trailing wheels, 7 feet 7 inches. Total wheel base, 14 feet 8 inches. Wheel base of tender, 11 feet equally divided. Cylinders, 16-inch diameter, stroke, 20 inches. Boiler, 10 feet 8 inches long, oval shaped, 4 feet high by 3 feet 10 inches wide outside, containing 229 brass tubes 1¾ inches in diameter. Copper fire-box, 5 feet 7 inches long. Maximum pressure, 120 lbs per sq. in. Capacity of tank, 1,400 gallons. Weight of engine, on leading wheels 11 tons, on driving wheels 10½ tons, on

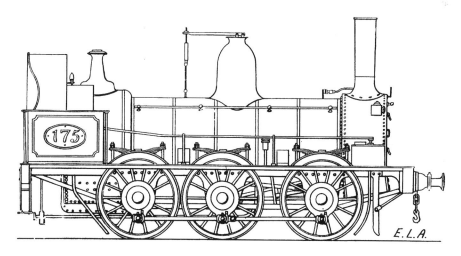

Fig. 14. Six-coupled Goods Engine, re-built in 1869.

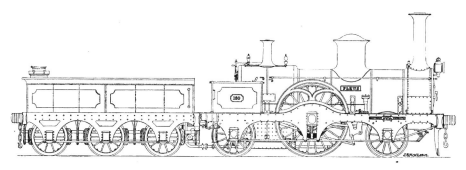

Fig. 15. **No. 180.** Hawthorn's famous Express Engine "Plews," 1848.

trailing wheels 5½ tons. Total weight, 27 tons.

The *Plews* ran its trial trip on 28 December, 1848, and afterwards ran express trains four times a week from Newcastle to York and back. Early in 1849 the *Plews*, driven by Hutchinson, ran in competition with No. 190, a famous Stephenson engine. Excellent performances were accomplished by both.

The *Plews* was re-built about 1865 and the name removed. Either now or earlier the driving wheels were reduced to 6 feet 6 inches. It finished its career on the Hull–Leeds and Hull– Doncaster services in 1884. As plain No. 180 it is illustrated by *Fig. 16*.

A set of five four-coupled passenger engines, built by R. Stephenson & Co., were ordered in 1846, but not being delivered until 1848 they looked rather an antiquated lot! They had high 'hay-stack' fire-boxes, from which the steam was taken, and consequently were without domes on the boiler. The reason for the adoption of this style of fire-box is not recorded, but they were amongst the very few instances of engines without domes on the line. They were noteworthy on account of the design incorporating outside valve gear as in No. 190, the famous express engine which followed. As usual, the makers fitted no flanges on the middle or driving wheels. The leading dimensions were: Driving and trailing wheels, 6-foot-1¼-inch diameter. Leading wheels, 3-foot-7-inch diameter. Cylinders, 15½-inch diameter, stroke, 22 inches. Boiler, 11 feet long, diameter 3 feet 8 inches. Fire-box, 3 feet 6 inches long, 3 feet 8 inches wide, and 4 feet 9¼ inches high, containing 135 tubes 2-inch diameter and 11 feet 4 inches long. The eccentrics were located between the outside frames and the driving wheels.

Engine No. 185 accompanied the royal train between Newcastle and York on the opening of the High Level Bridge in 1849. In 1875, after a long, useful life, it was stationed at Carlisle as pilot engine. It then had a new boiler with dome, etc. These engines mostly spent their declining years in the Hull district. Nos 185 and 188 retained many of their original features, including the peculiar curves of the framing, but the valve gear was all inside. Nos 186 and 189 had either new frames or a very considerable modification of the old ones, and worked to the last on the Hull and Doncaster train service.

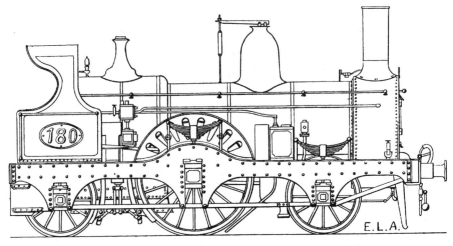

Fig. 16. **No. 180.** As altered, with smaller driving wheels and new boiler.

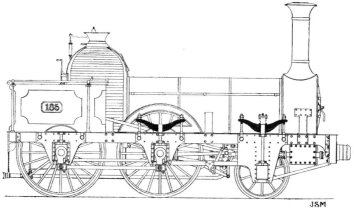

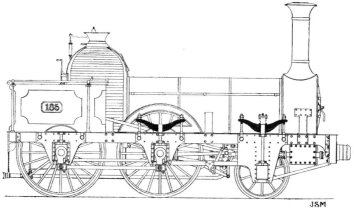

Fig. 17. **No. 185.** Four-coupled Express Engine, built 1848.
LIST OF THE 185 CLASS.

List of the 185 class:

Engine No.	Makers' No.	Date built	Scrapped
185	635	October, 1848	June, 1868
186	636	December, 1848	1882
187	637	March, 1849	1886
188	638	April, 1849	1882
189	685	May, 1849	1882

The celebrated 'single-wheeler' No. 190 is illustrated by Fig. 18. This engine enjoyed a considerable measure of fame both on account of its own success and the remarkable personality of her driver, Thomas Law, who refused to be separated No. 190 to any other engine, excepting when it was under repair, until after the lapse of years the engine had finally become too light for the traffic. No. 190 was completed by R. Stephenson & Co. in January, 1849 (makers' number, 726), and had the honour of drawing the Queen's train when the Newcastle High Level Bridge was opened the same year.

The principal dimensions were as follows: Driving wheels, 6-foot-7-inch diameter. Carrying wheels, 3-foot-10-inch diameter. Wheel base, leading to driving, 7 feet 4½ inches, driving to trailing, 7 feet 1½ inches. Total wheel base, 14 feet 6 inches. Cylinders, 16-inch diameter, stroke, 20 inches. Boiler barrel of 3/8-inch plates, oval in section, 3 feet 8 inches and 3 feet 9 inches by 11 feet long, containing 174 tubes 1 7/8 inches in diameter by 11 feet 3½ inches long. Total heating surface, 1,046 sq. ft. The eccentrics were outside the driving wheels, the sheaves being keyed on extensions of the driving axle as in the 185 Class.

In 1849 trials were run between the *Plews* and No. 190. T. Law with No. 190 succeeded in making the trip from Darlington to York and back, stopping at every station and pulling a train of 13 carriages, on a consumption of 18 lbs of coke per mile. Timothy Hackworth's son also desired a race with his new *Sanspareil* on the main line, but there is no record of this having taken place.

No. 190 was re-built at York by J. Stephenson, the District Locomotive Superintendent, in March, 1881, with No. 77, and they then became sister engines and worked at Hull on

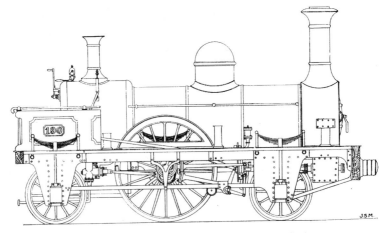

Fig. 18. **No. 190.** Stephenson's famous "Single" Express Engine.

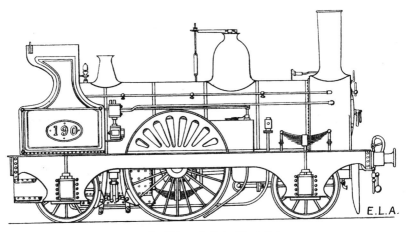

Fig. 19. **No. 190** as re-built in 1881 at York.

the same service. (See *Fig. 19.*) Finally the engine was re-built by T. W. Worsdell as a 2-2-4 side-tank engine, in which the trailing wheels were replaced by a four-wheeled bogie. It was stationed in the Newcastle district (Gateshead shed) for conveying the officials' saloon over the system.

No. 63 was a four-coupled six-wheeled passenger engine of truly Lilliputian proportions, built by R. Stephenson & Co. in 1849 (makers' number, 733). Our illustration, *Fig. 20*, is from a sketch kindly lent by W. G. Brown, of York, and shows that in some respects it was similar to the 189 Class, with inside cylinders and double frames, but on an altogether smaller scale, and had an ordinary fire-box and dome, etc. The coupled wheels were 4 feet 9 inches in diameter and leading wheels 3 feet 7 inches in diameter. Cylinders, 15-inch diameter, stroke, 20 inches. Engine wheel base, 11 feet 6 inches equally divided. Tender wheels, 3 feet in diameter. Wheel base, 10 feet

Whether there was any connection between No. 63 and the Tayleur engine of about four years earlier, bearing the same number, seems extremely doubtful, but the ancient-looking

T spokes in the leading wheels suggest that the builders had tried to 'sew a new shirt on to an old button!' The curious form of the wheels of the tender are also worth noting. The engine had undergone some modification in our drawing, Fletcher having added a cab and a new chimney and dome with spring-balance safety valves on it. Early in the sixties No. 63 was running local passenger trains between Newcastle and Sunderland and Newcastle and Tynemouth, and it finished its career on the Kelso branch line in 1878.

Fig. 21 shows one of the early Newcastle & North Shields Railway passenger engines built in 1840 by R. & W. Hawthorn (probably the *Exmouth*). It was acquired in June, 1847, and re-built with new driving wheels 4 feet 8 inches, as illustrated, in July, 1868.

Another old Newcastle & North Shields Railway engine, No. 149, the *Collingwood*, ran in the Northern Division for a short time. It was one of the very few 'four-coupled-in-front' engines the Company possessed, with driving wheels 5 feet in diameter and outside bearings. It finished its career as shunting pilot at Tweedmouth sixty years ago and acquired fame by running into the River Till.

In the early fifties the YN&BR had several odd tank engines running, some of them being re-builds of an earlier engine. Of these No. 73, built by R. & W. Hawthorn in 1852, is shown in *Fig.* 22. The design, dated 1851, figured in Theodore West's collection of diagrams, and it can be seen that the under part of the tank was set astride the trailing axle and there was a second tank under the boiler in front of the driving wheels. No. 73 was a four-coupled tank engine, with driving wheels 4 feet 6 inches in diameter, cylinders 13-inch diameter by 18-inch stroke, and outside frames.

These engines did duty on local passenger trains. No. 73 was on the Alnwick branch in the sixties and was replaced in 1882. A similar engine, No. 266, worked 'locals' in the Newcastle district. There was also No. 153.

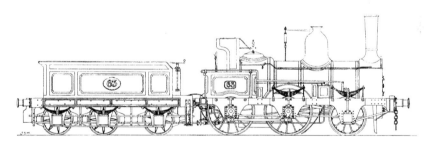

Fig. 20. **No. 63.** Stephenson's Four-coupled Express Engine. Built 1840.

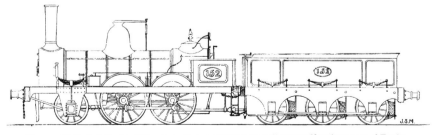

Fig. 21. Y.,N. & B.R. **No. 152.** Re-built, but retaining its well-known Hawthorn type of Tender.

Three powerful four-coupled express engines with double frames came from R. Stephenson & Co. in 1853. They were very successful, and the general design was followed when later engines were built of a larger size during the next decade or so. The driving wheels were 6 feet 2 inches in diameter. Leading wheels, 4 feet 1 3/16 inches in diameter. Cylinders, 15-inch diameter, stroke, 22 inches. Boiler, 10 feet long, diameter 4 feet 2 inches. Working pressure, 100 lbs per sq. in. Firebox, 4 feet 4 inches long by 4 feet 3 inches wide, containing transverse water space 4 inches wide. Wheelbase, 14 feet equally divided. Total length of engine, 22 feet 11½ inches. The driving wheels were without flanges. Our illustration, *Fig.* 23, is from material kindly supplied by the builders and shows the ornamental safety-valve and dome covers, suggesting 'Jenny Lind' influence. The transverse water space in the firebox and equally-divided wheel base were features Fletcher continued to adopt for many years in his passenger engines.

The 129 Class engines had a reputation for economical running and good steaming qualities, and were very popular with their drivers. They continued to work on the East Coast Scotch expresses until 1868, when No. 76 was superseded by No. 552 and No. 136 by No. 551, the loads having at last become too much for them. No. 129 was pilot at Newcastle Central Station for some time after quitting the main line, and No. 76 remained at York on local passenger trains until 1889.

No greater testimony of the qualities of these engines need be stated than the fact that No. 136 was re-built with a new boiler in 1882.

Table of the 129 class:

Engine No.	Date began running	Makers' No.
129	May, 1853	827
76	June, 1853	838
136	December, 1853	879

So great a change was wrought in Engine No. 159 during its re-construction that it would be difficult to say where any part of the old engine remained. It was being entirely re-modelled at Stephenson's works in the latter half of 1853, while the amalgamation of the several companies was being negotiated, and was finished in December of that year. Single driving wheels, 6 feet 6 inches in diameter were substituted for the previous coupled ones, a most peculiar feature of these being the slightly curved spokes. The cylinders, inside, were 16-inch diameter and stroke 22 inches. *Fig.* 24 shows the engine as thus re-modelled. It will be noticed it bore a marked resemblance to the 'Jenny Lind' engines, with which it has been confused, having the paddle-box splashers, but was without the fluted dome and safety-valve covers.

No. 159 was sent to the Southern Division of the NER, being located at Hull and working in the same link as Nos 77 and 190 on the Leeds expresses. The tenders of all these engines were alike and are illustrated on No. 1709, *Fig.* 25. This shows Engine No. 159 as it finally appeared after some minor improvements of A. McDonnell's in 1884, except that the new number 1709 was assigned to it in 1885 and the engine then placed in the duplicate list.

In 1850 the Hackworths completed at the Soho Engine Works, Shildon, an express

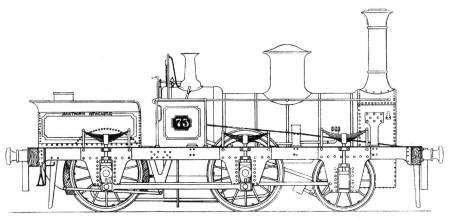

Fig. 22. **No. 73.** Four-coupled Well-tank Engine, built by R. & W. Hawthorn in 1852.

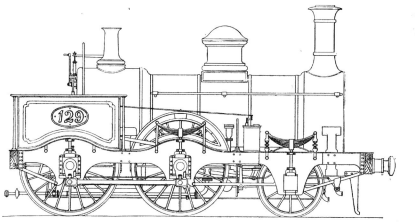

Fig. 23. **No. 129.** A Four-coupled Express Engine by Stephenson & Co. Built 1853.

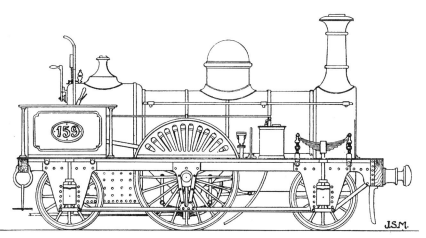

Fig. 24. **No. 159.** Stephenson's curious "Single" Express Engine. Built 1853.

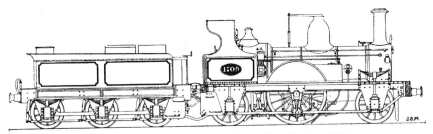

Fig. 25. **No. 159.** Re-numbered **1709** and fitted with a MacDonnell Chimney.

engine named the *Sanspareil*, commemorating the earlier *Sanspareil* of Rainhill trial fame. Timothy Hackworth was the pioneer Locomotive Superintendent of the first public railway in the world, being appointed in 1825 to take charge of the locomotives of the Stockton & Darlington Railway on the recommendation of George Stephenson, his official designation being Locomotive Foreman. Unlike some of his contemporaries he was of a somewhat retiring disposition, and many people claim that his inventive genius and mechanical skill have never received adequate recognition.

The *Sanspareil*, No. 135 on the NER, was the joint production of father and son, but it is probable that most of the ideas emanated from Timothy, and were the result of his knowledge and life-long experience as an inventor, designer, and builder of locomotives of all kinds.

The purchase of the *Sanspareil* was not completed until about 1854, so that the engine suffers an injustice when compared in size with its contemporaries on the line; but the *Practical Mechanics' Journal* quaintly stated that she was powerful enough to walk away with some hundred tons of deadweight, while she had repeatedly come up to the speed of 75 miles an hour.

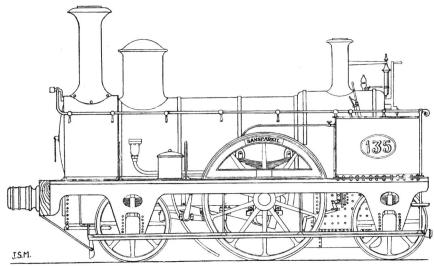

Fig. 26. **No. 135.** The "Sanspareil." Hackworth's Masterpiece.

The principal dimensions of the *Sanspareil* were as follows: Driving wheels, 6-foot-6-inch diameter. Leading and trailing wheels, 4-foot diameter. Cylinders, 15-inch diameter, stroke, 22 inches. Wheel base, leading to driving, 6 feet 11 inches; driving to trailing, 6 feet 8 inches. Total, 13 feet 7 inches. The boiler contained 221 brass tubes, 2-inch diameter. Heating surface, 1,188 sq. ft. Weight of engine in working order, on leading wheels 8 tons 6 cwt, driving wheels 11 tons 4 cwt, trailing wheels 4 tons 5 cwt. Total weight, 23 tons 15 cwt. A feature of the engine was its wrought-iron driving wheels with only ten spokes. The slide valves were specially designed to allow a portion of the steam required to perform the return stroke to be in the cylinders before the forward stroke was completed and thus form a cushion between the piston and cylinder covers. Weatherburn was at York when the engine was stationed there for a short period in 1858, and stated that no one but the inventor or his man was allowed to see these valves. They were afterwards removed and the usual form of 'D' valves substituted in their place, as these have all the advantages with greater simplicity of action. The engine was one of the first to have the boiler lagging covered with sheet-iron. It had a new boiler in 1878 and was broken up three years later. The Hackworths, with whom the result of the Rainhill trials had always been a sore point, were anxious to have a competitive trial between their *Sanspareil* and Stephenson's No. 190, for which so much was claimed, but the Railway Company seems not to have agreed to this taking place on their main line.

E. B. Wilson & Co.'s Passenger Engines

Ever since the *Jenny Lind* attracted attention, the Directors had contemplated placing an order with E. B. Wilson & Co., of Leeds, and they were only deterred from doing so in 1849 by reason of the success of No. 180 (the *Plews*) and No. 190. However, in 1853, with the amalgamation in sight, came the demand for additional engine power, and E. B. Wilson were asked to supply two large 'Jenny Linds' and three different sizes coupled passenger engines as well, making a total of nine.

These handsome engines may be said to represent the first lot of North Eastern express passenger engines proper, inasmuch as the enquiry came jointly from the Directors of the three railways, the York, Newcastle & Berwick, the York & North Midland, and Leeds Northern, and the order for them was placed by E. Fletcher himself, who was Locomotive Superintendent from July, 1853. The three companies were one in all but name, the passing of the Bill being delayed by Parliament until the following year.

The engines all bore the well-known classic features – fluted dome and safety-valve covers in the style of a Corinthian column on a square base; and, of course, radially-slotted driving splashers. This portion of the design, certainly the most elaborate ever attempted, was the work of a lady, the wife of James Fenton, manager of the firm – a circumstance probably unique in the history of the locomotive. The axle journals on the coupled engines were tapered towards the middle to prevent undue lateral oscillation.

In the following table, setting out the numbers of these nine NER passenger engines, it will be seen that three different sized coupled wheels were supplied and that the two 'singles' were large 'Jenny Linds', almost the largest built, with driving wheels 6 feet 3 inches in diameter:

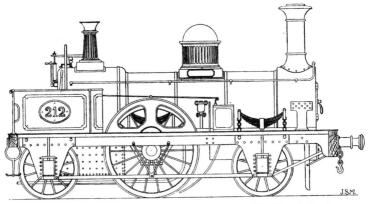

Fig 27. **No. 212.** Y.,N. & B.R. A " Jenny Lind " Single. By E. B. Wilson & Co., 1853.

Passenger engines built by E. B. Wilson & Co., Railway Foundry, Leeds:

Engine No.	Began running	Driving wheels feet	inches	How coupled	Re-built	Replaced
27	1853	6	3	Single	1878, York	1886
212	October, 1853	6	3	Single	–	1886
219	December, 1853	5	9	Coupled	1869, Leeds	1888
213	November, 1853	6	0	Coupled	1879, York	1889
214	November, 1853	6	0	Coupled	1879, York	1887
216	December, 1853	6	0	Coupled	1878, York	1889
217	December, 1853	6	0	Coupled	r880, York	1888
215	November, 1853	6	6	Coupled	1876, Leeds	1889
218	January, 1854	6	6	Coupled	1876, Leeds	1889

Nos 27 and 212, the two 'Jenny Linds', had cylinders 16 inches by 20 inches and bore close resemblance to the numerous examples of this type, having a total heating surface of 1,006 square feet. Their other leading dimensions were: Driving wheels, 6 feet 3 inches. Leading and trailing wheels, 4 feet. Wheel base, leading to driving, 7 feet 7 inches; driving to trailing, 7 feet 1 inch. Total, 14 feet 8 inches. Boiler, 10 feet 7 inches long by 3-foot-7-inch diameter, containing 162 tubes 2 inches in diameter. The tender, on six wheels 3-foot-6-inch diameter, contained 1,400 gallons of water. No. 212 had new splashers with two large openings instead of the small narrow ones fitted.

No. 219 was the smallest of the series, with coupled wheels only 5-foot-9-inch diameter and cylinders 16-inch diameter by 20-inch stroke.

Then follow the four engines with 6-foot coupled wheels and cylinders 15-inch diameter by 22-inch stroke and numbered 213, 214, 216, and 217. The cost of each, with tender, was £2,375. The total weight of engine was 30½ tons. These engines ran on the Leeds and Thirsk trains and came to be re-built by the late J. Stephenson, District Locomotive Superintendent at York. No. 216 is illustrated in *Fig. 28* as running after re-construction in October, 1878. It has an Adams safety valve on the boiler in addition to one on the dome. The remaining engines, Nos 215 and 218, often referred to as the 'Big Wilsons', were the largest express engines

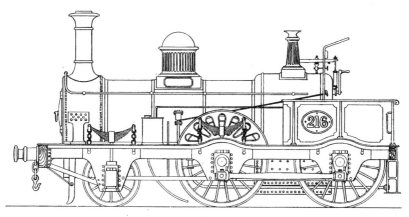

Fig. 28. **No. 216.** One of E. B. Wilson's Four-coupled Express Engines.

on the line, having driving and coupled wheels 6 feet 6 inches in diameter and cylinders 16 inches by 22-inch stroke. These were later enlarged to a diameter of 17 inches. Their other leading dimensions were: Coupled wheels, 6-foot-6-inch diameter. Leading wheels, 4-foot-6-inch diameter. Wheelbase, ending to driving, 7 feet 2 inches; driving to trailing, 7 feet 6 inches. Total, 14 feet 8 inches. The boiler contained 162 tubes 2-inch diameter. Heating surface, tubes, 891 sq. ft. Fire-box, 84. Total heating surface, 975 sq. ft. Working pressure, 120 lbs per sq. in. Weight on coupled wheels, 21 tons 8 cwt. Total weight of engine, 31 tons 11 cwt. Although generally stationed south of Newcastle and working between Leeds, Harrogate, and Thirsk, where they remained for the greater part of 30 years (see the *Locomotive Magazine*, 15 June, 1915), we have a note of No. 215 being at Tweedmouth working on the main line in 1859. No. 218 rendered herself notorious by blowing up at Holbeck station, 23 July, 1875, on a Leeds–Harrogate train. The damaged engine was illustrated in the *Locomotive Magazine*, 15 September, 1914. Both 215 and 218 were re-built at Leeds in 1876. The engines had previously been fitted with small cabs and new chimneys, and the safety valves relegated to the top of the dome to conform to the standard practice of the line at this period. *Fig. 30* represents Engine 218 altered and before the date of the explosion.

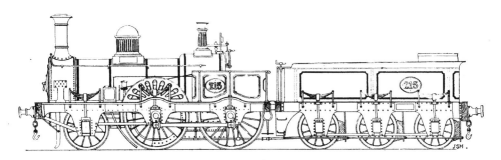

Fig. 29. **No. 215.** One of the big Wilson Four-coupled Express Engines.

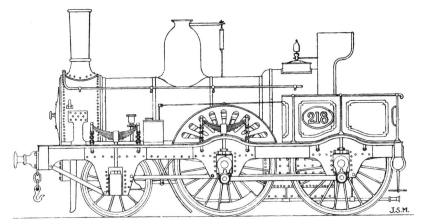

Fig. 30. **No. 218.** As re-built with cab, new dome and chimney.

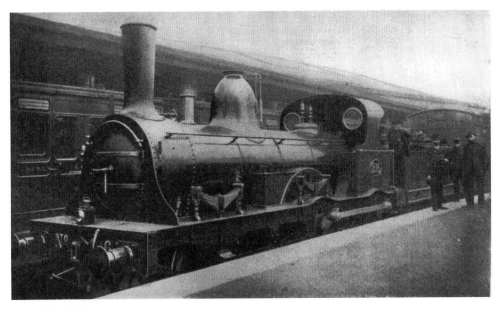

Above: No. 216, as re-built with strengthened frames, new boiler, and fitted with additional safety valve between chimney and dome.

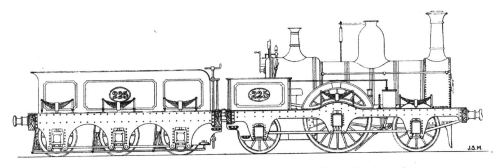

Fig. 31. **No. 225.** One of the 220 Class Single-Wheel Express Engines, 1854.

Six-Wheeled Single-Driving-Wheel Express Engines

Edward Fletcher was Acting Locomotive Superintendent from July, 1853, during the joint working arrangement of all the Companies, and was placed in full charge of the locomotives of the newly-formed NER a year later. During this period R. Stephenson & Co. began delivering the first engines of the 220 Class to the YN&BR. These had driving wheels 6-foot-6-inch diameter and cylinders of the small dimensions of 15-inch diameter and 20-inch stroke. They were numbered 220 to 225 (inclusive), makers' numbers 931 to 936, and two engines of very similar dimensions followed a few years later from the Gateshead works, numbered 66 and 258. The leading and trailing wheels of No. 66 were 3 feet 8 inches in diameter. Driving wheels, 6 feet 6 inches in diameter. Cylinders, 16 inches by 20-inch stroke. Weight in working order: on leading wheels 10 tons 10 cwt, driving wheels 13 tons, trailing wheels 7 tons 11 cwt. Total weight, 31 tons 1 cwt. These engines were designed to burn coke.

The dates of the 220 Class engines were as follows:

Engine No.	Began running	Builders	Replaced
220	March, 1854	R. Stephenson & Co.	1886
221	April, 1854	Do.	1888
222	July, 1854	Do.	1888
223	July, 1854	Do.	1888
224	August, 1854	Do.	1889
225	September, 1854	Do.	1889
66	April, 1859	N.E.R.	1885
258	October, 1863	Do.	1887

In later years, when re-built, Nos 180 and 190 were grouped with this class on account of their driving wheels and cylinder dimensions corresponding, and thus completed the round number of ten.

Fig. 31 represents No. 225 as originally built except that it probably had a round-topped dome according to Stephenson's usual practice. The same engine, as subsequently altered at York with Fletcher's mountings and new boiler, is illustrated by *Fig.* 33, below. No. 221 was re-built at York by J. Stephenson in May, 1882, with cylinders enlarged to 16 inches by 20-inch stroke. No. 223 was renewed with driving wheels only 6 feet in diameter and cylinders 16¼ inches by 20 inches, and began running again in July, 1882. As thus altered it is illustrated by *Fig.* 34. This figure was kindly supplied by E. L. Ahrons.

No. 224, driven by J. Atkinson, opened the Team Valley line with the Scotch Express on 15 January, 1872. In the Spring of 1882 No. 220 was re-numbered 1721 in place of one of Fletcher's new engines.

No. 66 was for some considerable time stationed at York, and in the years 1867–69, with two other singles, Nos 161 and 162, worked in a 'link' on important trains between York and Newcastle. It was re-numbered 1710 about 1885.

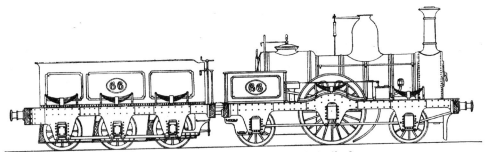

Fig. 32. **No. 66.** One of the 220 Class, built April, 1859.

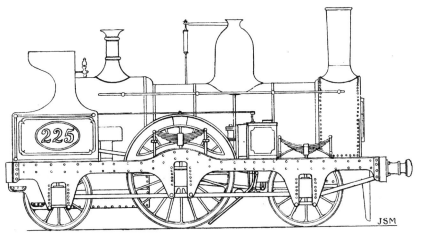

Fig. 33. **No. 225.** As altered, with new boiler and cab, by Mr. Fletcher.

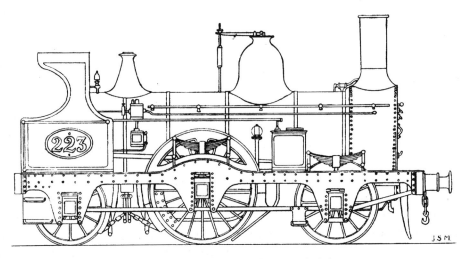

Fig. 34. **No. 223.** As re-built, with 6ft. driving wheels, in 1882.

York and North Midland Engines

One hundred and fourteen locomotives of the Y&NYMR were added to the joint stock of the newly-formed NER, their new numbers being 245 to 358 inclusive. The rolling stock comprised a very miscellaneous lot of, in many cases, small and worn-out specimens which had served their purpose and were not long in surviving, so that little information of many of them now exists. The coaching stock was said to be one of the worst in the country. York works began a busy period of re-building and overhauling, and confined their attention exclusively to the locomotives of this line until 1858 and to the Southern Division generally for many years later. They were entirely closed in 1905.

The sister engine to the 'A', built by Stephenson was No. 58 Y&NMR, and is said to have been NER No. 290; but as David Joy said he had it on the Oxford, Worcester and Wolverhampton line in the fifties, and he knew the engine at Leeds in his youth, it can scarcely have come into the hands of the NER.

Y&NMR No. 48, built for the Hull & Selby Railway in 1840 by Fenton, Murray & Jackson, ran during the Spring of 1854 between Hull and Bridlington fitted with patent rotary valves, but the engine was soon afterwards altered and the ordinary flat valves replaced.

Two 'single' passenger engines, built and designed by Shepherd & Todd, of the Railway Foundry, Leeds, in 1841, were named *Antelope* and *Ariel*. David Joy saw them in 1843 and described them as handsome and fast. At that time they had John Gray's expansive reversing gear, called the 'horse-leg' gear, patented in 1838. The following were their original chief dimensions: Cylinders, 13 inches by 24 inches. Driving wheels, 6-foot diameter. Carrying wheels, 3-foot-6-inch diameter, of cast iron. Total wheelbase, 11 feet 6 inches. Boiler, 9 feet long, 3-foot-6-inch diameter, contained 106 tubes 2 inches in diameter. Heating surface: fire-box, 63 sq. ft.; tubes, 538; total, 601 sq. ft. Grate area, 9.75 sq. ft. Steam pressure, 90 lbs sq. in. Weight of engine, 14 tons. Their numbers on the NER seem to have been 253 and 254. David Joy re-visited York engine sheds in 1883 and saw the old *Antelope*, which he thought 'a lovely, light, fleet-looking engine still'. It had, of course, then been re-built and enlarged. It may be noted that the three engines, *Ariel*, *Antelope*, and *Hudson*, opened the Hull–Bridlington Branch on 6 October, 1846. (See Tomlinson's *History of the NER*.)

It had long been known to engineers that the heat from the fire-box passed through the tubes and chimney too quickly, so Robert Stephenson tried the experiment of increasing the length of the boiler and tubes in some cases to as much as 14 feet to utilise more of this wasted heat. This plan he patented, along with placing the valves in a steam-chest between the two cylinders, in 1842. One of the first engines on this plan was the *Prince of Wales*, which David Joy saw and mentions in his Diary. The driving wheels were either 5-foot-6-inch or 6-foot diameter. The leading and trailing wheels, 3-foot diameter. Cylinders, 14-inch diameter by 20-inch stroke. The combined length of fire-box, boiler, and smoke-box was 17 feet. The boiler contained 150 tubes, with a heating surface of 765 sq. ft, and the copper fire-box 30 sq. ft, the total heating surface being 795 sq. ft. The weight of the engine in working order was 15 tons. With a train of five loaded coaches it is stated to have attained on one of its journeys an average speed for several miles of 48 miles an hour, and the consumption of coke was 19.2 lbs per mile. The NER number of the *Prince of Wales* was

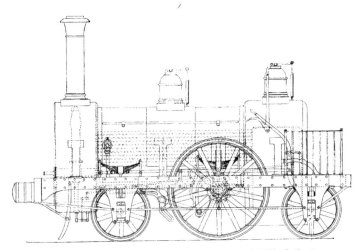

Fig. 35. Diagram of Y. & N.M.R. **"Antelope"** and **"Ariel."** Built 1841.

261. There is a large painting of this engine in the NER Literary Institute at Gateshead.

Six long-boiler four-coupled passenger engines were ordered by Thomas Cabry, the Locomotive Superintendent, in August, 1845, for the Y&NMR and built by E. B. Wilson & Co., of the Railway Foundry, Leeds. The late David Joy made the drawings. The four-coupled wheels were 6-foot diameter and the cylinders 15-inch diameter by 20-inch stroke. The boiler was 12 feet long by 3 feet 6 inches in diameter. Steam pressure, 90 lbs per sq. in. These were the first engines Joy distinctly remembered with the Stephenson link motion. The illustration of No. 10, *Fig. 36*, shows an engine of this class. It seems probable their numbers on the NER were 293 to 298, and if so their wheels had been reduced in diameter at a later period.

The engines around which most interest attaches were the series of 11 'Jenny Linds', including the famous *Jenny Lind* herself, built in July, 1847, and numbered 88 (NER No. 319). As almost everyone is aware these very successful locomotives were designed by

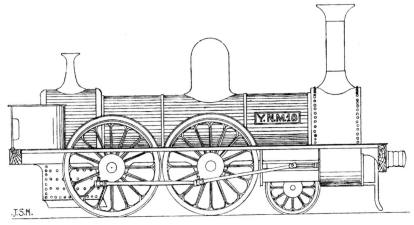

Fig. 36. **No. 10.** Y. & N.M.R. From a sketch by David Joy. Built 1845.

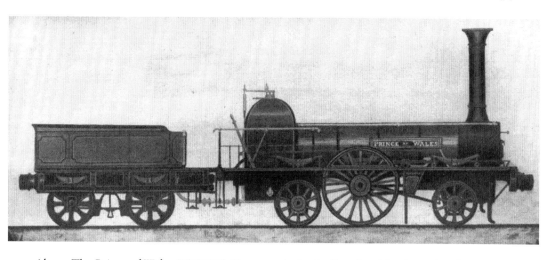

Above: The *Prince of Wales*. Y&NMR. From a painting in Gateshead Institute, dated 1843.

E. B. Wilson & Co., Leeds, who thereby derived a very considerable reputation, the actual draughtsman being the late David Joy of valve-gear fame. *The Engineer* pointed out that this design was the first high-speed, really economical engine, and ascribed their success very largely to their increased boiler pressure of 120 lbs per sq. in. instead of the 90 or 100 lbs then usual. The 'Jenny Lind' constituted a remarkable advance on what had gone before it, and indeed held its own for many years.

The first 'Jenny Lind' of all went to the London & Brighton Railway in June, 1847. This was immediately followed by No. 88, Y&NMR, to which the name *Jenny Lind* was attached on a brass plate with raised letters on each side of the boiler. The only other named *Jenny Lind* of this type ran on the MS&LR. The boiler was lagged with strips of mahogany and the other details were of the usual highly ornamental character associated with the engines from the Leeds Foundry.

The following table shows the dates built and the new numbers of the engines when taken over in 1854:

Y&NMR No.	Date built	NER No.	Replaced
88	July, 1847	319	1879
89	August, 1847	320	1878
90	September, 1847	321	1880
91	September, 1847	322	1880
92	October, 1847	323	1878
93	October, 1847	324	1878
94	November, 1847	325	1878
95	November, 1847	326	1884
102	January, 1848	333	1878
103	January, 1848	334	1879
113	June, 1848	344	1878

No. 103 had driving wheels 5 feet 6 inches in diameter but otherwise corresponded with the rest. The original dimensions were as follows: Driving wheels, 6-foot diameter. Leading

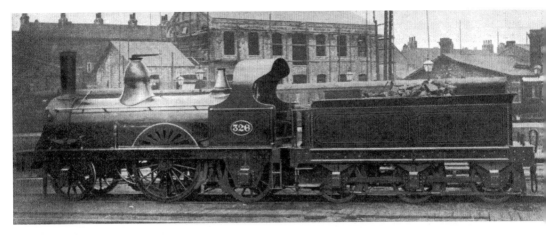

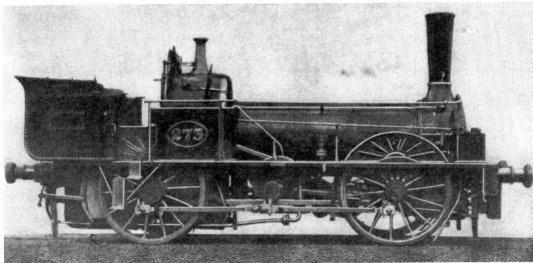

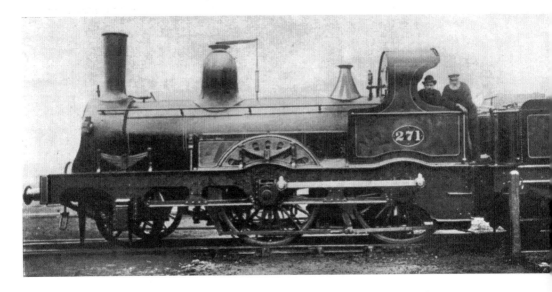

and trailing wheels, 4-foot diameter. Inside cylinders, 15-inch diameter by 22-inch stroke. Wheel base, leading to driving, 7 feet 8 inches; driving to trailing wheels, 7 feet 3 inches. Total, 14 feet 11 inches. The boiler, containing 124 tubes 2-inch diameter, was 11 feet long and 3-foot-8-inch diameter. Heating surface, tubes, 720 sq. ft. Fire-box, 80 sq. ft. Total, 800 sq. ft. Weight of engine in working order, 24 tons. Boiler pressure, 120 lbs per sq. in. The boilers were lagged with mahogany bound with brass bands. The last of these famous 'singles' on the NER to survive was No. 326, shown in the photograph. This engine was re-built at York by the late John Stephenson in November, 1877, by enlarging the cylinders to 16 inches by 24-inch stroke, putting on a larger boiler and moving the leading wheels forward so as to lengthen the wheelbase. This engine ran until 1884.

The Y&NMR acquired in January, 1830, a peculiar type of tank engine running on only four wheels all coupled to an intermediate driving shaft on T. R. Crampton's plan. E. B. Wilson & Co., of Leeds, built several of these engines for different lines. David Joy refers to these engines in his Diary as the 'Little Mails', and was favourably impressed by them. The cylinders were 11-inch diameter by 18-inch stroke, driving the 'dummy' crankshaft from their inside position as in a standard six-coupled engine and reversed by ordinary link-motion. The wheels were 5-foot diameter and wheel base 10 feet 11 inches. The boiler, constructed to carry a working pressure of 100 lbs, was 9 feet 3 inches long, 3-foot diameter, and especially low pitched. The fire-box, of copper, stood high above the boiler, being 4 feet 1 inch high, 2 feet 3 inches long, and 2 feet 9 inches wide. The boiler contained 110 tubes 9 feet 4¾ inches long and 2 inches in diameter. The total heating surface was 576 square feet. The inside frames were 8 inches deep, 1¼ inches thick, and 19 feet long. The tank held 225 gallons and the bunker one ton of coal. The extreme length of the engine was 22 feet 4 inches. *The Engineer* eulogised No. 273 as a well-finished, neat little engine, and reported that with a light train she had run steadily at 43 miles an hour.

Fletcher replaced No. 273 by one of his bogie tank engines in 1878.

In 1856 there were re-built at York two four-coupled passenger engines, so modernised that little if any of the earlier Y&NMR engines remained. Their numbers were 271 and 293. They had driving wheels 6-foot-1½-inch diameter and cylinders 16 inches by 22 inches, double frames, and outside coupling rods. They had round-topped domes and bell-mouthed chimneys and raised fire-boxes. No. 271 was re-built in November, 1879, and No. 283 in 1878 at York with flush boilers and similar cabs, domes, boiler fittings, etc., to the Wilson coupled engines Nos 213, etc., which they resembled very closely. No. 271 is illustrated as re-built, and may be compared with No. 216.

Opposite, from the top: No. 326, NER. One of the 'Jenny Lind' engines re-built. Y&NMR No. 95. *Middle:* Crampton's patent Tank Engine, No. 273, which was built in 1847. *Bottom:* NER No. 271 as re-built in York in 1879. Probably nothing of the Y&NMR engine remained.

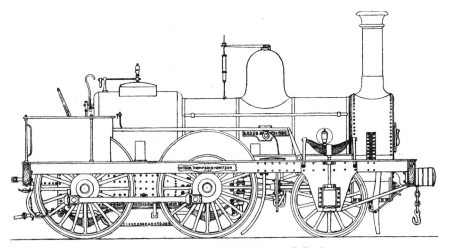

Fig. 37. **No. 8.** Leeds and Thirsk Railway. Built 1847.

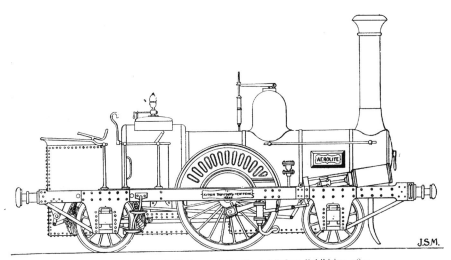

Fig. 38. The **"Aerolite,"** shown at the Crystal Palace Exhibition, 1851.

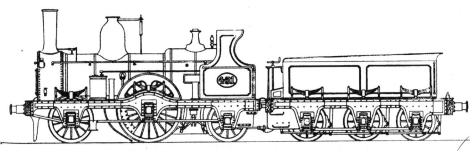

Fig. 39. **No. 451.** Built by R. & W. Hawthorn, September, 1861.

Leeds Northern Railway Engines

Twenty-eight locomotives were contributed by this Company, the old 'Leeds & Thirsk', to the NER stock. They were given the numbers 359 to 387. Of these, 359 to 361 disappeared in 1866. They were small six-wheeled four-coupled engines with 5-foot-6-inch driving wheels and cylinders 15 inches by 20 inches, built by Kitson & Co., Leeds, and seem to have been very similar to six on the Y&NMR by the same firm, numbered 352 to 357.

In 1847 were built six four-coupled passenger engines with 6-foot driving wheels and cylinders 16 inches by 22-inch stroke, also by Kitson & Co. These were numbered from 8 to 13 on the Leeds Northern and from 362 to 367 on the NER. Their leading dimensions were: Coupled wheels, 6-foot diameter. Leading wheels, 4-foot-6-inch diameter. Wheel base, 15 feet equally divided. The boiler was 10 feet 6 inches long, oval in section, 3 feet 9½ inches deep, and 3 feet 7½ inches wide outside, containing 147 tubes 1 7/8-inch diameter outside, 10 feet 10 1/8 inches long. Grate area, 15.5 sq. ft. Total weight in working order about 26 tons.

No. 364 was re-built at Leeds in August, 1875, in appearance like the 698 Class but was placed in the 1440 Class. It became quite modernised in all respects, the cylinders being enlarged to 17 inches by 24-inch stroke. The new boiler and fire-box were sent through from Gateshead. The *Aerolite* was a fine little six-wheeled single tank engine of Kitson, Thompson & Hewitson's standard design, built for the Great Exhibition of 1851 at the Crystal Palace (makers' number, 281). During the exhibition it was painted blue and was afterwards sold to the Leeds Northern Railway, about 1852, and stationed at Thirsk. Its first NER number was 369. In 1883 it was No. 1478 and in 1885 it was altered to 66. Originally the cylinders were 11-inch diameter by 18-inch stroke. The driving wheels were 6-foot diameter and the carrying wheels 3-foot-6-inch diameter, all of solid wrought iron. The tanks carried 500 gallons of water. The engine was very neat and well finished, and was appropriated for the Locomotive Superintendent's saloon on the NER. Owing to a collision at Otterington in 1868, when attached to Fletcher's special train, the *Aerolite* was re-built the following year at Gateshead as a 'single' side-tank engine with inside cylinders 13 inches by 20-inch stroke and double frames. For a short interval it had no number, until Alexander McDonnell made it 1478 in 1883. It very soon became No. 66 on being again re-built, when the only portion that remained was the inside frames. It was re-built as a two-cylinder compound by T. W. Worsdell with cylinders 13 inches and 18½ inches by 20 inches and a leading bogie, in 1886, and was finally altered in 1902 to a trailing-bogie engine by reversing the frames, by Wilson Worsdell, who replaced the name *Aerolite* in 1907. This famous engine is still used by the Chief Mechanical Engineer.

North Eastern Railway
Six-wheeled single-driving-wheel express engines

From 1861 onwards Fletcher once more for a time reverted to 'single' express engines of the 220 design, with enlarged cylinder and boiler dimensions and consequently heavier frames and other parts. There appears to have been nine or more of these fine engines of

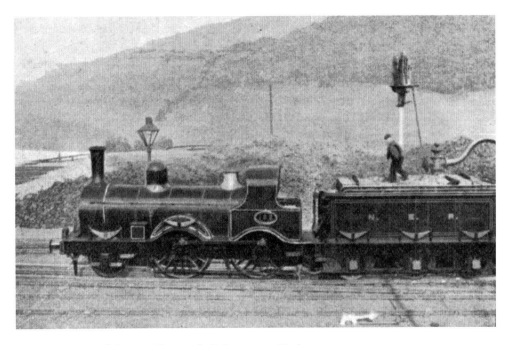

Above: No. 162 of the 450 Class, re-built in 1879 at York.

the 450 Class, and in their restricted sphere they were very successful, being, of course, confined to the more level portions of the system. Indeed, they were working on the Leeds and Scarborough expresses until the late nineties – no mean achievement on a section which has always been the pride of the York authorities.

The locomotive builders seem to have been busy at this time, as Stephenson & Hawthorn only managed to contribute six engines between them, and three were soon afterwards built at Gateshead.

The following were the numbers and dates of the 450 Class:

Engine No.	Date began running	Builders No.	Works No.	Re-built	New No.
447	July, 1861	R. Stephenson	1411	1884	1720
448	August, 1861	Do.	1412	1885	1721
449	September, 1861	Do.	1413	1883	1736
450	August, 1861	R. & W. Hawthorn	1131	1886	1935
451	September, 1861	Do.	1132	1883	1737
452	October, 1861	Do.	1133	1886	1722
162	October, 1862	Gateshead Works	–	1879	–
161	March, 1863	Do.	–	1888	1693
280	January, 1866	Do.	–	1888	1694

The Stephenson & Hawthorn engines had the following dimensions: Driving wheels, 6-foot-6½-inch diameter. Leading wheels, 4-foot-6-inch diameter. Trailing wheels, 4-foot diameter. Total wheelbase, 16 feet, equally divided as usual. Cylinders, 16-inch diameter, stroke, 22 inches. The tender contained 2,000 gallons of water. The tender wheels were 4 feet 0½ inch in

diameter. No. 280, built at Gateshead, differed from the above as follows: Driving wheels, 6 feet 8 inches. Leading and trailing wheels, 4 feet 1 inch. Total wheel base, 15 feet 6 inches. Cylinders, 17-inch diameter, stroke, 20 inches (afterwards 22 inches). Boiler diameter, 3 feet 9 inches. Length of barrel, 11 feet 6 inches. Length of fire-box, 4 feet 3 inches, outside width, 4 feet 3¼ inches. The fire-box was divided by a partition extending to the roof and had two fireholes.

The engines had open splashers and no cab, only a weatherboard, until re-built – No. 451 being the first in 1885.

The majority of this class were re-built about the time of the 'Tennant' interregnum, when large boilers of the 1463 type were fitted and the cylinders enlarged to 17-inch diameter. The boiler contained 197 tubes 2 inches in diameter; the total heating surface being 1,248 sq. ft.

No. 162 was re-built and entirely re-modelled in 1879 by J. Stephenson, at York, as a four-coupled express engine with 6-foot driving wheels and double frames of a much more solid and substantial design than were usual at this time. The cylinders were 17-inch diameter and stroke 22 inches. The engine began running in March the heaviest expresses between Leeds, York, and Scarborough, where it continued for 20 years. An exceedingly good job was made of it, but no others were similarly treated. The photograph shows the engine with the new boiler put in at York in 1891 by T. W. Worsdell, and after finishing its career on the Bradford line No. 162 was broken up in 1903.

Nos 1693 and 1694 in the duplicate list finished their careers on the Bradford trains in 1894.

Four-Coupled Double-Framed Passenger Engines

The Company was now requiring a larger number of passenger engines and prepared to build for themselves on a big scale at the Gateshead Works. Fletcher, returning to coupled engines (which he always afterwards adhered to for express work), took for his model the fine 129 Class of 1852, but gave the 25 Class 6-foot-6-inch driving and trailing wheels and cylinders 16 inches by 22 inches.

There were a dozen of this class built, and although spread over some years it will be remembered that during this time Hawthorn were building their 545 Class for identical work. Both lots had tenders of similar design and driving wheels of the same diameter but were entirely different in other respects.

While the 545 Class engines ran chiefly between York and Newcastle, the '25' Class were running on the Northern Section. No. 26, driven by John Hewgill, did excellent service between Newcastle and Edinburgh in the early days of 'through' running to the Scottish capital. Engine 468, driven by Wm Simpson, was the first North Eastern engine to work a train to Edinburgh when this arrangement began in May, 1869.

The '25' Class had big fire-boxes with a water space in the middle, adding to the heating surface, and two doors for firing. The wheel base was equally divided, as was usual at this period. *Fig. 40* shows the original design of this class. This engine, No. 312, was re-built at Gateshead with new boiler and cylinders in 1880. No. 102 replaced the old Stephenson 'single' built in 1845, but was not a re-build.

The numbers and dates of the 25 Class were as follows:

Engine No.	Began running	Replaced
25	August, 1863	1899
26	January, 1865	1891
312	June, 1863	1890
148	July, 1866	1891
257	November, 1876	1900
468	March, 1868	April, 1901
250	May, 1868	1905
473	June, 1868	1905
683	January, 1869	1888
459	April, 1869	1900
463	April, 1869	1899
462	May, 1869	1898
102	July, 1869	1891

Nos 26, 102, and 148 were together re-built at York in 1883 as sister engines, and another batch, Nos 25, 257, 459, 463, and 468 in 1887. No. 462 was re-built at Leeds in 1884, and Ahrons declares it came out with McDonnell number plates with the date 1869 instead of 1867. No. 683 was never re-built. The boiler was used for a pumping engine at Leeds. Two of the engines were re-numbered 2251 and 2253 in the duplicate list before breaking up. No. 157 of the 24 Class had new 6-foot-6-inch driving wheels fitted in 1882. Its original wheels were all enlarged by supplementary tyres and ordinary tyres with flanges outside them, bringing the wheels to the correct diameter. The boiler was the same as No. 312.

Newcastle and Carlisle Engines

The Newcastle and Carlisle, one of the very earliest lines, part of which was opened in 1836, was merged in the NER in 1863. The 39 locomotives from this Company were given the new numbers 453 to 491 (inclusive). The following table, most of which was compiled by A. E. Mason, of Hawick, shows at a glance their chief dimensions. No. 5, *Samson*, re-built just previous to the taking over of the line, is illustrated below by *Fig. 41*. The engines and tenders were painted red and used the right-hand side line in passing, as on the Greenwich Railway, instead of the left.

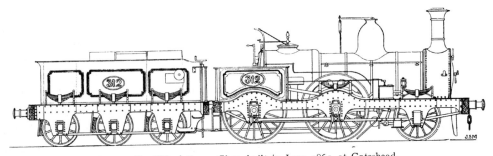

Fig. 40. **No. 312** of the 25 Class, built in June, 1865, at Gateshead.

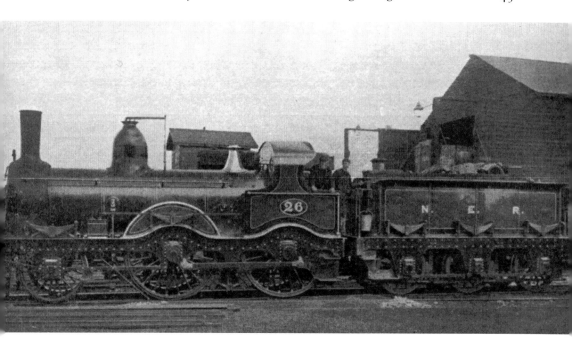

Above: No. 26, one of the 25 Class passenger engines, built in 1864. *Below:* No. 250, also of the 25 Class, re-built with strengthened frames, new boiler, and Worsdell chimney and dome.

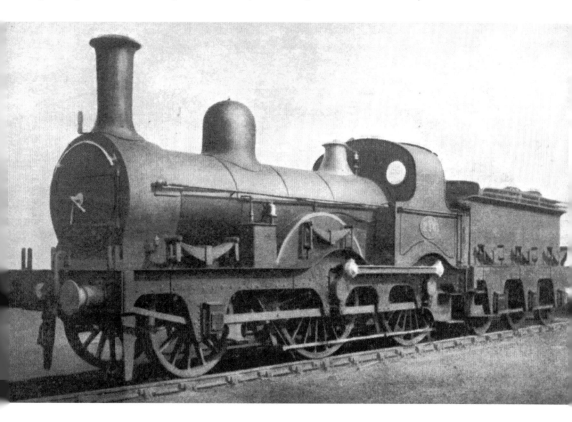

N.E. No.	Name	N&C No.	Builders	Date Built	Wheels.	Dia. of coupled wheels ft in.		Cylinders dia. str. in. in.		Total heating surface sq. ft	Steam pressure lb
453	Hercules	4	Hawthorn	1857	0-6-0	4	6	15	22	659	110
454	Samson	5	Do.	1836	2-4-0	5	0	14	18	499	–
455	Goliah	6	Do.	1836	0-6-0	4	0	14	18	473	70
456	Atlas	7	Stephenson	1861	0-6-0	4	6	15	22	619	40
457	Tyne	8	Hawthorn	1861	0-6-0	4	6	15	22	673	110
453	Eden	9	Stephenson	1861	0-6-0	4	6	15	22	619	110
459	Lightning	10	Hawks & Thompson	1837	0-4-2	4	6	14	15	440	65
460	Newcastle	11	Hawthorn	1860	0-6-0	4	6	15	22	659	110
461	Carlisle	12	Do.	1860	0-6-0	4	6	15	22	659	110
462	Wellington	13	Do.	1838	2-4-0	5	0	14	18	531	50
463	Victoria	14	Hawks & Thompson	1838	2-4-0	6	0	15	18	528	80
464	Nelson	15	Hawthorn	1838	2-4-0	5	0	14	18	529	80
465	Northumberland	16	Do.	1838	2-4-0	5	0	14	18	529	–
466	Cumberland	17	Do.	1838	2-4-0	5	0	14	18	529	–
467	Durham	18	Do.	1839	0-6-0	4	0	14	18	529	–
468	Sun	19	Do.	1839	0-4-2	4	9	14	18	530	80
469	Matthew Plummer	21	Thompson Bros.	1839	0-6-0	4	0	14	18	529	60
470	Adelaide	22	Do.	1840	0-6-0	4	0	14	18	529	60
471	Mars	23	Do.	1840	0-6-0	4	0	14	18	528	80
472	Jupiter	24	Do.	1840	2-4-0	4	9	14	18	–	–
473	Venus	25	Do.	1841	2-4-0	4	6	14	18	563	70
474	Saturn	26	Do.	1841	0-6-0	4	6	14	18	528	80
475	Globe	27	Hawthorn	1846	0-6-0	4	3	15	24	594	90
476	Planet	28	Do.	1846	0-6-0	4	3	15	24	631	90
477	Albert	29	Do.	1847	2-4-0	5	0	15	21	661	90
478	Swift	30	Do.	1847	2-4-0	5	6	15	21	597	90
479	Collingwood	31	Do.	1848	0-6-0	4	6	16	24	769	85
480	Allen	32	Do.	1848	0-6-0	4	6	16	24	769	85
481	Alston	33	Stephenson	1850	0-6-0	4	6	15	22	619	90
482	Hexham	34	Do.	1850	0-6-0	4	6	15	22	619	90
483	Prudhoe	35	Hawthorn	1852	0-6-0	4	6	15	22	661	110
484	Naworth	36	Do.	1853	0-6-0	4	6	15	22	661	110
485	Blenkinsopp	37	Stephenson	1853	0-6-0	4	6	15	22	619	110
486	Bywell	38	Do.	1853	0-6-0	4	8	15	22	619	110
487	Dilston	39	Hawthorn	1855	0-6-0	4	6	15	22	661	110
488	Langley	40	Do.	1855	0-6-0	4	8	15	22	661	110
489	Thirlwell	41	Stephenson	1855	0-6-0	4	8	15	22	619	110
490	Lanercosl	42	Do.	1855	0-6-0	4	6	15	22	619	110
491	Featherstonehaugh	43	Hawthorn	1857	0-6-0	4	8	15	22	655	110

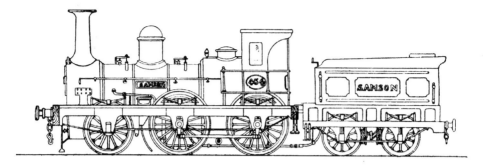

Fig. 41. **No. 454.** **"Samson,"** Newcastle and Carlisle Engine.

Samson

The *Samson* was rebuilt by the Newcastle & Carlisle Railway a year or two previous to the amalgamation and then had larger dimensions than shown in the above table. It was originally a 0-4-2 and was re-built as a 2-4-0 type.

492 Class
The 'Whitby Bogies' – four-coupled bogie passenger engines. Built 1864–5.

The Whitby line is one of the 'mountain-grade' sections of this country, ruling in parts as steep as 1 in 48 and 1 in 50. In 1864 Fletcher designed and R. Stephenson & Co., of Newcastle, constructed a special class of passenger engines capable of overcoming the gradient difficulties and numerous sharp curves on this line.

They were the first and only passenger tender engines Fletcher designed with homes, and as the illustration of No. 492, below, shows, these were placed well behind the centre of the smoke-box close to the coupled wheels to provide a short wheel base to negotiate the curves. Hence their appearance was somewhat peculiar, but they were entirety satisfactory in their work.

They had coupled wheels 5-foot diameter, bogie wheels 3-foot diameter, and cylinders 16 inches by 22-inch stroke.

List of the 492 Class:

Engine No.	Began running	Works No.	Renumbered	Altered	Scrapped
492	September, 1864	1581	1807	July, 1889	1893
493	September, 1864	1582	1710	January, 1887	1888
494	November, 1864	1583	1712	January, 1887	1888
495	February, 1865	1584	1808	July, 1889	1893
496	March, 1863	1585	1809	July, 1889	1893
497	March, 1865	1586	–	–	1883
498	March, 1865	1587	–	–	1884
499	April, 1865	1588	1713	January, 1887	1888
500	May, 1865	1589	–	–	1884
501	June, 1865	1590	1810	July, 1889	1893

No. 1809 (No. 496) continued to work until 1893 and was the last of the lot to run.

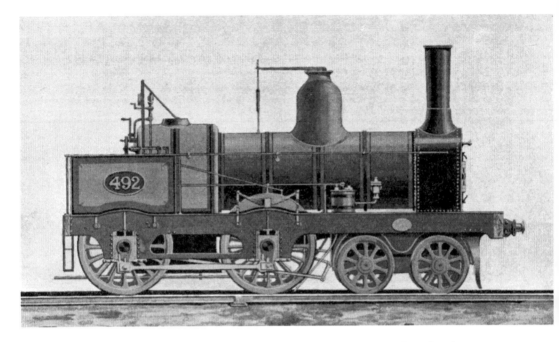

Above: No. 492, one of the Special Whitby Engines built in 1864. Fletcher's first bogie engine.

544 Class
Six-wheeled four-coupled express engines. 1865

This class comprised ten engines built by R. & W. Hawthorn, Newcastle, during 1865 and the following year and were successfully employed on the North Eastern main line for many years.

The principal dimensions of the 544 Class were: Driving wheels, 6-foot-6-inch diameter. Coupled wheels, 6-foot-6-inch diameter, 8-foot centres. Leading wheels, 4-foot-6-inch diameter. Cylinders, 16-inch diameter, stroke, 22 inches. Boiler, 10 feet 3 inches in length, 4-foot diameter, containing 197 tubes 2-inch diameter. Heating surface: fire-box 98 sq. ft, tubes 1,085 sq. ft, total 1,183 sq. ft. Weight of engine in working order, 34 tons 5 cwt, distributed as follows: on driving wheels 13 tons 17 cwt, trailing wheels 10 tons, leading wheels 11 tons 8 cwt. The tender contained 2,000 gallons of water and space for 2 tons of coke.

These engines presented some fresh features of design, probably of Hawthorn's suggesting, but in many important points, such as the equally-divided wheel base, the hand of Fletcher is still dominant, and the tenders and all the boiler mountings except the chimneys were his standard practice of the period.

Of the unqualified success of the whole class there was no doubt, and they outlasted many of their contemporaries. The design was reproduced in an enlarged form in the 901 Class engines seven years later.

Dates of the 544 Class:

Engine No.	Makers' No.	Date built	Re-built
544	1306	September, 1865	1883
545	1307	October, 1865	1881
546	1308	October, 1865	1881
547	1309	November, 1865	1886
548	1310	November, 1865	1881
549	1311	November, 1865	1884
550	1312	December, 1865	1882
551	1313	December, 1865	1883
552	1314	January, 1865	1883
553	1315	January, 1865	1886

No. 550 was first of all altered to 1945, and in 1892 the following five engines, Nos 546, 547, 1945, 551 and 552, were re-numbered 1723, 1773, 1774, 1754, and 1755. No. 1774 was frequently at Newcastle up to the end of her career. The last to survive was No. 1753, in 1904 running between Bradford, Leeds, and Hull.

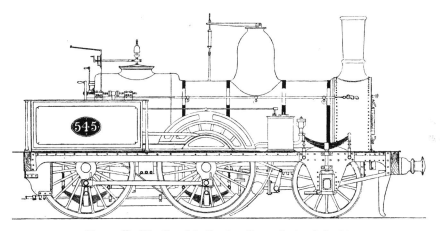

Fig. 42. **No. 545.** One of the Hawthorn Express Engines, built 1865.

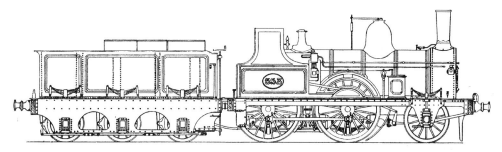

Fig. 43. **No. 553.** Re-built with new boiler in 1886 at Gateshead.

24 or 38 Class
Six-wheeled four-coupled passenger engines
Double frames and bearings. First one built 1867.

These smart little engines were a smaller edition of the 25 Class, designed by Fletcher and built at Gateshead Works. Their driving wheels were 6 feet in diameter and cylinders 16 inches by 22-inch stroke. Leading wheels, 4-foot-1-inch diameter. Wheel base, leading to driving, 7 feet 3 inches; driving to trailing, 7 feet 6 inches. Total, 14 feet 9 inches.

There was no brake on the engine and a hand brake on the tender only.

Fig. 44 shows in outline the appearance of this class. The compensating beam shown between driving and trailing wheels was not introduced on any of the 38 Class engines as far as we know. No. 29, re-built with strengthened frames, a cab, and a safety valve on the fire-box, is illustrated by Ahrons in *The Railway Magazine*, December, 1916. No. 162 was not one of this class. It had always been different, and when re-built had deeper and heavier frames altogether.

List of the 38 Class:

Engine No.	Date built	Remarks
38	July, 1867	Replaced in 1882.
157	July, 1868	Re-built with 6-foot-6-inch wheels at Gateshead in 1882.
29	April, 1869	Re-built at York in 1887.
147	April, 1869	Re-built at Leeds in 1882.
24	May, 1869	Re-built at Darlington, 1882.
682	May, 1869	Scrapped in 1883.
286	July, 1869	Scrapped in 1888.
472	October, 1870	These lasttwo were not re-built. Scrapped in 1888 and 1883.
369	September, 1871	

There were three engines of this type with double frames, similar in all other respects to the 24 Class but with four-coupled wheels of a diameter of only 5 feet 6 inches. Their cylinder dimensions were 17 inches by 22-inch stroke. Their numbers were 21, dated February, 1869; 680, built October, 1869; and 139, built March, 1871. No. 680, when new, ran on the Consett Branch. No. 21 was notable as being the first engine the NER fitted with the Westinghouse brake.

Photographs on opposite page: No. 64, showing additional safety valve between chimney and dome, which was Fletcher's practice in 1870 and 1871. No. 50, 675 or 50 Class, re-built with new fire-box and boiler by T. W. Worsdell.

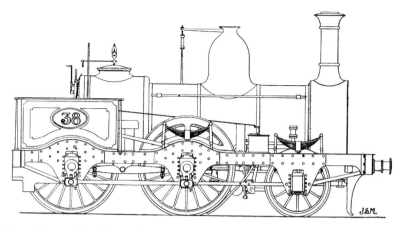

Fig. 44. Diagram of one of the 24 Class. They were not built with the compensating beam between driving and trailing wheels shown in the drawing.

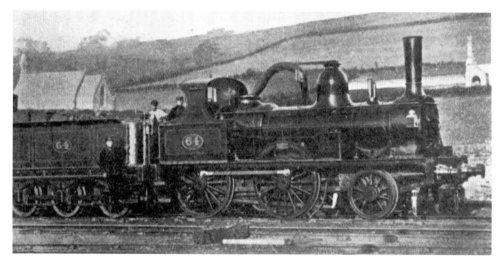

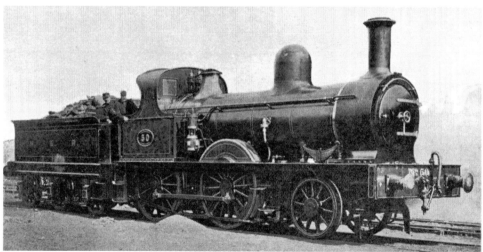

675 Class
Mixed traffic engines. First one built 1870

These smart little engines were designed on the same lines as the re-built 75, already described, by Fletcher. They were heavier, of course, and more powerful. Their driving wheels were 5-foot-6-inch diameter and cylinders 15 inches by 22-inch stroke, except No. 465, which had 15½-inch cylinders. They worked passenger trains on the hilly sections of the system and on stopping trains in the York district. Although it is said Hull and Scarborough had most when new, No. 64 was stationed at Carlisle, a little later also Nos 465 and 803. Three others, Nos 68, 177, and 355, worked to Carlisle from Newcastle, being shedded at Gateshead.

List of 675 Class in order of building:

Engine No.	Date began running	Date scrapped	Engine No.	Date began running	Date scrapped
675	March, 1870	1887	68	September, 1872	1890
676	May, 1870	1887	296	March, 1873	1890
678	July, 1870	1887	54	May, 1873	1890
679	November, 1870	1887	482	May, 1871	1890
677	December, 1870	1888	465	June, 1873	–
316	April, 1871	1890	478	July, 1873	1890
179	June, 1871	1890	810	July, 1873	1890
176	August, 1871	1890	304	November, 1873	1887
454	August, 1871	1887	355	January, 1874	1890
64	December, 1871	1885	333	1875	1890
177	January, 1872	1890	483	January, 1875	1889
801	January, 1872	1886	812	February, 1875	1884
248	February, 1872	1890	50	April, 1875	1890
802	March, 1872	1890	165	April, 1875	1886
103	May, 1872	1890	70	June, 1875	1887
803	June, 1872	1886	811	December, 1875	1887
168	July, 1872	1887	181	May, 1877	1890

T. W. Worsdell re-built these engines with new boilers and improved their appearance by narrowing the smoke-box front and new safety valves, domes, and chimneys.

686 Class
Four-coupled six-wheel passenger engines, Built 1870

This interesting class of passenger engines was designed by Fletcher chiefly for the Leeds Northern line and the Hull district generally. They did at first run some of the Scotch expresses from York but they were essentially Southern Division engines, and as so often happened were more ornate than those running in the North on the main line. Beyer, Peacock & Co. constructed twelve and R. Stephenson & Co. eight. The Beyer-Peacock series had wide brass bands and the name of their builders round the driving splashers,

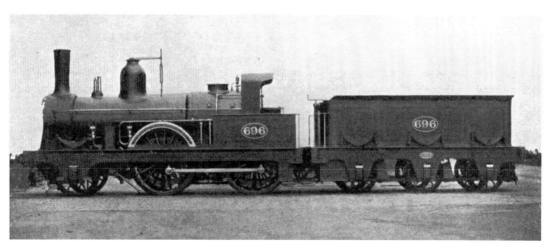

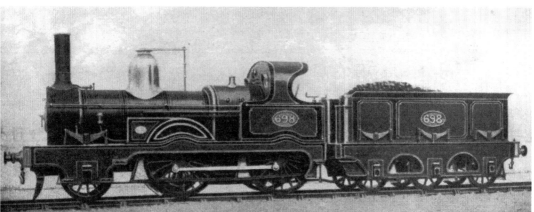

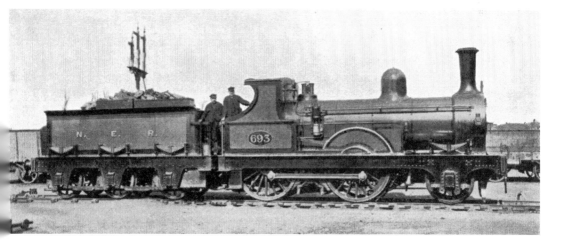

From the top: No. 696, one of the 686 Class built by Beyer, Peacock & Co. in 1870. No. 698, built by R. Stephenson & Co. This engine and No. 699 had brass domes, the rest of the class had painted domes. No. 693 of the Beyer-Peacock series re-built by Mr McDonnell.

while Nos 698 and 699 of the Stephenson series had polished brass domes until 1886.

The two sets were never alike in their appearance and had their sand-boxes in different positions, but their chief dimensions were more or less identical. The builders had exercised a free hand in carrying out the details. The driving wheels were 6-foot diameter. Coupled wheels, 6-foot diameter. Leading wheels, 4-foot diameter. Wheel base of engine, 16 feet equally divided. Cylinders, 16-inch diameter by 22-inch stroke (later enlarged to 17 inches by 22 inches and 24-inch stroke). Boiler, 10 feet 3 inches in length. Fire-box, 5 feet 6 inches long. Heating surface: fire-box 102 sq. ft, tubes 1,079 sq. ft, fire grate 16 sq. ft. Similar to 901 Class. Weight of engine, empty, 48 tons; full, 62 tons. Tender, full, 25 tons. It will be noticed from No. 696 that the Beyer-Peacock series were only provided with brake blocks on the six-wheeled tender. No. 694 was re-numbered 11 in 1910 and for some time ran the officers' saloon at Darlington.

Complete list of 686 Class:
Beyer, Peacock & Co., Builders, Manchester

Engine No.	Date built	Makers' No.	Re-built at	Year
686	March, 1870	932	York	1886
687	March, 1870	933	York	1886
688	March, 1870	934	Leeds	1885
689	April, 1870	935	York	1886
690	April, 1870	936	Darlington	1886
691	March, 1870	937	Leeds	1881
692	April, 1870	938	York	1883
693	April, 1870	939	York	1883
				1886
694	April, 1870	940	Darlington	1886
695	April, 1870	941	Darlington	1886
696	April, 1870	942	Darlington	1886
697	April, 1870	943	Darlington	1886

Robert Stephenson & Co., Builders, Newcastle-on-Tyne.

Engine No.	Date built	Makers' No.	Re-built at	Year
698	December, 1870	1947	York	1886
699	December, 1870	1948	Darlington	1886
700	February, 1871	1949	York	1886
701	March, 1871	1950	York	1886
702	April, 1871	1951	Darlington	1886
703	April, 1871	1952	York	1884
704	May, 1871	1953	York	1887
705	May, 1871	1954	York	1887

Some of the early York re-builds were similar to No. 700. Old No. 254, re-numbered 2254, with 6-foot-6-inch coupled wheels, was running at Scarborough up to 1898. It was built November, 1857, and retained its wooden-framed tender to the last. Cylinders were 16 inches by 22 inches. Also No. 1781, originally No. 260, with 6-foot coupled wheels, dated York, 1858, was similar. The cylinders were 16½ inches by 22 inches.

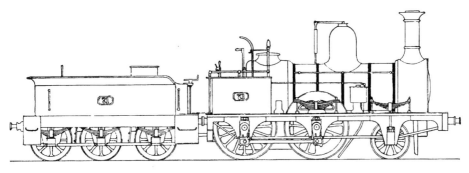

Fig. 45. S. & D. R. **No. 71.** " **Hackworth**," as originally constructed in 1851.

Locomotives from the Stockton & Darlington Railway.

One hundred and fifty-seven locomotives were transferred from the Stockton & Darlington to the North Eastern in July, 1863. The old line, however, remained under a special committee for ten years and the locomotives were not re-numbered until 1873. In most cases 1,000 was added to the existing number of the engine, that being about the number already owned by the NER at that time. In September, 1875, there were 55 of the old S&DR engines still in existence. Goods and mineral engines naturally predominated on the S&DR, but there were some very fine passenger engines on the line.

One of the most notable of these was a smart four-coupled express engine named *Hackworth*, after the first Locomotive Superintendent of the line, and built in March, 1851, by Alfred Kitching at the Hope Town Foundry, Darlington. The driving and coupled wheels were 5 feet 10 inches in diameter. Leading wheels, 3-foot-6-inch diameter. Cylinders, 17 inches by 24-inch stroke. Diameter of boiler, 4 feet. The *Hackworth* had double frames and the boiler was reduced from the usual S&DR. length to allow the fire-box to be located between the two pairs of coupled wheels. Our illustration shows the engine in its original form. The engine was re-numbered 1071 and entirely re-built in 1873 at the Darlington North Road Works, and a new works number, 84, was assigned to it, so complete was the renewal. It was almost similar to the 1050 Class and little of the old double-framed engine remained. New driving wheels 6-foot diameter with inside bearings only were fitted. T. W. Worsdell again re-built the engine in 1889 and its number was altered to 1717 in the duplicate list to enable it to continue its useful career, which ended in 1901. It has been stated that its final number was 1915.

The 'Woodlands' Class

This class was originally designed by Alfred Kitching in 1848, but only the last five of the class survived to be transferred to the NER. These were No. 99, *Ayton*, built 1855; No. 116, *Lartington*, and No. 117, *Nunthorpe*, built 1856; No. 118, *Elmfield*, built 1857; and No. 166, *Oswald Gilkes*, built November, 1860. The first three were built by Gilkes, Wilson & Co., Middlesbro', and the two newest were by Kitching & Co., of the Hope Town Foundry. The engines were of the usual six-wheeled type, having four-coupled wheels

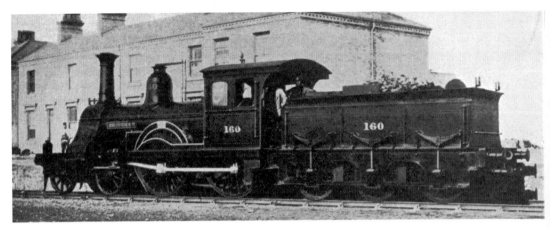

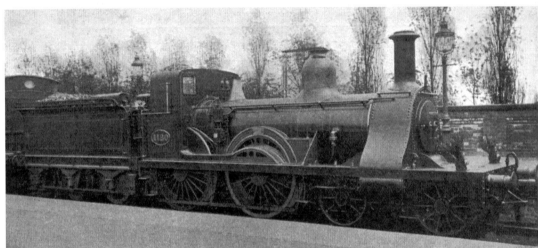

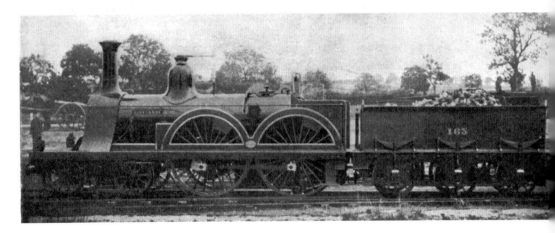

From the top: No. 160, Stockton & Darlington Railway's *Brougham*. *Middle image:* The *Brougham* re-numbered 1160 on the NER and fitted with smaller cab. No. 163, *Morecambe*, another S&DR engine, as originally built in February 1862 by Stephenson & Co.

5-foot diameter. The cylinders, inside, were 16-inch diameter by 19-inch stroke. The tenders held 1,200 gallons and 4 tons of coal. The boilers were 12 feet 6 inches long and 3-foot-8-inch diameter

Many years ago John Kitching stated the 'Woodlands' Class were copied by James Cudworth in designing his 59 Class on the SER for the Hastings trains.

The *Brougham* and *Lowther*, Nos 160 and 161, were built by R. Stephenson & Co. and delivered in April and May, 1860, expressly for the passenger service over the South Durham & Lancashire Railway (Barnard Castle, Bowes, and Tebay branch), opened to Brough in September, 1860, and throughout in August, 1861. The large cab was designed to afford an ample protection to the driver and fireman on the exposed moors encountered on this section, and in its design we see a peculiar resemblance to all modern NER locomotives, with two side windows and extension over the tender. The steep gradients on this section restricted the diameter of the coupled wheels to 6 feet. The leading bogie – considered a great innovation but really only a revival of an old invention – was quaintly described by a contemporary writer as 'a peculiarity about the construction of the locomotive which adapts it to short curves'. The cylinders were outside and 16-inch diameter with a stroke of 24 inches. Bogie wheels, 3-foot-6-inch diameter. Boiler, 11 feet in length, 4 feet in diameter, containing 176 iron tubes. Total heating surface, 1,128 sq. ft. Weight of engine, empty, 32 tons 4 cwt.

'Saltburn' Class

In 1862 these handsome passenger engines, designed by William Bouch, were delivered by their builders, R. Stephenson & Co., named respectively *Saltburn*, *Keswick*, *Morecambe*, and *Belfast*. They were a big advance on any previous engines built for the old line and were, perhaps, an effort on the part of 'the first public railway' to show what it could do to rival its younger but bigger neighbour the NER, which soon afterwards swallowed it up altogether. They had four-coupled driving wheels, 7-foot-0½-inch diameter, placed with 7-foot-6-inch centres. Bogie wheels, 3-foot-6-inch diameter, with 6-foot-1-inch centres. Total wheel base of engine, 20 feet 0¼ inch. Boiler, 10 feet in length, 4 feet in diameter, containing 174 iron tubes 9 feet 8 inches long. Grate area, 12¾ sq. ft. Total heating surface, 1,053 sq. ft. Weight of engine, 46 tons. Total length over buffers of engine and tender, 47 feet 7½ inches. Height from rail level to top of chimney, 13 feet 5 inches. The tender ran on six wheels 3-foot-6-inch diameter. Total weight of engine and tender in working order, 71 tons 6 cwt 3 qrs.

The 'Saltburn' Class had William Bouch's patent steam brake acting from a piston on to the coupled wheels and a small auxiliary tank below the footplate for heating the feed-water by means of the spare steam from the boiler.

List of 'Saltburn' class with dates:

S&DR No.	Name	Works No.	Began running	Scrapped
162	*Saltburn*	1332	January, 1862	1879
163	*Morecambe*	1333	February, 1862	1888
164	*Belfast*	1334	March, 1862	1882
165	*Keswick*	1335	March, 1862	1886

Although the *Saltburn* as such disappeared in 1879, a new 7-foot coupled passenger engine built at Darlington in 1880 was said to contain much of the old veteran in its make-up. This engine was numbered 1162, had cylinders 17 inches by 26 inches, and ran until 1914. No. 1163, *Morecambe*, re-built, without its name, finished its career as spare engine at York, and No. 1165, *Keswick*, acted in a similar capacity at Scarborough in the 'eighties'.

The 1001 Glass Goods Engines, 1864–1875

The 1001 Class long-boiler engines, so long famous on the NER, originated on the S&DR. in 1856. The original design was William Bouch's, who developed them out of his two well-known veterans *Tow Law* and *Shotley* of 1852. The majority of them, however, were built after the amalgamation and during 1864–1873, the period covered by the separate Management Committee.

This was bound to be one of the most numerous classes on the line. It comprised all the engines on the S&DR section with inside bearings and long boilers, known as short-coupled, *i.e.*, having the trailing wheels in front of the fire-box.

No. 1001 was built at the North Road Works in May, 1868, but was by no means the first of the series, as these works had been building this type since they were opened in 1864, beginning with No. 175, *Contractor*.

The *Contractor*, built October, 1864, had cylinders 17 inches by 24-inch stroke. Wheels, 4 feet 11½ inches. Boiler, 4-foot diameter, 13 feet 8 inches in length, containing 158 tubes 2-inch diameter. Steam pressure 130 lbs per sq. in. Total weight, 32 tons 18 cwt. Height to top of chimney, 13 feet 8½ inches.

No. 1032 built at the North Road Works in 1875, was the last of this class and was exhibited at the S&DR Jubilee celebrations at Darlington in September the same year. Besides the Darlington-built engines the following by outside firms should be mentioned: The 1145–1150 Series, built by R. & W. Hawthorn in 1860, named *Panther*, *Ostrich*, *Leopard*, *Zebra*, *Fox*, *Mastiff*.

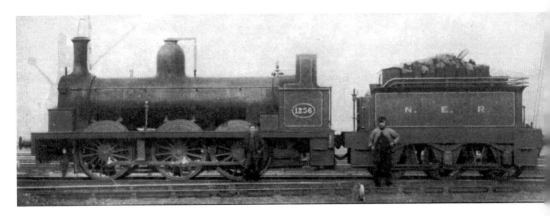

No. 126 of the 1001 Class. Built by the NER in 1873, North Road Works.

The 1151–1159 and 1167–1170 Series, by Gilkes, Wilson & Co., 1860–4, named *Mercury, Venus, Mars, Jupiter, Saturn, Herschel, Planet, Lune, York, Newlands, Clifton, Tufton, Reliance*.

Note: The 1207–1218 and 1221–1225 Series by R. & W. Hawthorn, 1868–70; Nos 1246–1264, built by Hopkins, Gilkes & Co., 1873–5; Nos 1271–1280, by Dubs & Co., 1874; and 1281–1290, by the Avonside Engineering Co., 1874–5, were exactly similar engines with the exception of having slightly different chimneys and domes.

No. 1141, *Excelsior*, built by Gilkes, Wilson & Co. in July, 1859, had a heating surface of no less than 1,728 sq. ft. Its driving wheels were 5-foot diameter and weight in working order 31 tons. Nos 1186, *Union*, and 1191, *Autumn*, built at Darlington in 1866 and similar to the Stephenson series already mentioned, were the last engines fitted with Bouch's system of feed-water heating by a double chimney and smoke-box.

The 1001 Class were always kept up to date. Their chief dimensions when re-built by Worsdell with new boilers were as follows: Cylinders, 17-inch diameter; stroke, varying from 18 inches to 28 inches in different engines. Coupled wheels, 5 feet 0½ inches (some 4 feet). Wheelbase, 7 feet 7 inches front and 5 feet 3 inches trailing. Total wheel base, 11 feet 10 inches. Boiler: length, 14 feet; diameter, 4 feet 3 inches. Heating surface: fire-box, 9.51, tubes, 1,483; total, 1,578.1 sq. ft. Fire-grate area 13.3 sq. ft. Weight: on leading wheels, 9 tons 8 cwt; driving wheels, 14 tons 2 cwt; trailing wheels, 11 tons 14 cwt; total, 35 tons 4 cwt. Weight of engine and tender in working order, 57 tons 6 cwt.

According to the *Locomotive Magazine* the following numbers were still running in 1914 on the Rosedale mineral line: 1079, 1255, 1259, 1263, 1272, 1275, 1277, 1281, 1282, 1286, 1287, 1289, and 1290. In December, 1916, No. 1289 was renewed and painted at Darlington for a further term of years on this branch.

List of 1001 Class built at North Road Works, Darlington:

1001, May, 1868.

1002–1003, December, 1865.

1004–1008, August, 1870.

1010–1018, April, 1869.

1022, March, 1870.

1024–1027, July, 1870, April, 1869, Sept., 1869, and April, 1875.

1029–1032, Jan., 1871, Feb., 1871, Nov., 1869, and Feb., 1875.

1034, January, 1871.

1036, August, 1870.

1039, June, 1871.

1044, April, 1868.

1047–1048, Nov., 1870, and April, 1871.

1053–1054, March, 1867, and Aug., 1876.

1060–1061, Oct., 1870, and July, 1870.

1064, May, 1873.

1067, January, 1875.

1078–1079, Sept., 1870, and Jan., 1875.

1081, January, 1867.

1093–1094, April, 1867, and May, 1867.

1186, February, 1865.

1219-1220, September, 1869.

1231–1237, Aug., 1871, Sept., Oct., and Feb., 1872, Feb., 1872, April, 1872, and April, 1872.

1186, February, 1865.

1191, April, 1866.

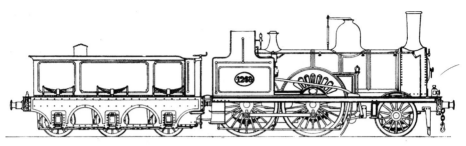

Fig. 46. N.E.R. **No. 1268** of the "Ginx's Babies" Class as first altered.

1238 and 1265 Classes - 'Ginx's Babies'.
Darlington-built locomotives, 1871–1882.

In 1871 William Bouch, brother of the designer of the first Tay Bridge, built at the North Road Works a remarkable class of four-coupled bogie express engines chiefly for the steeply-graded Darlington and Tebay section.

The first four engines came out with Stockton & Darlington numbering, 238 to 241, and besides being different in appearance from the later ones built in 1874 they had smaller tenders with curiously sloping backs. These six were numbered 1265 to 1270, as the 1,000 was then being added to the surviving stock of the old S&DR running in the Darlington district. These ten engines were primarily enlargements of the *Saltburn*, built in 1862, the sizes of the wheels and wheel bases being almost identical but the cylinders had a stroke of no less than 30 inches. They were a veritable collection of ingenious contrivances, and on account of their size, and partly owing to their treatment during their early days, they became known as 'Ginx's Babies', from a popular novel of that period.

Their original dimensions were as follows: Driving wheels 7-foot-1-inch diameter. Trailing wheels, 7-foot-1-inch diameter, placed 7 feet 3½-inch centre to centre. Bogie wheels, 3 feet 7 inches, 6-foot-6-inch centres. Total wheelbase, 21 feet 0½ inch. Cylinders, 17-inch diameter by 30-inch stroke. Piston valves, 13-inch diameter. Boiler: 140 lbs pressure, 11 feet

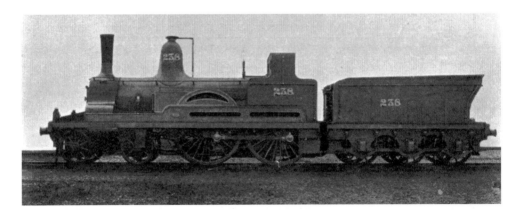

Above: S&DR No. 238, showing William Bouch's original design.

2 inches long, 4-foot diameter outside; of Low Moor iron plates 7/16 inch in thickness, and containing 167 tubes 2-inch diameter. Total heating surface, 1,217 sq. ft. Weight of engine in working order, 41¼ tons. Tender, 23 tons. The fire-box had a partition lengthwise but not extending to the roof as in the 447 Class, and they were not suitable for burning coal.

They were fitted with a patent screw reversing gear designed by Bouch in 1864, in addition to a steam retarder which confined the air in the cylinders and acted as a brake. There was also a hand screw brake on the trailing wheels and the tender. The piston valves gave constant trouble, being solid, and thus the trapped water, unable to escape, was liable to cause fracture.

'Ginx's Babies' are said to have attained on trial a speed of 60 miles an hour with a train of fourteen passenger coaches. Their average consumption of coke was about 28 lbs per mile. They were gorgeously painted and a large amount of brass about them added to their brilliant appearance.

No. 238 was tried for a short time on the Newcastle and Berwick main line with a Darlington driver but did not do much important work. Another of the class, No. 241, was tried more thoroughly on the main line by a Gateshead man experienced on East-Coast expresses, but he preferred his own engine, No. 844 (901 Class).

Fletcher very soon commenced altering these engines, for which purpose they were sent to Gateshead; in fact No. 1269 did not run a year. After an extensive trial of four years four of the others were re-built in 1879 and the rest soon followed.

Their boilers were left untouched but the cylinders were placed inside the frames and the stroke reduced to 26 inches, except in the case of Nos 1265 and 1270, wherein they were altered to the standard 18-inch diameter and stroke of 24 inches. Ordinary slide valves replaced the cylindrical valves and brake blocks were applied to all four coupled wheels. The leading four-wheeled bogie was discarded for a pair 4 feet 6 inches in diameter, and the total weight of the engine was reduced to 37¼ tons.

Engine No. 1268, newly re-built, was in the procession at the George Stephenson Centenary, Newcastle, in June, 1881. These engines were re-boilered by T. W. Worsdell with standard 901 Class boilers and fittings; also new tenders, holding 2,200 gallons of water, were supplied.

Ginx's Babies:

Engine No.	Darlington Works No.	Began running	Re-built at Gateshead	Scrapped
1238	69	December, 1871	1879	1908
1239	70	August, 1872	1880	1908
1240	71	October, 1872	1880	1908
1241	72	November, 1872	1879	1909
1265	73	May, 1874	1879	1914
1266	90	July, 1874	1880	1913
1267	91	August, 1874	1879	1914
1268	92	September, 1874	1881	1913
1269	93	November, 1874	1874	–
1270	94	December, 1874	1882	1914

1068 Class

This numerically small class was turned out at Darlington at the close of William Bouch's term of office in 1875, when J. Kitching took charge of affairs. They were built for the Central Division and also ran on the Harrogate line between Leeds and Stockton.

They took the places of earlier S&DR engines, which would otherwise have been given these numbers on the NER had they survived. They do not appear to have had number plates originally. On account of the plucky way in which these six engines tackled the hilly stretches of line adjacent to the Yorkshire moors they were christened the 'Gamecocks'. The following were their leading dimensions: Coupled wheels, 6-foot-0½-inch diameter. Leading wheels, 4 feet 8½ inches. Wheel base, 16 feet 6 inches. Coupled wheels, 8 feet apart. Cylinders, 17 inches in diameter; stroke, 26 inches. Boiler, 11 feet long and 4-foot diameter; working pressure, 140 lbs per sq. in.; containing 158 tubes 2-inch diameter. Total heating surface, 1,100 sq. ft. Total weight of engine in working order, 33 tons 18 cwt, distributed as follows: on leading wheels 11 tons, on driving wheels 10 tons 4 cwt, on trailing wheels

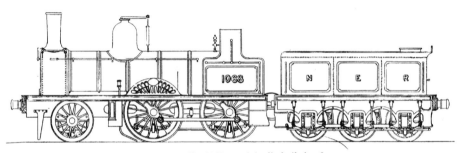

Fig. 47. N.E.R. **No. 1068** as originally built in 1875.

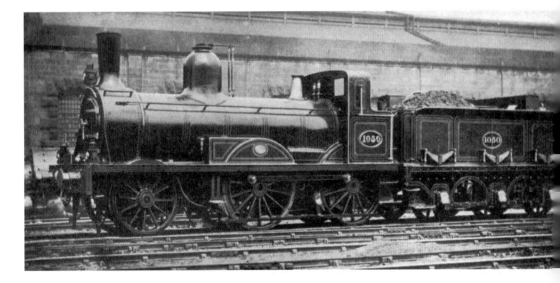

No. 1050, the second of the 1068 Class, showing slight alterations from the original design and a larger tender

10 tons 4 cwt. The tenders had wheels 4-foot diameter, spaced 5 feet apart, as in the 1238 Class, and weighed 28 tons in working order. Their capacity was 2,400 gallons of water and 6 tons of coal. The reversing was done by screw gear, which permitted the lever to be worked either by lever or screw as desired. Bouch's steam retarder was also fitted.

The experiment of a shorter piston stroke was tried with No. 1068, and, accordingly, new cylinders with 24-inch stroke were fitted. The result was a slight increase in speed and a small saving of fuel, but neither was sufficient to make it worth while to alter the rest of the class. (*Vide Locomotive Magazine*, 1903.)

No. 1068 stood next to the old *Locomotion*, No. 1, at the Iron Horse Show of the Railway Jubilee, at Darlington in 1875.

The 1068 Class were all very soon altered by Fletcher and given new tenders with a 12-foot-3-inch wheelbase. They were fitted by W. Worsdell with 901 Class boilers, having a length of 10 feet 3 inches, a diameter of 4 feet 3 inches, and a total heating surface of 1,097 sq. ft.

List of 1068 Class:

Engine No.	Works No.	Began Running	Date Scrapped	Engine No.	Works No.	Began Running	Date Scrapped
1068	105	August, 1875	1910	1066	124	April, 1876	–
1050	115	November, 1875	1909	1062	125	May, 1876	1907
1035	123	March, 1871	1908	1098	126	July, 1876	–

No. 11 Class

The 11 Class express engines were similar in appearance to the 'Gamecocks' with their inside frames and bearings, but they had larger driving wheels, rounded cabs, and were all built at Darlington in 1877. Their principal dimensions were: Driving and trailing wheels, 6 feet 6 inches. Leading wheels, 4-foot-8-inch diameter. The centres being 7 feet 11 inches and 8 feet 7 inches respectively. Total wheel base, 16 feet 6 inches. Cylinders, 17-inch diameter; stroke, 24 inches. Boiler, 11 feet long, 4-foot diameter. Fire-box-5 feet long. Total heating surface, 1,091 sq. ft. Weight of engine, 38 tons 4 cwt in working order. Tender tank capacity, 2,400 gallons.

Numbers of the 11 Class:

Engine No.	Works No.	Began running	Date scrapped
1166	160	October, 1877	1912
11	161	November, 1877	1912
*1100	162	December, 1877	1912
*1114	163	December, 1877	1910

* *The two last had a cylinder stroke of 26 inches.*

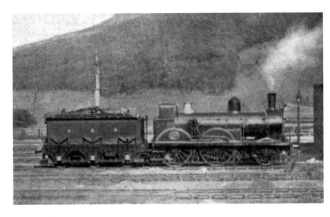

Left: No. 1100, of the 11 Class. Re-built.

Below: No. 40, as originally built at North Road Works, Darlington, in June 1882, standing in York station.

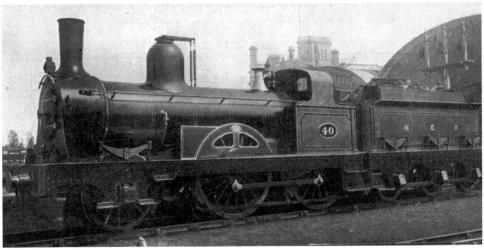

The 40 Class Engines

These four express engines were built at Darlington in 1882 for the Central Division. They had outside bearings and springs to the leading wheels. Their principal dimensions were as follows: Cylinders, 17-inch diameter; stroke, 24 inches. Driving and trailing wheels, 6 feet 6 inches in diameter. Leading wheels, 4 feet 8 inches in diameter. The centres being 7 feet 11 inches and 8 feet 7 inches respectively. Total wheelbase, 16 feet 6 inches. Boiler, 11 feet 2 inches long; diameter, 4 feet 2 inches. Fire-box shell, 5 feet long. Total heating surface, 1,091 sq. ft. Weight of engine in working order, 39 tons 8 cwt. Tender tank capacity, 2,400 gallons.

List of the 40 Class:

Engine No.	Date built	Date scrapped
40	June, 1882	1909
58	July, 1882	1912
1099	July, 1882	1912
1101	August, 1882	1912

901 Class
Consisting of fifty-five engines, Designed by Edward Fletcher. First one built 1872.

A period of prosperity throughout the county, consequent on the Franco-German War, was affecting all classes of traffic in 1871, and Fletcher set about designing a big class of powerful express engines as well as several other types which he introduced at this time. In addition to other traffic sleeping cars were about to be introduced on the night expresses on the East-Coast Route, and this meant heavier loads.

This new class of fifty-five engines (when all were completed) were six-wheeled engines having four-coupled wheels 7 feet in diameter. Fletcher never reconciled himself to the advantages of smoother running in a locomotive with a leading bogie; at any rate he considered it unnecessary unless special circumstances demanded it, and even altered Bouch's Darlington engines to conform to his ideas.

But in other respects he was ahead of his time, and his 901 Class were in the very front rank of express passenger engines for considerably over ten years. The journals of the leading axles were 6-inch diameter by 12 inches long.

There were slight variations in the different batches, but the following principal dimensions of the Gateshead series may be taken as typical of the 901 Class in general. The 1872–6 engines had cylinders 17-inch diameter by 24-inch stroke, while the 1880–2 series had cylinders 17½ inches in diameter. Their driving wheels were 7-foot diameter, leading wheels 4-foot-6-inch diameter. Wheel base, leading to driving wheels, 7 feet 9 inches; driving to trailing wheels, 8 feet 4 inches. Boiler diameter, 4 feet 3 inches. Length of barrel, 10 feet 4 inches. Length of fire-box shell, 5 feet 6 inches. Boiler contained 254 tubes 1 9/16-inch diameter. Heating surface: tubes 1,110 sq. ft, fire-box 98.5 sq. ft. Total, 1,208.5 sq. ft. Grate area, 16.1 sq. ft. Weight in working order: on leading axle 12.6 tons, driving axle 14 tons, trailing axle 13.8 tons. Total, 39.14 tons. Weight empty 37 tons. Tender, diameter of wheels, 3 feet 8 inches. Wheelbase, leading to middle 6 feet 4 inches, middle to trailing 5 feet 11 inches. Tank capacity, 2,200 gallons. Coal space, 3½ tons. Weight in working order, 26 tons 14 cwt. Weight empty, 15 tons 7 cwt.

On the completion of Nos 901 and 902, the first two from the Gateshead Works and the pioneers of the class, a series of ten (Nos 844–853) came from Beyer, Peacock & Co., Manchester, early in 1873, having similar general dimensions but differing slightly in outside appearance. The sand-boxes of the latter were below the footplate level, and their cabs angular instead of rounded as in Fletcher's standard design. Next in order came the Gateshead engine No. 903 – and then a further ten engines were delivered in November and December, 1873, by Neilson & Co., Glasgow, numbered 924–933 (inclusive). These, like the Gateshead series, had their sand-boxes on the frame and presented a particularly neat appearance, having polished brass rims along the coupling rod splashers in addition to those on the driving splashers. Gateshead continued to turn out a number of this class almost every year until 1882, when No. 485 (since re-numbered 1325) appeared in June, bringing the series to a close.

The last half-dozen or so had butt-jointed barrels and their tenders the increased capacity of 2,500 gallons.

In 1884 A. McDonnell, Locomotive Superintendent, altered a considerable number,

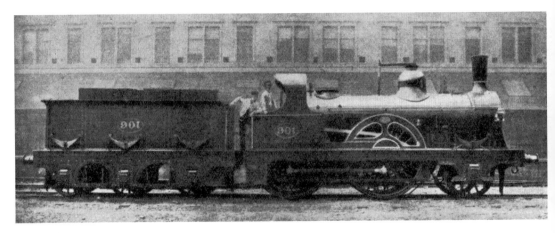

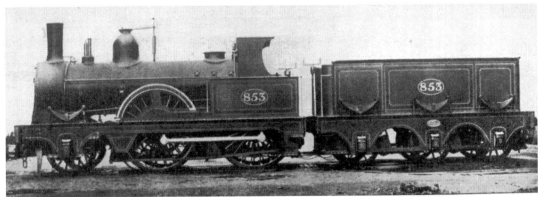

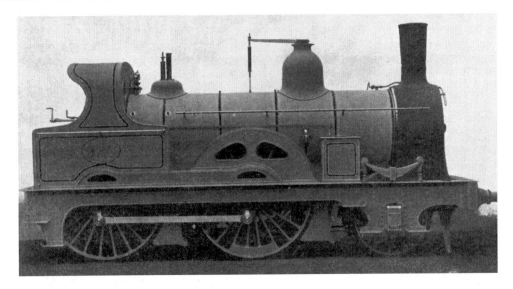

Top: No. 901 as originally built. An additional safety valve was placed on the boiler between chimney and dome. *Middle:* No. 853 of the 901 Class, illustrating the ten engines built by Beyer, Peacock & Co., Manchester. *Bottom:* No. 926, illustrating the ten engines built by Neilson & Co., Glasgow, in 1873.

including Nos 362, 846, 902, 905, 906, 910, 925, 931, and 932, in most cases fitting closed domes and Ramsbottom safety valves. In the case of No. 362 the leading springs were hung out of sight below the frames. No. 925 was the first altered, but in this engine the leading springs remained as shown in our illustration and the leading foot-steps were not removed as in No. 362. No. 925 also had her brass beading round the driving splashers removed. The reversing gear was changed over to the left-hand side according to McDonnell's usual practice.

Engine Summary

Engine No. 910 was taken into the shops in the Autumn of 1884, and emerged in May, 1885, with a new boiler and a round-topped dome, but the old plain built-up chimney remained. This engine, unfortunately, had a smash-up on 18 September, 1885, on the 3.20 p.m. from York Scotch express, due Newcastle at 5.11 p.m. The left-hand coupling-rod broke when passing Birtley but the damage was mostly confined to the engine.

Between Newcastle and Edinburgh on the fastest and heaviest expresses the coal consumption of Engine 902, ably driven by Ewart, was said to average 20 and 21 lbs per mile before its alteration.

During the race to Edinburgh in 1888 the 901 Class accomplished some remarkable performances. Nos 269 and 1325 on different occasions ran from York to Newcastle with the Scotch express, consisting of eight vehicles, in 82 minutes for the 80¾ miles. No. 178 had taken the same train of ten vehicles from Berwick to Edinburgh, 57½ miles, in 58 minutes, start to stop, the engine (a 4-coupled compound) having had to be detached at Berwick. Ten minutes longer is considered good time now-a-days. A pretty general re-building of these engines was undertaken by T. W. Worsdell during 1887–8 when a new standard boiler was fitted and modern chimney, dome, and Ramsbottom safety valves, also plain or filled-in splashers, bringing them up to date. Some re-built by McDonnell were also renewed. These standard boilers were 10 feet 3 inches long, 4-foot-3-inch diameter, 140 lbs pressure, and contained 206 tubes 1¾-inch diameter. Their heating surface was: fire-box, 98 sq. ft; tubes, 999 sq. ft. Total, 1,097 sq. ft.

In 1906 the last alteration was made, when two were re-built at the Darlington works by Wilson Worsdell and still bigger boilers fitted. These were Nos 167 and 933, the former retaining a small (though not original) cab with a raised roof, and remained a six-wheeled engine and looking a veritable bull-dog with its high-pitched boiler. No. 933 was

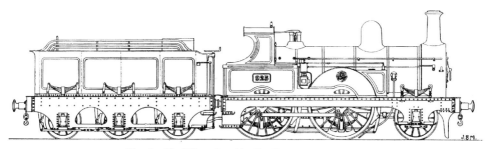

Fig. 48. **No. 925** as altered by Mr. McDonnell in 1884.

transformed into a smart four-coupled bogie engine and large cab with side windows. The new boilers were 10 feet 6 inches long, 4 feet 10 inches in diameter. Diameter of tubes, 2 inches. Heating surface: tubes, 1,057 sq. ft; fire-box, 141 sq. ft. Total, 1,198 sq. ft. Notwithstanding these extensive alterations No. 933 was scrapped in 1914.

Engine Summary

No. 901 was in the accident to the Up Scotch express at the Morpeth curve on 25 March, 1877. The engine was withdrawn from service in 1913 after covering a total of 1,345,696 miles!

No. 902 ran in the 1896 trials between Newcastle and Tweedmouth. The cylinders were then 18¼-inch diameter. The average coal consumption was 42 lbs per mile.

No. 905 was the pilot engine in the Northallerton collision on 4 October, 1894.

No. 910 went to the Newark brake trials in June, 1875, and was exhibited at the Darlington Jubilee in September of the same year.

No. 925, driven by T. W. Brown, was awarded the first prize for the best decorated passenger engine at the Central Station, Newcastle, at the George Stephenson Centenary, 9 June, 1881.

No. 178 was in two bad accidents. It was involved in the Thirsk disaster to the Scotch express at Manor House Cabin, 2 November, 1892. The injured driver, Rowland Ewart, was afterwards presented with a watch made entirely of brass recovered from the wreck of his engine. No. 178 also suffered in the Marshall Meadows accident near Berwick on 10 August, 1880, when the Up Scotch express left the metals owing to a loose rail.

No. 363 was also at the Stephenson Centenary, Newcastle, specially decorated for the occasion.

Complete list of 901 Class:

Ten built by Beyer, Peacock & Co., Manchester

Engine No.	Makers' No.	Date built 1873	Date re-built	Date withdrawn
844	1241	May	1885	1913
845	1242	May	1883	1913
846	1243	June	1887	1913
847	1244	June	1885	1914
848	1245	June	1885	1913
849	1246	Jure	1886	1913
850	1247	June	1886	1913
851	1248	June	1886	1914
852	1249	June	1886	–
853	1250	July	1887	–

Opposite page: No. 363 of the 901 Class specially painted for the Stephenson Centenary, Newcastle, in 1881. No. 901 as altered in 1886 by T. W. Worsdell. Showing one of several changes in her appearance.

Ten Built by Neilson & Co., Glasgow.

Engine No.	Makers' No.	Date built 1873	Date re-built	Date withdrawn
924	1799	November	1885	1914
925	1800	November	1887	1914
926	1801	December	1886	1914
927	1802	December	1885	1914
928	1803	December	1885	1914
929	1804	December	1885	1914
930	1805	December	1885	1914
931	1806	December	1886	1914
932	1807	December	1886	1914
933	1808	December	1886 & 1906	1914

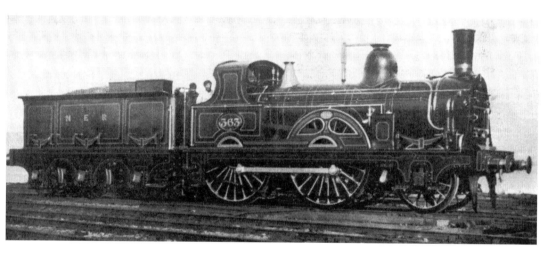

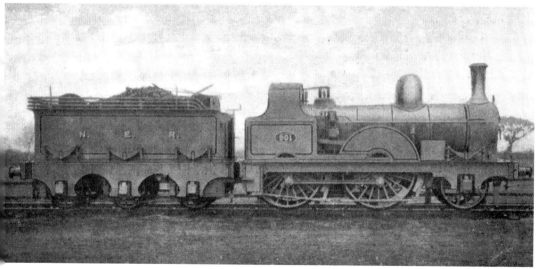

Thirty-five built at Gateshead Works.

Engine No.	Date began running	Date re-built	Date withdrawn	Engine No.	Date began running	Date withdrawn
901	October, 1872	1886	1913	362	May, 1880	1919
902	December, 1872	1887	1913	363	June, 1880	–
903	November, 1873	1887	1913	365	August, 1880	1919
904	January, 1874	1886	1918	366	September, 1880	–
905	July, 1874	1888	1914	367	October, 1880	–
906	August, 1874	1888	1913	135	November, 1880	–
907	March, 1875	1886	1916	368	June, 1881	–
909	April, 1875	1887	1919	640	September, 1881	1920
910	April, 1875	1886	–	464	October, 1881	–
911	May, 1875	1887	1914	75	December, 1881	1919
156	August, 1875	1888	–	153	December, 1881	1918
*178	August, 1875	1887	–	19	April, 1882	–
912	December, 1875	–	–	269	April, 1882	–
53	December, 1875	1886	–	265	May, 1882	–
352	December, 1875	1889	–	1325	June, 1882	–
329	March, 1876	1888	1919			

Note: No. 135 was originally 1462; No. 75 was 1464; both altered January, 1885. No. 19 was re-numbered 1463 in 1883 and again changed to 19 in January, 1885. No. 1325 was 485, then 1477 in 1883, and again 1325 on 1 January, 1885.

167	July, 1876	–	1920
1459	July, 1876	–	1920

*New Plain Splashers only were fitted to 178 in 1885.

1440 Class
Consisting of fifteen engines. First one built 1876.

Principal dimensions, except the coupled wheels, same as the 901 Class. Tenders similar to 901 Class.

When Fletcher had for some years been constructing a number of his big 7-foot coupled express engines he made a pause, and in 1876 once more reverted to passenger engines with smaller coupled wheels but practically identical in other respects. The reduction of the driving wheels to a diameter of 6 feet meant a slight decrease in the total weight, but the boiler dimensions were the same as the 901 Class. Owing to the liberal dimensions of the cylinders these engines were exceedingly capable of dealing with heavy loads on adverse gradients, and as a class they proved themselves most useful. In the year 1882 Fletcher had four more of these engines built similar in all respects, bringing their total number to fifteen.

Engine Summary

Engine 364 was a curiosity, having had a previous existence. According to J. Kitching it was one of the Leeds & Thirsk Railway express engines built by Kitson in 1847 (No. 8 Class), illustrated previously. It was re-built at Leeds (NER) Works in 1875, the boiler and fire-box

being sent from Gateshead. The cylinders were, of course, increased to 17-inch diameter and stroke of 24 inches, and in all respects conformed to the general appearance of the 1440 Class excepting that the outside frames were curved over the coupling rods as in the 'Tennant' engines.

No. 1444, after some ten or twelve years' service, was sent to Darlington for a general overhaul, and was then fitted with Younghusband's patent valve gear. The curves of the trailing splashers were outlined by a wide polished brass beading as on the driving splashers. It is said the new number plates retained the original date and the name of the Gateshead Works. Both Westinghouse and vacuum brakes were fitted for working 'foreign' stock between York and Scarborough.

Nos 1442 and 1446 were tried experimentally in the Summer of 1905, running together on the afternoon East-Coast dining-car express between Newcastle and York.

Numbering: The four engines built in 1882 were numbered 486, 488, 489, and 668. No. 486 remained unchanged; No. 488 became 1472 in 1883 and 159 in 1885; No. 489 became 1473 in 1883 and 150 in 1885; No. 668 became 1476 in 1883 and 220 in 1885. These four engines had cylinders 17½ inches in diameter by 24-inch stroke when new.

List of 1440 Class:

Engine No.	Began running	Withdrawn	Engine No.	Began running	Withdrawn
364	August, 1875	1919	1447	January, 1878	1922
1440	October, 1876	–	1448	May, 1878	–
1441	February, 1877	–	1449	June, 1878	–
1442	March, 1877	–	159	June, 1882	–
1443	May, 1877	–	486	July, 1882	–
1444	August, 1877	1920	150	August, 1882	–
1445	September, 1877	1919	220	September, 1882	–
1446	December, 1877	–			

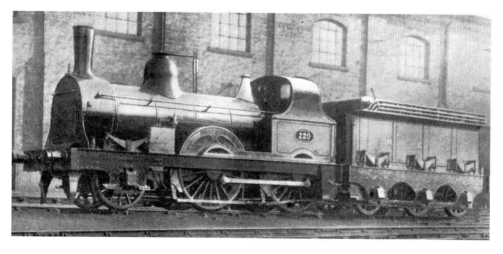

NER No. 220, showing the original appearance of the 1440 Class.

In 1883 Fletcher retired from the position of Locomotive Superintendent after holding that office with distinction for practically thirty years. He was succeeded by Alexander McDonnell, of the Great Southern & Western Railway, Ireland.

It may be said that Fletcher remained somewhat conservative in his ideas by adhering to the six-wheeled type of passenger engine as long as he did, but he was far-sighted enough to see that coupled engines would ultimately supersede the 'singles', and was the first locomotive engineer to discard building the latter type, just as many years later Wilson Worsdell was the first British locomotive superintendent to build six-coupled bogie engines for fast passenger traffic. Naturally an entire change of design was only to be expected, and leading bogies for express engines were among the improvements introduced by the new Chief.

Opportunity was also taken in 1883 to enlarge and re-organise the Gateshead Locomotive Works to enable a bigger volume of building and re-construction to be undertaken. It is interesting to note that at about this date Wilson Worsdell and the late W. M. Smith, of 'compound' fame, joined the staff of the Locomotive Superintendent. Theodore West lightly asserts that McDonnell's administration was too short to reduce the numerous varieties of engines on the system, and emphasises the fact that this was one of the important changes he intended to carry out. West, however, forgot to mention that McDonnell found at least time enough to add another three classes to the already innumerable hoard on the long-suffering NER!

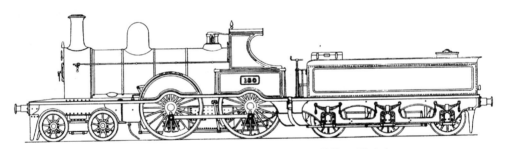

Fig. 49. **No. 180,** with original taper chimney of Mr. McDonnell's design.

No. 1496. One of the 1492 Class, built by R. & W. Hawthorn, Leslie & Co. Ltd.

1492 Class

Consisting of twenty-eight engines. First one built in 1884.
McDonnell, Locomotive Superintendent.

Weights and Dimensions

Driving and coupled wheels (new), 6 feet, 8¼ inches, 8-foot-4-inch centres. Bogie wheels (new), 3-foot-1¼-inch diameter, 5-foot-3-inch centres. Tender wheels, 3-foot-8½-inch diameter. Wheelbase: engine, 20 feet 24 inches; tender, 12 feet 6 inches. Total wheel base, 41 feet 6¼ inches. Cylinders, 17-inch diameter; stroke, 24 inches. Boiler contained 193 tubes 1¾-inch diameter. Grate area, 16.8 sq. ft. Length of barrel, 10 feet 3 inches; diameter, outside, 4 feet 3 inches. Working pressure, 140 lbs per sq. in. Weight in working order; on bogie, 12 tons 4 cwt; on driving wheels, 15 tons; on trailing wheels, 12 tons 6 cwt. Total, 39 tons 10 cwt. Maximum weight of engine and tender in working order, 67½ tons. Capacity of tender, 2,500 gallons.

There is little doubt that this design from the aesthetic point of view was an improvement on many engines that had hitherto run on the NE system. Being in many ways admirable it was distinctly unfortunate that their designer should have handicapped them from the first by inadequate boiler power, for if any railway had a surfeit of medium-powered engines gathered up from all the different smaller companies it was the North Eastern.

Certainly the 1492 Class were larger than their Irish prototypes, except in the matter of gauge, but they lacked the ease, freedom, and power of Fletcher's creations, and the many changes in design caused them to be very unpopular with their drivers.

In spite of the early traditions of the line the reversing lever was located on the left side of these engines, and a source of trouble at the beginning was some stiffness of movement in the regulators. According to Ahrons, in the *Railway Magazine*, one of the chief sources of discontent was the discarding of cylinder drain-cocks, to which the men were accustomed.

The swing-link bogie on these engines, however, was a welcome addition for which their designer deserved credit for introducing on the line. The bogie frames had lifeguards as well as the main frames.

R. & W. Hawthorn, Leslie & Co. built twelve of the 1492 Class, half of which were delivered in 1885, the rest being built at the Gateshead Works. The Hawthorn engines could be distinguished by a flatter curve of the footplate over their coupling rods, and on West's diagrams have slightly larger dimensions.

The 1492 Class only remained for a very short time on the main line. During the severe winter of 1888, when the Newcastle–Edinburgh section was blocked with snow, some fast running with the East Coast expresses was made by these engines between Newcastle and Carlisle – a section for which they were singularly adapted. But from the nature of that line, with its severe curves, there is little doubt the story of the 60 miles being accomplished in the hour is decidedly within the mark.

Wilson Worsdell renewed these engines with standard boilers of the 901 type, so consequently their weights and other dimensions were changed. The boiler length was 10 feet 3 inches, containing 206 tubes 1¾ inches in diameter. Fire-grate area, 15 1/6 sq. ft. Heating surface: fire-box, 98 sq. ft; tubes, 999 sq. ft. Total, 1,097 sq. ft. Tender capacity,

2,500 gallons. Coal space, 3½ tons. Weight, empty, engine 36½ tons, tender 14½ tons. Total weight, 51 tons. Weight in working order, engine 39½ tons, tender 28½ tons. Total weight, 68 tons.

Engine Summary

Nos 38, 112, 158, and 238 ran with Fletcher tenders from the 686 Class when the latter were re-built in the 'nineties', so that they might take a 44-foot turntable.

List of the 1492 Class:

Sixteen built at Gateshead Works.

Engine No.	Date built	Withdrawn
38	1884	1915
112	1884	1915
126	1884	–
158	1884	–
180	1884	–
186	1884	1915
231	1884	1914
234	1884	1915
281	1884	–
385	1884	1915
426	1884	1915
500	1884	1917
576	1884	1918
664	1884	1920
1318	1884	1920
1331	1884	1920

Twelve built by R. & W. Hawthorn, Leslie & Co., Ltd., Newcastle.

Engine No.	Works No.	Date built	Withdrawn
1492	1996	1884	1915
1493	1997	1884	1917
1494	1998	1884	1915
1495	1999	1884	1914
1496	2000	1884	–
1497	2001	1884	1917
1498	2002	1885	1914
1499	2003	1885	–
1500	2004	1883	–
1501	2005	1885	1920
1502	2006	1885	1917
1503	2007	1885	1915

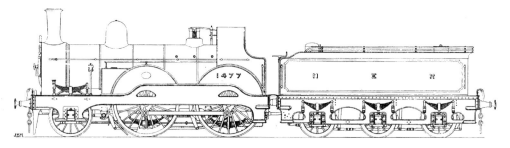

Fig. 50. Diagram of the original design of the 1463 Class. Built at Gateshead Works.

1463 Class – The 'Tennant' Engines
Consisting of twenty engines. Built 1885.

Original Chief Dimensions

Driving and trailing wheels, 7-foot-1¼-inch diameter. Leading wheels, 4-foot-7¼-inch diameter. Distance, leading to driving wheels, 8 feet; driving to trailing wheels, 8 feet 8 inches. Total wheel base, engine and tender, 37 feet 8¾ inches. Cylinders, 18 inches in diameter; stroke, 24 inches. Boiler: length, 10 feet 7 inches; inside diameter, 4 feet 3 inches; containing 221 tubes 1¾ inches in diameter. Length of fire-box, 5 feet 10 inches. Heating surface: fire-box, 110.5 sq. ft; tubes, 1,102 sq. ft. Total, 1,212.5 sq. ft. Grate area, 18 sq. ft. Working pressure, 140 lbs per sq. in. Tender capacity, 2,651 gallons. Coal space, 5 tons. Weight: on leading wheels 12 tons 12 cwt, on driving wheels 15 tons 14 cwt, on trailing wheels 13 tons 16 cwt. Total weight in working order, 42 tons 2 cwt. Tender wheels, 3 feet 9¼ inches in diameter. Wheel base, 12 feet 8 inches equally divided. Weight on leading wheels, 6 tons 14 cwt; on middle wheels, 5 tons 16 cwt; on trailing wheels, 6 tons 6 cwt. Total weight of tender in working order, 30 tons 16 cwt.

In 1885 the NER added to the then very small list of 100-mile runs in this country by timing the Down night Scotch express without a stop between Newcastle and Edinburgh – the longest run in Europe at that period! Although possessing many fine engines capable of light loads, this meant a bigger type of engine altogether just when there happened to be no locomotive chief to design them owing to McDonnell's retirement. Henry Tennant was then the General Manager of the NER, and during this interregnum he called together a conference of the locomotive officials of the line and suggested building this new class.

Plans and designs were drawn up, approved of by the Committee, and the result was the twenty handsome express engines known officially as the 1463 Class, popularly called the 'Tennants' ever since.

The likeness of the 'Tennants' to Great Northern practice was entirely a coincidence. The two chief officials most closely associated with the construction of these fine engines were the late Wilson Worsdell, at Gateshead, and George Graham, Divisional Superintendent, Darlington. Hepper was then chief draughtsman.

Improved machinery and greater accuracy of construction is said to have been a large factor contributing to their success and popularity.

Compared with the 901 Class the 'Tennants' had the advantage of a longer boiler and an inch added to their cylinder diameter. Their tenders were of much increased capacity and of a much neater design, the springs being placed below instead of above the footplate. They had no number plates, their numbers being transferred in 5-inch gilt figures on the trailing splashers in GNR or 'Stirling' fashion. Brass figures were tried on 1463 but were discarded. The name of the works and the date were carried on a flat polished brass plate on the driving splasher.

The 'Tennants' all appeared in 1885; ten (1463–72) being built at Darlington, and ten (1473–79 and 1504–6) at Gateshead. The Darlington engines differed from the Gateshead lot in several minor details. They had rather wider chimneys, smaller dome covers, and deeper brass collars round the smoke-box. The side frames of the former were painted deep claret colour, whereas the latter were light red. There was a difference, too, even in the shading of the figures and letters, and a broad black band only ran round the rims of the wheels of the Darlington engines, Gateshead adopting a narrower border and white line. No. 1463 when new was sent straight to York, followed by 1465, 1466, 1467, and 1468 as they were finished. Nos 1504, 1505, and 1506, the last of the series, were stationed at Edinburgh, and the others were all stationed at Gateshead. With the exception of 1473, which ran a 'slow' to Berwick at first, all were put straight into express passenger traffic and they immediately became great favourites with the men.

If exceptionally pleasing in appearance the 1463 Class were no less wonderful in their actual performances, and although by 1888 T. W. Worsdell had turned out a number of his 'giants' – both simples and compounds – these remarkable little 'Tennants' had a big share in hauling the racing trains bound for Edinburgh that year. Indeed the York–Newcastle section was almost exclusively in their hands during those eventful days in August. Engine 1475 (driver, Robson) accomplished on 31 August, the last day of the race, what was considered the finest feat of all, with a train of seven six-wheeled coaches weighing 100 tons, between York and Newcastle. A condensed log of the run was given by the Revd W. J. Scott in 'The Race to Edinburgh, 1888' (*Railway Magazine*, Vol. I.).

York was left at 1.48½ p.m., Darlington passed at 2.33, and in spite of a stop of 1¾

Above: No. 1463, built at Darlington. Original painting and uncovered safety valves.

minutes for signals at Ferryhill and checks at Chester-le-Street, Newcastle (80¼ miles) was reached at 3.12. Four consecutive miles were run at 47½, 47¼, 47, and 47 seconds, or at the rate of 76.6 miles per hour. The average running speed was 62 miles per hour throughout. The official statement was that the actual running time was 78 minutes. According to J. Pearson Pattinson the same engine ran in 80 minutes on 25 August, and in 81 and 82 minutes on the 29th and 30th respectively. Indeed the actual average running time between York and Newcastle during August was only 83½ minutes, with an average load of 115 tons.

On the 28th of the month an Edinburgh engine, No. 1505, ran the 124¼ miles from Newcastle in 127 minutes, or only one minute longer than the record claimed for a bigger and newer engine. During the race to Aberdeen in 1895, when loads were distinctly heavier, the 'Tennants' again gave a good account of themselves. On one occasion No. 1468, driven by W. Acomb, left York 13 minutes late and arrived at Newcastle right time. The same engine (and driver) is stated to have hauled a light 'special', conveying the Chancellor of the Exchequer (Sir M. Hicks Beach) from York to Malton, 22½ miles, in 19 minutes.

Wilson Worsdell re-fitted the 'Tennants' with new boilers in 1895 and raised their working pressure to 160 lbs per sq. in. The length of the new boilers was 10 feet 7 inches and the diameter 4 feet 3 inches. Length of fire-box, 5 feet 10 inches. Grate area, 17 sq. ft. Number of tubes, 205; diameter, 1¾ inches; giving a heating surface of 1,026.2 sq. ft; fire-box, 110 sq. feet; a total heating surface of 1,136.2 sq. ft.

Their chief work after this alteration was on the fast Leeds, York, and Scarborough expresses, and for some years they were frequently seen piloting one of the Scotch expresses. It is interesting to know that these fine engines are all still in service (July, 1923).

Engine Summary

No. 1466 took part in the 1888 race to Edinburgh between York and Newcastle.

No. 1467 was at one time fitted experimentally with Younghusband's valve-gear.

No. 1468 hauled the royal train from York when the Prince of Wales (late King Edward VII) visited Wynyard Park.

No. 1472 ran in the 1896 trials between Newcastle and Tweedmouth.

No. 1505 was the leading engine of the snowbound Scotch express which was run into the snow plough, 15 March, 1888, near Annitsford station.

List of the 1463 Class:

Darlington		Gateshead	
Engine No.	Built	Engine No.	Built
1463	February	1473	June
1464	May	1474	June
1465	May	1475	July
1466	May	1476	July
1467	June	1477	August
1468	June	1478	August
1469	June	1479	August
1470	July	1504	September
1471	July	1505	September
1472	July	1506	September

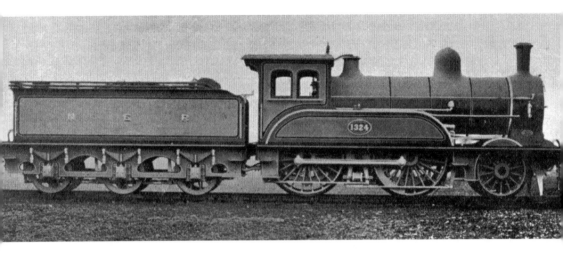

Above: No. 1324, Class D. As it appeared in the Newcastle Exhibition in 1887.

1324 and 340
Two-cylinder compound express engines. First built 1886.

T. W. Worsdell, who had been in a similar position on the GER, was appointed Locomotive Superintendent at Gateshead in 1885. He applied the Worsdell-von Borries two-cylinder compound system to all new classes of express engines with the exception of Class G.

The first passenger express engine was No. 1324, built in 1886, and another engine of the same class, No. 340, came out in 1888. They were originally known as Class D, but having introduced his bogie engines of Class F in 1887, and then altering these two with a leading bogie to correspond, Worsdell included them in the Class F list, and Class D remained vacant until Raven's passenger tanks came out in 1913.

This new engine was distinctly handsome and attracted a good deal of attention in its young days both on the line and in the Newcastle Exhibition, where it was very much admired. Worsdell, of course, introduced his compound system on the GER, and the long elliptical splasher had been previously adopted on some of his GER engines, but the large roomy cab was a great innovation by which T. W. Worsdell earned the eternal gratitude of the North Eastern engine drivers.

This model has been taken as a pattern, and more orders closely followed ever since by both Gateshead and Darlington.

Original Dimensions of Nos 1324 and 340

Driving and coupled wheels, 6-foot-8¼-inch diameter. Leading wheels, 4-foot-7½-inch diameter. Wheels of cast iron. High-pressure cylinder, 18-inch diameter, on left-hand side, and low-pressure cylinder, 26-inch diameter, on right-hand side of engine, placed on an incline of 1 in 60; stroke, 24 inches for both. The slide valves above the cylinders were actuated by Joy's valve gear. Heating surface: fire-box, 112 sq. ft; tubes, 1,211.3 sq. ft; total, 1,323.3 sq. ft. Boiler, 10 feet 7 inches long, 4-foot-6-inch diameter. Grate area, 17.33 sq. ft. Boiler

pressure, 175 lbs per sq. in. Weight of engine in working order: on leading wheels, 12 tons 18 cwt; driving wheels, 17 tons 19 cwt; trailing wheels, 12 tons 9 cwt 2 qrs. Total weight of engine, 43 tons 6 cwt 2 qrs. Total weight of engine and tender in working order, 78½ tons.

No. 1324 had been at work for about three months on the main line when she was returned to the paint shop preparatory to being placed in the Newcastle-on-Tyne 1887 Jubilee Exhibition. Here for most of the year she remained on view in striking contrast with *Locomotion*, No. 1, Stockton & Darlington Railway, also exhibited.

No. 340, the second engine, came out in 1888 fitted with Smith's patent piston valves instead of the usual flat or 'D'-shaped pattern. These were arranged in a distinctly novel manner. One valve, 7-inch diameter, was used for the high-pressure cylinder, and two valves, 5½ inches in diameter, for the low-pressure cylinder, the latter valves being placed side by side and actuated by one rod connected to each of the valve spindles. The cylinders had fixed to them at each end a 2-inch spring-loaded relief valve for the purpose of allowing trapped water to escape.

T. W. Worsdell found these engines to work well. They were said to burn 15 per cent less coal than similar non-compound engines, but they were unsteady at a high speed. Consequently, leading bogies were fitted in place of the single pair of carrying wheels to spread the weight of the huge low-pressure cylinder, following the design of the Class F engines to which they were both added, as already noted. When the conversion of the compounds was ultimately decided upon No. 1324 was the first engine to appear with two simple high-pressure cylinders, piston valves, and ordinary link motion.

Class F
Four-coupled bogie express engines. First built 1887.

Class F, including F1, originally included 35 engines having the same general dimensions as No. 1324, but all with leading bogies. Class F, the compounds, had one high-pressure cylinder 18 inches in diameter and one low-pressure cylinder 26-inch diameter, both with a stroke of 24 inches; the F1 'simple' engines having two high-pressure cylinders 18 inches in diameter, the stroke being 24 inches. Their boilers and motion were identical, so that a very exact comparison of the merits of each system could be made.

Original Dimensions of Class F

Driving and coupled wheels, 6-foot-8-inch diameter, 8-foot-8-inch centres. Bogie wheels, 3-foot-7-inch diameter, 6-foot-6-inch centres. Tender wheels, 3-foot-9-inch diameter. Wheel base: engine, 21 feet 11 inches; tender, 12 feet 8 inches. Total, 43 feet 10¾ inches. Boiler, 10 feet 7 inches long. Barrel, 4-foot-7-inch diameter, contained 242 tubes 1¾-inch diameter. Heating surface: fire-box, 112 sq. ft; tubes, 1,211 sq. ft; total, 1,323 sq. ft. Grate area, 17¼ sq. ft. Tank capacity 3,038 gallons. Coal space, 4½ tons. The working pressure for the compounds was 175 lbs., and for the 'simples' 140 lbs per sq. in. Weight of engine in working order, 46 tons 9 cwt, and empty 43 tons 2 cwt for the compounds, the 'simples' being 10 cwt lighter in both cases.

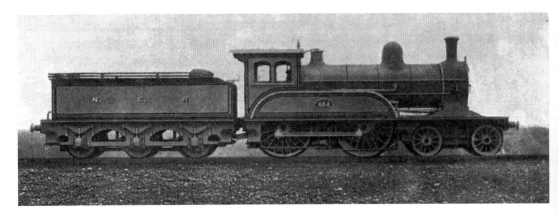

Above: No. 684 Class F (Compound), with Joy's valve gear and old style of painting.

Having first built ten of each system in 1887 T. W. Worsdell was perfectly satisfied with the results of the compounds, so that in 1890 ten additional Class F engines were added, and five more followed in 1891.

An excellent feature of these engines was their generous heating surface, which was not bettered for several years. The first batch of these engines was running when the great race to Edinburgh began in 1888. The 'Tennant' engines were found quite capable of running to almost any required speed, and in most cases were used. The ground between York and Newcastle suited them admirably. North of Berwick, however, the Grant's House Bank is an obstacle in the way of big driving wheels. Between Newcastle and Edinburgh, on 31 August, the last day of the race, the record run was made by Engine No. 117 of this class. The time taken for the 124¼ miles was 126 minutes, with a load of 100 tons. The train arrived in the Scottish capital 34 minutes before the booked time! The driver was R. Nicholson, who so distinguished himself with 1620 in the 1895 race to Aberdeen.

Engine No. 663 a compound, figured in the accident to the runaway express down the Ryhope Bank on 19 August, 1889. This engine was re-built as a 'simple', with two high-pressure cylinders, in January, 1900, followed by No. 514 and the whole of the Class F engines.

Full list of Class F engines:

Ten built as Simples

Engine No.	Date
85	1887
96	1887
154	1887
194	1887
230	1887
673	1887
777	1887
803	1887
808	1887
1137	1887

Built as Compounds and since re-built

Engine No.	Date	Engine No.	Date	Engine No.	Date
1	1887	1532	1890	1542	1891
18	1887	1533	1890	1543	1891
42	1887	1534	1890	1544	1891
115	1887	1535	1890	1545	1891
117	1887	1536	1890	1546	1891
355	1887	1537	1890	1324	1886
514	1887	1538	1890	340	1888
663	1887	1539	1890		
684	1887	1540	1890		
729	1887	1541	1890		

No. 1 is now numbered 356, the electric locomotives now having the numbers 1–12.

Sir V. L. Raven has recently fitted these engines with entirely new boilers and superheaters. Diameter of boiler, 4 feet 3 inches; length, 10 feet 7 inches. Boiler pressure, 160 lbs per sq. in. Length of fire-box, 6 feet. Boiler contains 105 tubes 1¾-inch diameter, giving 525 sq. ft heating surface; 18 superheat tubes 5¼-in. diameter, giving 270 sq. ft; superheat element, 263 sq. ft; and firebox, 112 sq. ft. Total heating surface, 1,170 sq. ft. Total weight of engine and tender in working order, 82 tons.

Class G (The 'Waterburys')

Consisting of twenty engines. Originally 2-4-0 Type. First one built 1887.
Built at Darlington Works.

Original Dimensions

Driving and coupled wheels, 6-foot-1¼-inch diameter, 8 feet 1¼-inch centres. Leading wheels, 4-foot-1-inch diameter, 7 feet 8 inches from driving wheels. Tender wheels, 3-foot-9-inch diameter. Wheelbase, 12 feet 8 inches. Total wheel base, 37 feet 6¼ inches. Cylinders, 17-inch diameter, 24-inch stroke. Boiler contained 203 tubes 1¾-inch diameter. Barrel, 4-foot-3-inch diameter. Heating surface: fire-box, 98 sq. ft; tubes, 984 sq. ft. Total, 1,082 sq. ft. Grate area, 15 1/6 sq. ft. Tank capacity, 2,651 gallons. Coal space, 4 tons. Weight, empty: engine, 37¼ tons; tender, 17¼ tons. Total, 54½ tons. Weight, full: engine, 40¼ tons; tender, 32 tons. Total, 72¼ tons.

With the exception of the two compound engines, Nos 1324 and 340, Class G were the only six-wheeled passenger engines built by T. W. Worsdell, and like all his engines they had Joy's valve gear.

Originally regarded as mixed-traffic locomotives, and taking the numbers of several of Fletcher's old mixed-traffic 675 Class, the majority of the Class G engines were sent to the Leeds and Harrogate and Hull districts. They soon earned for themselves the enviable nickname of the 'Waterburys', from their ability to keep good time on passenger trains. At any rate their regularity was a marked feature. It is true they had taken the place of engines in a worn-out condition, and if they displayed no very extraordinary turn of speed it was no

Above

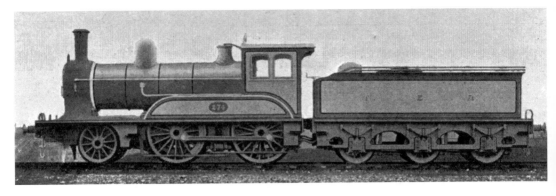

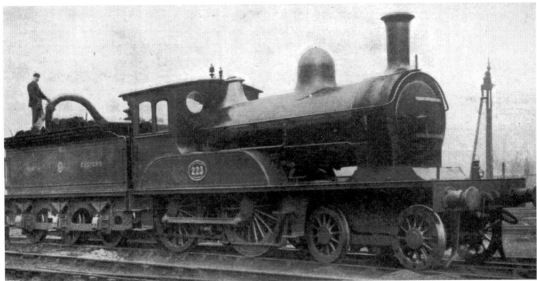

Top: No. 274, Class G. One of the 'Waterburys'. Old style of painting.
Lower image: No. 223, another Class G. Re-built with leading bogie and link motion.

reflection on the class whatever. Anyhow, the authorities looked with favour on these smart little engines – for their size and weight they have always been remarkably efficient – and in 1901 Wilson Worsdell, who succeeded his brother at Gateshead, began re-building them into really respectable express engines. The cylinders were enlarged to 18-inch diameter. A leading bogie was fitted, with wheels 3 feet 1¼-inch diameter, 6 feet 6 inches apart; the total wheel base being now increased to 42 feet 11¼ inches. Piston valves of 'Smith's' design were adopted, and Stephenson's link motion.

The weights were increased as follows: Engine, empty: 41 tons 8 cwt; tender, 17 tons 16 cwt 1 qr. Total, 59 tons 4 cwt 1 qr. In working order: engine, 44 tons 7 cwt; tender, 34 tons 8 cwt. Total, 78 tons 15 cwt. In the re-construction the capacity of the tenders was increased to 3,038 gallons by the addition of a well tank.

No. 1107 was re-built by (now Sir) V. L. Raven, with an extended smoke-box and superheater equipment, in 1913, and others of the class likewise.

Complete list of Class G engines:

Engine No.	Built	Engine No.	Built
23	1887	217	1888
214	1887	222	1888
258	1887	223	1888
274	1887	328	1888
557	1887	337	1888
675	1887	372	1888
676	1887	472	1888
677	1887	521	1888
678	1887	1107	1888
679	1887	1120	1888

Class I

Consisting of ten engines. 7-foot bogie singles. First one built 1888.
Mr. T. W. Worsdell, Locomotive Superintendent at Gateshead Works.

Original Dimensions of Class I Engines

Driving wheels, 7-foot diameter. Trailing wheels, 4-foot-6-inch diameter. Bogie wheels, 3-foot-6-inch diameter. Tender wheels, 3-foot-9-inch diameter. Driving to trailing wheels, 8-foot-8-inch centres. Bogie wheel base, 6 feet 6 inches. Engine wheel base, 21 feet 11 inches. Tender, 12 feet 8 inches. Total, 42 feet 11¾ inches. Cylinders: high-pressure, 18-inch diameter; low-pressure, 26-inch diameter; stroke, for both, 24-inch diameter. Boiler, tubes 203 1¾-inch diameter. Barrel, 4-foot-3-inch diameter. Heating surface: fire-box, 110 sq. ft; tubes, 1,016 sq. ft. Total, 1,126 sq. ft. Grate area, 17¼ sq. ft. Capacity, tank 3,038 gallons. Coal space, 4 tons. Weight empty: engine, 40¾ tons; tender, 18¼ tons. Total, 59 tons. Weight full: engine, 43¾ tons; tender, 35 tons. Total, 78¾ tons.

Classes I and J, as single-driving-wheel bogie express engines on the compound principle, constituted a very novel and interesting experiment, unique as far as this country is concerned. Their performances varied somewhat, and if a little inconsistent at times both classes did some remarkably fine work in their original states.

The Class I engines were designed expressly for the Leeds, York, and Scarborough expresses, and were interesting as being the first lot of single-driving-wheel engines built by the NER for nearly twenty-five years. Owing to their driving wheels being greater in diameter than the Class F engines, which they immediately followed, their boiler space was more restricted and the heating surface consequently reduced all round. Besides, they were designed for a smaller coal consumption.

T. W. Worsdell completed two of these engines in 1888, three were built in 1889, and five followed in 1890. It was certainly a novelty to have two first-class types of single-driving-wheel engines turned out at one time on a railway which for so long a period had built nothing but coupled engines.

All the wheels had inside bearings only, and the sand-boxes were under the frame, thus

differing from the large 'singles' (Class J), where the sand-box rests on the front of the driving splashers. Their sensitive steam-distributing gear being less exposed and on a more mechanical if less ingenious plan than their bigger sisters, they enjoyed a longer measure of existence, running in their original form until the beginning of the twentieth century.

Like all other compounds, their turn, however, ultimately arrived, and when altering the cylinders Wilson Worsdell took the opportunity of adding outside bearings and frames to the trailing wheels. Although the cause was now removed, this was rather an admission of their unsteadiness, which it seemed impossible to avoid, and recalls the impression from a ride behind these two-cylinder compounds left on the mind (and body!) of a passenger after a journey with several stops or signal checks.

As usual, two 18-inch high-pressure cylinders replaced the two unequal compound ones, and Stephenson's link motion replaced the radial valve gear. The boiler pressure of 175 lbs per sq. in. was retained. The weights of engine and tender were slightly altered, being as follows: Engine, empty, 40¾ tons; tender, 18¼ tons. Total, 59 tons. Engine, full, 43¾ tons; tender, 35 tons. Total, 78¾ tons.

No. 1529, built June, 1890, was the first engine re-constructed with new cylinders, piston valves, and link motion in 1900.

List of Class I engines:

Engine No.	Date built	Re-built	Engine No.	Date built	Re-built
1326	1889	1900	1527	1890	1901
1327	1889	1900	1528	1890	1920
1328	1889	1900	1529	1890	1900
1329	1888	1901	1530	1890	1902
1330	1888	1901	1531	1890	1902

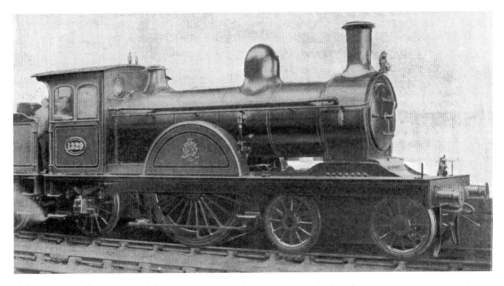

Above: No. 1329, Class I, re-built, new coat-of-arms on driving splashers.

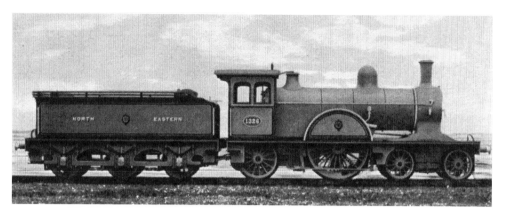

Above: No. 1326, Class I, a two-cylinder Compound.

Class J
7-foot-7-inch bogie singles. Designed by T. W. & Wilson Worsdell.

Built in 1889–90 on the Worsdell-von Borries Lapage compound system. Joy's valve gear and rocking shafts. T. W. Worsdell, Loco. Superintendent.

Re-constructed in 1894–5 by Wilson Worsdell. Same wheels, but two high-pressure cylinders and piston valves with link motion.

Original Dimensions

Cylinders: high-pressure, 20-inch diameter; 24-inch stroke. Low-pressure, 28-inch diameter; 24-inch stroke. Heating surface: fire-box, 123 sq. ft; tubes, 1,016 sq. ft. Total, 1,139 sq. ft. Driving wheels, 7-foot-7¼-inch diameter. Trailing wheels, 4-foot-6-inch diameter. Bogie wheels, 3-foot-6-inch diameter. Engine wheel base, 21 feet 11 inches. Tender, 12 feet 8 inches. Total, 43 feet 11¾ inches. Boiler contains 203 tubes 1¾-inch diameter. Grate area, 20¾ sq. ft. Working pressure, 175 lbs per sq. in. Boiler designed for 200. Weight: on driving wheels, 17 tons 15 cwt; trailing wheels, 13 tons; bogie wheels, 15 tons 18 cwt. Total, 46 tons 13 cwt, in working order. Empty, 44 tons 3 cwt. All the compound engines up to this period had cylinders of a size standardized by T. W. Worsdell for both passenger and goods service, viz., 18 inches and 26 inches respectively, by 24-inch stroke. These dimensions seemed to suit the latter better than the express engines. With the introduction of these larger 'singles' a change was made and the diameters of both cylinders enlarged, resulting in increased speeds. The coal consumption was officially stated to average 28½ lbs per mile, or about 2 lbs lower than any other class of engine on the line.

Engine 1517, the pioneer of this new class, began regular running on 5 October, 1889, taking trains of from ten to twenty-two coaches unaided; and a sister engine, No. 1521, was shown at the Edinburgh Exhibition the following year. On Worsdell's own authority this class was built for running the heavy main-line trains between Newcastle and Edinburgh, where, to show how things have changed, powerful four- or six-coupled engines are now employed.

As compounds, some really wonderful performances were achieved by Class J, and Engine 1518 was authentically timed at 86 miles an hour – the first instance of so high a speed being recorded in Britain. This was accomplished on the level and not downhill, and with eighteen carriages was so far beyond the ordinary performances of single-wheelers as to be termed phenomenal.

With a train of 290 tons weight Engine 1521 was recorded by the late Charles Rous-Marten to make up time on the 'Flying Scotsman' between York and Newcastle. David Joy, who designed the valve gear, records with pride in his diary the praise these engines merited, so one may only imagine the gratification of T. W. Worsdell, the creator of this remarkable class, on their success and the favourable reception accorded them by the engineering world generally!

Trouble with the outside steam-chests, crowded out into an exposed position owing to the huge inside cylinder dimensions, led to their early conversion; assisted, perhaps, by the complicated but very ingenious combination of Joy's valve gear and rocking shafts to communicate the motion from the connecting rods to the slide valves.

During the conversion Smith's patent piston valves were fitted, with a diameter of 8 inches, placed above and slightly between the cylinders, inclined down to the driving axle. Outside bearings and frames for the trailing wheels added a graceful curve to the already handsome exterior, and the adhesion weight on the driving wheels was increased to 18 tons 10 cwt. The water scoop was fitted to the tenders while in the shops to enable them to pick up water whilst running at full speed.

Dimensions as re-built

Cylinders, 19-inch diameter; stroke, 24 inches .Tender capacity, 3,940 gallons. Coal space, 5 tons. Weight, empty: Engine, 44 tons 3 cwt; tender, 19 tons 6 cwt. Total, 63 tons 9 cwt. Weight, full: Engine, 46 tons 19 cwt; tender, 41 tons 2 cwt. Total, 88 tons 1 cwt.

A record created by Engine 1517 on 12 December, 1904, on the Leeds–Edinburgh flier deserves mentioning, when the distance of 80¼ miles between York and Newcastle was covered in 79 minutes at an average speed of 61 miles an hour. This was, of course, under ordinary working conditions and not racing.

These engines for many years worked the 75-minute expresses between Leeds and Scarborough. The *Railway Magazine* of December, 1913, contains an account of some remarkable speeds attained by Engine 1523 on this train during the summer of that year.

List of the Class J engines:

Engine No.	Date built	Re-built	Engine No.	Date built	Re-built
1517	August, 1889	1894–1920	1522	1890	1895
1518	September, 1889	1894–1920	1523	1890	1895–1920
1519	November, 1889	1894–1920	1524	1890	1895–1919
1520	December, 1889	1894–1920	1525	1890	1895–1919
1521	December, 1889	1894	1526	1890	1895–1920

Opposite: No. 1526, Class J. Worsdell-von Borries Compoun system. No. 1524, Class J, in the intermediate stage. re-built as 'Simple, but without outside bearings to the trailing wheels. No. 1520, Class J. re-built in 1894 as a 'Simple', with piston valves and link motion.

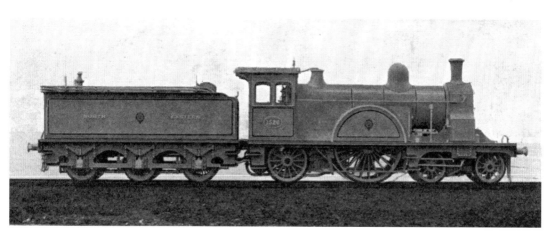

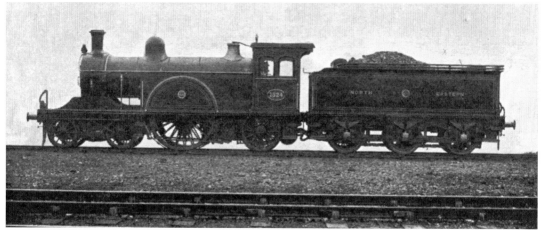

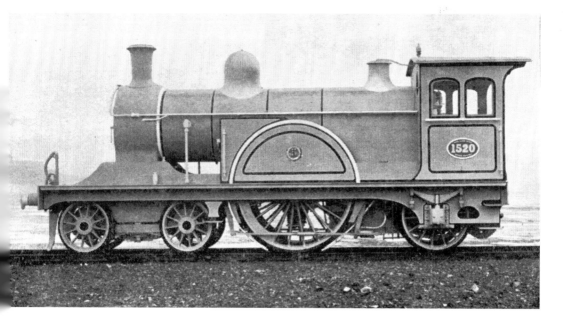

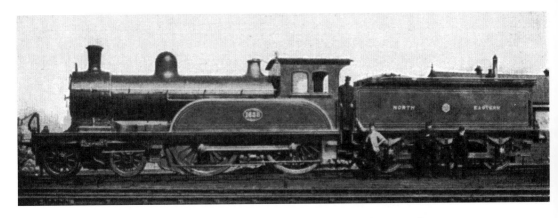

Above: No. 1638, Class M1 with extended smoke-box and outside steam chests.

Class M1 (4-4-0 Type)
Number in class, twenty. First one built 1892.

Mr. T. W. Worsdell, who had championed the cause of the two-cylinder compound system on the line since 1885, retired in 1890, leaving his brother, Wilson Worsdell, in sole charge at Gateshead.

With prophetic foresight Wilson Worsdell adopted larger coupled wheels on the Class M engines, perhaps influenced by the phenomenal speeds of the 'singles', with their big wheels, and he discarded Joy's valve gear in favour of Stephenson's link motion.

The vexed question of compounding being still in doubt, one of the engines, No. 1619, designated Class M, was built as a two-cylinder compound with a new cylinder ratio. It was thought possible that the slightly slower revolutions of the larger driving wheels would allow the expansive properties of the steam longer time to take effect.

These were the first express engines in England whose weight in working order, including the tender, exceeded 90 tons. The eccentrics were located between the cranks on the driving axle, so that a novel form of rocking shaft was necessary to transmit the motion to the slide valve in the outside steam-chests; and although this detail had later to be altered, the engines, when the opportunity presented itself in 1895, created records in high, sustained speed not surpassed by any other locomotive in this country, and rendered themselves and the name of their designer famous for ever.

Original Dimensions of Class M1 Engines

Diameter of cylinders, 19 inches; stroke, 26 inches. Driving and coupled wheels, 7-foot-1¼-inch diameter, 9-foot-3-inch centres. Bogie wheels, 3-foot-7¼-inch diameter, 6-foot-6-inch centres. Tender wheels, 3-foot-9¼-inch diameter. Wheelbase: Engine, 23 feet 6 inches; tender, 12 feet 8 inches. Total, 45 feet 8¾ inches. Boiler, 225 tubes 1¾-inch diameter. Barrel, 4-foot-4-inch diameter. Grate area, 19½ sq. ft. Designed for working pressure of 180 lbs per sq. in. Heating surface: fire-box, 121 sq. ft; tubes, 1,220 sq. ft. Total, 1,341 sq. ft. Tender capacity, 3,940 gallons. Coal space, 5 tons. Weight in working order:

on bogie wheels, 17 tons; on driving wheels, 18 tons 4 cwt; on coupled wheels, 15 tons 10 cwt. Total, 50¾ tons. Tender, 40¼ tons. Total, 91 tons.

The Class M engines bore the brunt of the North Eastern's share in the race to Aberdeen in 1895, and their magnificent work on that occasion has never been approached north of Newcastle and only recently equalled on the southern section.

On the night of 21 August, 1895, the East-Coast Companies made a special effort, and although the train consisted of six heavy six-wheeled joint-stock coaches, Engine 1620 ran from York to Newcastle in 78½ minutes, an average speed of 61.5 miles an hour – truly a fine performance, which was immediately eclipsed by a sister engine, No. 1621, which created a world's record by running from Newcastle to Edinburgh at an average speed of 66 miles an hour, covering the 124¼ miles in 1 hour 53 minutes!

The times and point-to-point speeds were as follows:

8-0 p.m. ex King's Cross–Aberdeen express.
Times on the east-coast record run, 21/22 August, 1895, between York and Edinburgh:

Distance	Stations	Times	Speed, point to point	Remarks
M. C.				
	York	Dep. 11.4½		
11 15	Alne	Pass 11.18	49.7	Average speed 61.5 miles an hours
22 16	Thirsk	Pass 11.27	73.4	
29 76	Northallerton	11.34	66.4	Engine No. 1620
38 72	Ervholme	11.42½	63.2	
44 10	Darlington	11.47	69.6	Driver: G. Turner
56 77	Ferryhill	12.0	58.6	Fireman: E. Hodges
66 7	Durham	12.11	49.7	
71 69	Chester-le-Street	12.16	69.3	
80 42	Newcastle	Arr. 12.23	74.2	
	Newcastle	Dep. 12.25		
16 45	Morpeth	Pass 12.43	55.2	Average speed 66 miles an
34 63	Alnmouth	12-58	70.5	hour.
51 44	Belford	1.14	64.9	
66 70	Berwick	1.25	83.6	
78 11	Reston Jn	1.37	56.3	
95 11	Dunbar	1.53	63.7	
106 51	Drem	2.3	69.0	
111 11	Longniddry	2.6½	77.1	
117 71	Inveresk	2.12	73.6	
121 31	Portobello	2.15	70.0	
124 31	Edinburgh	Arr. 2.18	60.0	

It is worth remarking that Chas. Rous-Marten discounted this run somewhat because the time of passing Portobello in the guard's journal furnished to him was 2.16, and he proved it was impossible to cover the 3 miles to Waverley in two minutes! Several watches, however, corroborated the arrival time of 2.18 at Waverley Station.

As already indicated, Wilson Worsdell altered the position of the valves to a more usual and less exposed situation under the smoke-box, and fitted piston valves, standard on all the express engines. The extended smoke-box was also done away with. No. 1623 was altered in October, 1903, and No. 1631 in February, 1904, and the entire series soon followed as they came in for general repairs. They returned to the main line for a short spell after re-building, but are now partially relegated to branch work.

Engine Summary

No. 1620 and No. 1621. For record runs by these two engines between York and Edinburgh see preceding page. Engine 1621 was specially reserved for the brake trials on the NER in 1896.

No. 1622. This engine suffered very severely in the memorable collision at Northallerton in 1894; also took part in the race to Aberdeen in 1895.

No. 1635. A full account of the working of this engine in comparison with four other classes on the line was given by Smith in 1898.

No. 1638 took part in the race to Aberdeen in 1895, driven by W. Boyd.

No. 1639. Built with piston valves in the outside valve chests – one of the first engines on the NER on which these patent cylindrical valves were fitted. The original coal consumption of the engine was stated to average 29 lbs per mile.

Complete list of the Class M1 engines

Engine No.	Date built	Works No.	Engine No.	Date built	Works No.
1620	December, 1892	1.93	1630	1893	11.93
1621	March, 1893	2.93	1631	1893	12.93
1622	April, 1893	3.93	1632	1893	13.93
1623	May, 1893	4.93	1633	1893	14.93
1624	June, 1893	5.93	1634	1893	15.93
1625	1893	6.93	1635	1893	16.93
1626	1893	7.93	1636	1893	17.93
1627	1893	8.93	1637	1893	18.93
1628	1893	9.93	1638	1893	19.93
1629	1893	10.93	1639	March, 1894	20.93

Engine No. 1619
Wilson Worsdell, Locomotive Superintendent.

Built in May, 1893, as a two-cylinder compound. Cylinders, 19 inches and 28 inches by 26 inches, on the Worsdell-von Borries system.

Re-built in 1898 as a three-cylinder balanced compound, on W. M. Smith's system.

This engine earned considerable fame for itself and has been fully described previously. It was distinguishable from the 1620–1639 Series by its outside steam-chests on each side of the smoke-box, but its general dimensions were similar to them. The low-pressure cylinder was of the same diameter as in the Class J engines, but the high-pressure cylinder 1 inch less

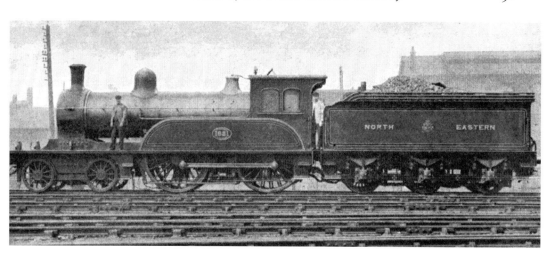

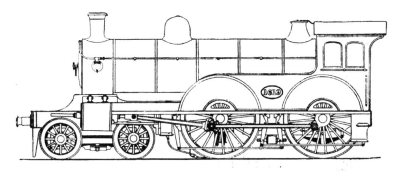

Diagram of Engine **1619** as re-built in 1908.

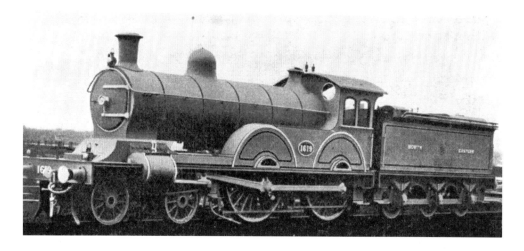

Top: No. 1638, Class M1 with extended smoke-box and outside steam chests. *Middle:* Diagram of No. 1619, as re-built in 1908. *Lower image:* No. 1619, re-built as a three-cylinder Compound.

in diameter. In the case of 1619 a working pressure of 200 lbs per sq. in. was adopted.

Engine 1619 took her regular turns with the other main-line express engines, hauling heavy loads unassisted on a lower coal consumption than her sisters. She was acknowledged to be an experiment, and was rather more costly to construct in the first place than corresponding 'simple' engines, and Worsdell was well satisfied with the results Nos 1620–1639 were giving.

Early in 1898 the time came for converting, but instead of altering the engine to a 'simple' a new system of three-cylinder compound working, patented by the late W. M. Smith, was chosen. No. 1619 re-appeared in August practically a new engine, with its high-pressure cylinder between the frames and under the smoke-box, having a diameter of 19 inches and a stroke of 26 inches driving a cranked axle. The two outside cylinders, the low-pressure, were 20-inch diameter with a stroke of 24 inches, all driving the same pair of wheels, which were coupled to the trailing wheels in the usual manner. The two low-pressure cranks were placed at right-angles, and the high-pressure crank made an angle of $135°$ with each of the other two. The high-pressure cylinder was fitted with a piston valve, the two low-pressure cylinders having ordinary flat valves.

The engine presented an exceptionally neat exterior, with its smoke-box flush with the boiler lagging, brass-capped chimney, and particularly effective splasher arrangement. A new and enlarged boiler was provided, with an outside diameter of 4 feet 6 inches and a working pressure of 200 lbs per sq. in. Engine 1619 had 17 patent water tubes in the fire-box to augment the heating surface and improve the circulation in the boiler.

The chief dimensions as altered were: Driving and coupled wheels, 7-foot diameter; 9-foot-3-inch centres. Bogie wheels, 3-foot-6-inch diameter; 6-foot-6-inch centres. Weight on the four-coupled wheels, 35½ tons. Wheel base: Engine, 23 feet 6 inches; tender, 12 feet 8 inches. Heating surface: fire-box, 118½ sq. ft; patent water tubes, 39 sq. ft; tubes, 1,711 sq. ft. Total, 1,328 sq. ft. Boiler: length, 10 feet 7 inches, containing 234 tubes 1¾-inch diameter The fire-grate was 8 feet long and had an area of 23 sq. ft. Tender capacity: water, 3,940 gallons; coal space, 4½ tons. Weight, empty: engine, 49½ tons; tender, 19½ tons. Total, 68¾ tons. Weight, in working order: engine, 53¼ tons; tender, 38¾ tons. Total, 92 tons.

The engine was designed so that it worked either as a compound or as what may be termed a semi-compound. When the engine was starting a heavy train, or ascending an incline, all three cylinders developed equal horse-power. This was effected by a second small regulator, controlled by the driver, allowing more or less steam, as the case may be, from the boiler to the receiver. A preliminary trial was made on 22 August, 1898, with 1619 between Newcastle and Tweedmouth on a special train of twelve carriages. The average power developed during the trial was 803.5 indicated horse-power.

Engine 1619 went into regular running in September, 1898, and up to the end of that year ran 21,000 miles and gained on booked time 1,172 minutes.

It is, of course, a matter of history that 1619 was the forerunner of a famous set of compounds on the Midland Railway, having much bigger dimensions and all still to the fore.

In August, 1900, a new fire-box and water tubes were fitted, and the following dimensions were also altered. Weight, empty: engine, 49 tons 3 cwt 3 qrs; tender, 19 tons 6 cwt. Total, 68 tons 9 cwt 3 qrs. Weight, full: engine, 53 tons 6 cwt; tender, 41 tons 2 cwt. Total, 94 tons 8 cwt. Tender capacity, 3,940 gallons. Coal space, 5 tons.

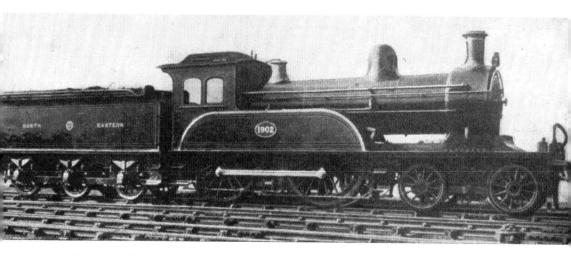

Above: No. 1902, Class Q, 4-4-0. Brass-capped chimneys have now been replaced by cast iron.

Class Q
Four-coupled bogie express engines. Thirty engines in the class.
First one built in 1896.

Dimensions

Driving and coupled wheels, 7-foot-1¼-inch diameter; 9-foot-3-inch centres. Bogie wheels, 3-foot-7¼-inch diameter; 6-foot-6-inch centres. Tender wheels, 3-foot-9¼-inch diameter. Wheel base: Engine, 23 feet 6 inches; tender, 12 feet 8 inches. Total, 45 feet 8¾ inches. Cylinders, 19½-inch diameter; 26-inch stroke. Boiler: 201 tubes 1¾-inch diameter; barrel, 4-foot-4-inch diameter. Grate area, 19¾ sq. ft. Heating surface: firebox, 123 sq. ft; tubes, 1,089 sq. ft. Total, 1,212 sq. ft. Tank capacity, 3,375 gallons. Well capacity, 565 gallons. Total, 3,940 gallons. Coal space, 5 tons. Weight, empty: engine, 46 tons 4 cwt; tender, 17 tons 17 cwt. Total, 64 tons 1 cwt. Weight, full: engine, 49 tons 9 cwt; tender, 37 tons 17 cwt. Total, 87 tons 6 cwt.

In many ways the design of these thirty engines is quite unique and deserves special notice. Worsdell has provided the North Eastern drivers with splendid protection on the footplate, and in this case to the usual roomy cab was added a clerestory roof with ventilators, suggestive of a dining-car rather than a locomotive. An improved design of chimney, with a brass cap, was originally fitted and gave these engines a particularly smart appearance.

Compared with the Class M engines this new class have cylinders ½ inch larger in diameter, being 19½ inches; the stroke, of 26 inches, remains the same. The slide valves, above the cylinders, were originally worked through the medium of short rocking shafts from the link motion. Now that piston valves have been fitted the latter are driven direct.

The fitting of small boilers on the Class Q engines was an error of judgment, which was rectified when the succeeding Class R engines came out. A design for a bigger boiler for Class Q was made, but the courage of some high official was insufficient to secure its adoption in the original design.

The coal consumption of the Class Q engines when new was 38 lbs per mile during the

three summer months on main-line traffic. Engine 1929, with patent water tubes in the fire-box, consumed 35.5 lbs per mile. Average distance travelled per month was 5,000 miles.

Engine Summary

No. 1872. Chas. Rous-Marten timed this engine between Darlington and York in the record time of exactly 40 minutes, start to stop.

No. 1875 on Saturday, 2 June, 1900, ran through to King's Cross Station from Harrogate on a troop special.

No. 1904 made a record run of 41 minutes, start to stop, between York and Scarborough (42 miles) on the occasion of the trials which preceded the establishment of the Leeds–Scarborough special seaside expresses.

No. 1929 was for a time running with patent water-tubes in the fire-box.

Complete list of the Class Q engines:

Engine No.	Date	Engine No.	Date
1871	1896	1906	1897
1872	1896	1907	1897
1873	1896	1908	1897
1874	1896	1909	1897
1875	1896	1910	1897
1876	1896	1921	1897
1877	1896	1922	1897
1878	1896	1923	1897
1879	1896	1924	1897
1880	1896	1925	1897
1901	1897	1926	1897
1902	1897	1927	1897
1903	1897	1928	1897
1904	1897	1929	1897
1905	1897	1930	1897

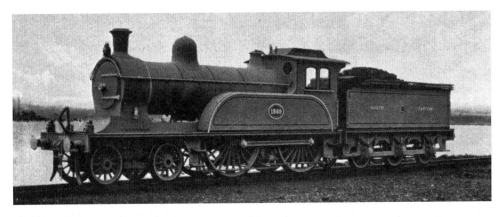

Above: No. 1869, Class Q1. The largest coupled wheels in the world.

Class Q1
Engines Nos 1869 and 1870. Built 1896. Four-coupled bogie express engines.

Principal Dimensions

Driving and coupled wheels, 7-foot-7¼-inch diameter; 9-foot-6-inch centres. Bogie wheels, 3 foot-7¼-inch diameter; 6-foot-6-inch centres. Tender wheels, 3-foot-9-inch diameter. Wheel base: engine, 23 feet 9 inches; tender, 12 feet 8 inches. Total, 46 feet 2¾ inches. Cylinders, 20-inch diameter; 26-inch stroke. Boiler: 201 tubes 1¾-inch diameter; barrel, 4-foot-4-inch diameter. Grate area, 20¾ sq. ft. Heating surface: fire-box, 127 sq. ft; tubes, 1,089 sq. ft. Total, 1,216 sq. ft. Tank capacity, 3,375 gallons. Well capacity, 565 gallons. Total capacity, 3,940 gallons. Coal space, 5 tons. Weight, empty: engine, 47 tons 7 cwt 1 qr; tender, 19 tons 6 cwt. Total, 66 tons 13 cwt 1 qr. Weight, full: engine, 50 tons 16 cwt; tender, 41 tons 2 cwt Total, 91 tons 18 cwt.

A few privileged persons viewed Engine No. 1869 on its completion at Gateshead, but with so little initial ceremony few classes of locomotives on any railway have so quickly gained popularity and praise as these two fliers, Nos 1869 and 1870. This was partly due, no doubt, to their extremely handsome appearance and nicely proportioned design; for, with their short, brass-capped chimneys, commodious clerestory-roofed cabs, and big driving wheels (which always stamp a locomotive as a record-breaker in the popular mind) these two engines at once won for themselves many admirers.

The driving wheels are 7 feet 7¼ inches in diameter, the largest in existence for a coupled engine in regular service, and for size the claims of many single-driving-wheel engines are quite out-rivalled.

It is perhaps somewhat wide of the mark to say that these engines were a direct outcome of the racing to Aberdeen in 1895, but the North Eastern Railway had always adopted a policy of 'being ready', and in anticipation of still higher speeds the following year these engines were specially designed.

Nos 1869 and 1870 are the only *racing* locomotives that have ever been built by a railway company, and with two such engines the North Eastern was well prepared to again try conclusions with its rivals. On the trial trip No. 1869 reached a very high rate of speed. The average between Newcastle and Tweedmouth was said to be close on 60 miles per hour.

Five of these engines were projected. Worsdell decided to try two, and on the non-resumption of racing in 1896 no more with 7-foot-7¼-inch wheels were constructed. Thirty similar engines with 7-foot driving wheels were built. (See Class Q.)

Primarily intended for lightish loads, Class Q1 have proved equal to the task of keeping time on any train on the main line south of Berwick. In a broad sense these two engines may be said to have the speed of a 'single' engine having the same size driving wheels, with the advantage of a better grip of the rails due to coupling.

With regard to fast running the author has timed No. 1869 on the old 12.20 p.m. Sheffield express, between Darlington and York Stations, in 42 minutes 7 seconds, being an average speed of about 63 miles per hour; and the same engine has run from York to Newcastle in under 81 minutes. No. 1869 has also run from York to Malton, 22½ miles, in 22½ minutes.

Class R (2011 Class)
Consisting of sixty engines. First one constructed in 1899.

Principal Dimensions

Driving and coupled wheels, 6-foot-10-inch diameter, 9-foot-6-inch centres. Bogie wheels, 4-foot diameter, 6-foot-6-inch centres. Tender wheels, 4-foot diameter. Wheelbase: engine, 23 feet 9 inches; tender, 12 feet 8 inches. Total, 46 feet 2 7/8 inches. Cylinders, 19-inch diameter; 26-inch stroke. Boiler: barrel, 4-foot-9-inch diameter; 11 feet 6 inches long. Grate area, 20 sq. ft; 255 tubes 1¾-inch diameter. Heating surface: fire-box, 144 sq. ft; tubes, 1,383 sq. ft. Total, 1,527 sq. ft. Tender capacity: tank, 3,375 gallons; well, 162 gallons. Total, 3,537 gallons. Coal space, 5 tons. Weight, empty: engine, 48 tons 4 cwt; tender, 19 tons 6 cwt. Total, 67 tons 10 cwt. Weight, full: engine, 51 tons 14 cwt; tender, 37 tons 18 cwt. Total, 89 tons 12 cwt.

The great feature of these engines was their extreme simplicity and increase in heating surface, being over 20 per cent more than in the preceding class of express engine. The working pressure was originally fixed at 200 lbs per square inch, since reduced to 170 lbs when superheated.

The cylinders, where a slight reduction on the 7-foot engines was made, being 19-inch diameter, drive down to the axle at an inclination of 1 in 11. The eccentrics drive the piston valves beneath the cylinders without the medium of rocking shafts. These valves are 8¾ inches in diameter, and a considerable measure of the success of this class is due to their use.

We have seen the 2011 Class engines unassisted make up time between Edinburgh and Newcastle with trains of 350 tons, and with such locomotives available piloting should seldom be necessary.

Engine Summary

No. 2011 held a record for mileage in this country when new. From 28 August, 1899, to 31 December, 1901, the engine ran 139,543 miles. The average mileage for each month was 10,822. The engine was worked by a double shift of men.

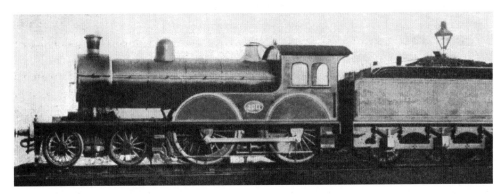

No. 2011, Class R. The most successful four-coupled Express Engine on the NER.

No. 2019 and No. 2023. On the occasion of the King and Queen's visit to Edinburgh on 11 May, 1903, these engines hauled the royal train between York and Newcastle and Newcastle and Edinburgh, respectively, both going and returning.

No. 2020, in 1901, with a train of 117 tons, ran from Darlington to York in 41 minutes 25 seconds, an average speed of about 66 miles an hour; also took part in the Westinghouse Brake trial at Newcastle-on-Tyne, July, 1901.

No. 2026, on 30 November, 1903, made a record run from Darlington to York with the 1.8 p.m. 'flier' and a dynamometer car – a load of seven eight-wheeled bogie coaches – doing the 44¼ miles in exactly 40 minutes.

No. 2028 for a time ran fitted to burn liquid fuel on Holden's system. Later removed.

List of Class R engines:

Engine No.	Date built	New series – cont.	
2011–2018	1899	Engine No.	Date built
2019–2030	1900	1147	1907
2101–2110 inclusive	1901	1184	1907
		1206	1907
New series		1207	1907
476	1906	1209	1907
592	1906	1210	1907
707	1906	1217	1907
708	1906	1223	1907
711	1906	1232	1907
712	1906	1234	1907
713	1906	1235	1907
724	1906	1236	1907
725	1906	1258	1907
1026	1906	1260	1907
1042	1907	1262	1907
1051	1907	1665	1907
1078	1907	1672	1907

Class S
Six-Coupled Bogie Express Engines. First one built in 1899.

The Class S engines have for the last 15 years been running painted black, and almost exclusively on main line goods trains.

These huge ten-wheelers were the pioneer six-coupled engines built specially for express passenger work in Britain, and they were also the heaviest locomotives for that traffic in the country. On the coupled wheels alone there was a weight of no less than 46¾ tons! The North Eastern were justly proud of their latest creation from Gateshead, and one of these locomotives was sent over to the Paris Exhibition in 1900, where she gained a gold medal.

Dimensions of 2001 Class
Driving and coupled wheels, 6-foot diameter; 7-foot centres either way. Bogie wheels, 3-foot-6-inch diameter; 6-foot-6-inch centres. Tender wheels, 3-foot-9-inch diameter. Wheel

base: engine, 26 feet 0½ inch; tender, 12 feet 8 inches. Total, 51 feet. Cylinders, 20-inch diameter; 26-inch stroke. Boiler: barrel, 4-foot-9-inch diameter; 204 tubes, 2-inch diameter. Grate area, 23 sq. ft. Heating surface: fire-box, 130 sq. ft; tubes, 1,638 sq. ft. Total, 1,768 sq. ft. Tank capacity, 3,375 gallons. Well capacity, 565 gallons. Total, 3,940 gallons. Coal, 5 tons. Weight, full: engine, 62 tons 19 cwt; tender, 44 tons 2 cwt. Total, 107 tons 1 cwt.

The pioneer engine No. 2001 ran her trial trip in July, 1899, and demonstrated that there was any amount of speed in this type of express engines, notwithstanding the coupled wheels of but 6-foot diameter.

These engines were originally designed with a total wheel base of 48 feet 4¾ inches to turn on a 50-foot turn-table. This was accomplished by restricting the footplate, so that only one window could be put in each side of the cab, and carrying small tenders having wheel bases of only 12 feet. The total capacity compared with the present tenders was only 3,701 gallons, including the well tank holding 537 gallons. The weight was 38 tons 12 cwt. The first three of these engines had ordinary slide valves and, of course, Stephenson's link motion. The eccentrics were long and were curved part of their length to clear the forward coupled axle.

The later engines of this class (No. 2004 and onwards) were fitted with the usual large cabs of Worsdell's design. For this extra accommodation the footplate was extended backwards 2 feet, the total wheelbase of engine and larger tender being consequently lengthened to 51 feet.

In addition to the type being an entire innovation there were some special features in the engines worth noticing. In order to reduce the friction of the six-coupled wheels on the rails while rounding curves the driving or centre pair were flat without flanges, and Worsdell tried the experiment of a copper front tubeplate to avoid corrosion.

The fire-boxes were shallow in comparison with the standard practice on the North Eastern Railway: except at the front they did not extend lower than the footplate.

These engines had metallic packing glands. The tail rods worked through the front end of the cylinders.

They were fitted with Davies and Metcalfe's exhaust steam injectors.

The last five engines were fitted with Smith's patent piston valves, an improvement which the remainder have since had fitted. This was done to the first three at the time of the alteration of their small cabs, about six months after their building.

In view of the awkward curves at Newcastle it was afterwards found advisable to have flanges on the driving wheels, and all the six-coupled express engines have been altered accordingly.

An additional series of ten engines were built at the Darlington Works in 1906. They were painted 'passenger' green, and except for wash-out plugs in the fire-box, slightly heavier weight, and larger tenders they were exactly like 2001–10 series.

The whole class of twenty engines has since been painted black and relegated to express goods traffic.

A further series of twenty engines for perishable and fast goods traffic, distinguishable by their smaller splashers, were built at Gateshead Works in 1907–8–9. These have patent variable blast pipes, ash ejector, and smaller boilers containing 225 tubes 1¾-inch diameter, with a total heating surface of 1,578 sq. ft.

The numbers of these twenty goods engines are:

Engine No. Dual brakes	Built	Engine No. Westinghouse brake only	Built
738	1907	750	1908
739	1908	751	1908
741	1908	752	1908
743	1908	753	1908
744	1908	754	1908
745	1908	755	1908
746	1908	756	1908
747	1908	758	1908
748	1908	759	1908
749	1908	762	1909

Engine Summary

No. 2003. Younghusband's patent valve gear is being tried on this locomotive. Also has asbestos covering round the boiler.

No. 2004 was the first one built with large cab. Diagrams were taken from this engine in September, 1900, in a series of trials on the 'Scotsman' between Newcastle and Edinburgh.

No. 2006. This engine was sent to the Paris Exhibition in 1900. Copies of the obverse and reverse of the medal gained there are carried on the driving splashers. After returning to England she was fitted to burn liquid fuel. This apparatus, however, has since been removed.

Nos 2009 and 2010 were the first engines lined in gold, having worked the royal train between York and Newcastle with HM the King, when Prince of Wales, in 1900.

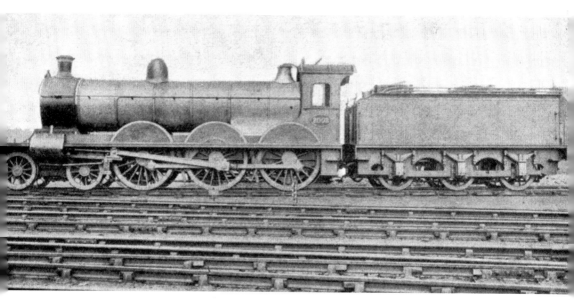

No. 2002 (unpainted), Class S. Showing original form of cab.

List of Class S engines (passenger):

Engine No.	Built at Gateshead	Engine No.	Built at Darlington Works
2001	June, 1899	726	1906
2002	June, 1899	740	1906
2003	June, 1899	756	1906
2004	June, 1899	757	1906
2005	June, 1899	760	1906
2006	January, 1900	761	1906
2007	March, 1900	766	1906
2008	March, 1900	768	1906
2009	June, 1900	775	1906
2010	June, 1900	1077	1906

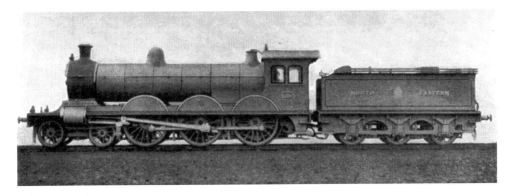

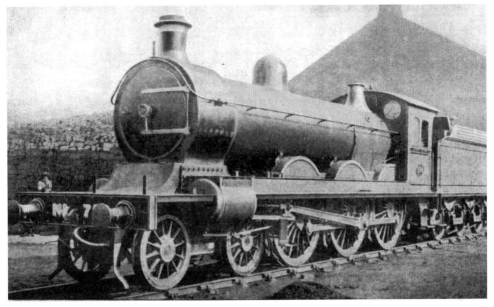

Top: No. 2006, Class S. This engine gained a gold medal at the Paris Exhibition, 1900. *Lower image:* No. 754. One of the Class S Express Goods Locomotives.

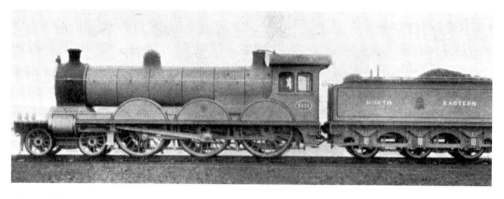

Above: No. 2111, Class S1. One of the larger six-coupled 4-6-2 Bogie Express Engines.

Class S1

Six-coupled bogie express engines. Five engines in the class. First one built 1900.

Weight and Dimensions

Driving and coupled wheels, 6-foot-8¼-inch diameter; 7-foot-7-inch centres. Bogie wheels, 3-foot-7¼-inch diameter. Tender wheels, 3-foot-9¼-inch diameter. Wheelbase: engine, 27 feet 6 inches; tender, 12 feet 8 inches. Total, 51 feet 9¾ inches. Cylinders: 20-inch diameter; 26-inch stroke (with piston valves 8¾-inch diameter). Boiler: barrel, 4-foot-9-inch diameter, 15 feet 10½ inches long. Fire-grate area, 23 sq. ft; 193 tubes 2-inch diameter, of steel. Heating surface: fire-box, 130 sq. ft; tubes, 1,639 sq. ft. Total, 1,769 sq. ft. Tank capacity, 3,375 gallons. Well capacity, 565 gallons. Total, 3,940 gallons. Coal space, 5 tons. Weight, empty: engine, 60 tons 4 cwt; tender, 19 tons 6 cwt. Total, 79 tons 10 cwt. Weight, full: engine, 67 tons 2 cwt; tender, 40 tons. Total, 107 tons 2 cwt.

These five engines came out with several improvements gained from experience with the smaller six-coupled engines, viz., piston valves, flanges on the driving wheels, and large cabs.

The coupled wheels are of a size calculated to allow a somewhat freer motion at very high speeds than the 6-foot engines, and the increase to 6 feet 8 inches – an ideal diameter for a coupled express engine – does not appreciably detract from their hill-climbing power.

A striking feature of these engines is their tall brass safety valve covers, the lever of which could only be conveniently reached by bringing it through the roof of the cab.

Royal Run

On the return of King Edward VII from his autumn visit in Scotland on 11 October, 1902, the royal train was drawn by Engine 2111 between Berwick and Newcastle, and between Newcastle and York by a sister engine, No. 2112. Wilson Worsdell, Chief Mechanical Engineer, rode on the footplate.

Like the Class S engines these five had for some time been painted black, but are now green again and are running express passenger trains once more.

List of Class S1 engines:

Engine No.	Date
2111	January, 1901
2112	May, 1901
2113	July, 1901
2114	Julv, 1901
2115	August, 1901

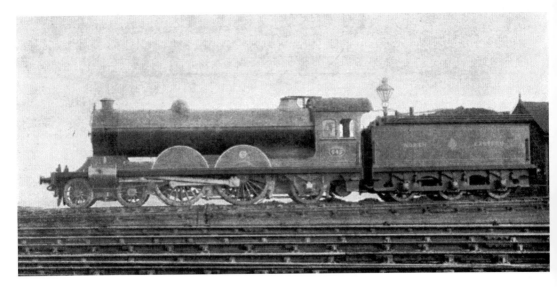

Above: No. 649, Class V. 4-4-2 'Atlantic' Passenger Express Engine.

Class V ('Atlantic' Engines)

Wilson Worsdell, Chief Mechanical Engineer.
Consisting of ten engines. First one constructed 1903.

Dimensions

Driving and coupled wheels, 6-foot-10-inch diameter; 7-foot-7-inch centres. Bogie wheels, 3-foot diameter. Trailing wheels, 4-foot diameter. Tender wheels, 3-foot-9¼-inch diameter. Wheel base: 28-foot engine; tender, 12 feet 8 inches. Total, 52 feet 3¾ inches. Cylinders: 20-inch diameter; 28-inch stroke (piston valves). Boiler: barrel, 5-foot-6-inch diameter; 268 tubes 2-inch diameter. Fire-gtate area, 27 sq. ft. Fire-box, 9 feet long. Heating surface: fire-box, 180 sq. ft; tubes, 2,275 sq. ft. Total, 2,455 sq. ft. Tank and well capacity, 4,125 gallons. Coal space, 5 tons. Weight, full: engine, 72 tons; tender, 43½ tons. Total, 115½ tons.

Engine No. 532, the pioneer of the 'Atlantic' type on the NER, left the Gateshead shops on Tuesday, 3 November, 1903. After two spins to York, when exactly a week old, No. 532 was put to work the 9.35 a.m. Newcastle to Edinburgh express, returning in the evening on the 2.50 'mail', in order to work off the stiffness inherent in a new locomotive.

In November the engine was returned to the shops to have the cab roof raised to enable a better view ahead to be had over the enormous boiler; and the whistles were removed from the cab roof on to the fire-box. After two trial trips run on 4 and 8 December, with a load of 300 tons behind the tender, when indicator diagrams were taken and the horse-power recorded, the engine was declared satisfactory and ready to be handed over to the Running Department. This design of huge 'Atlantic' type express locomotives was brought by Wilson Worsdell directly from his visit in the USA to the famous Atlantic City 'fliers' which run from Philadelphia.

The boiler had the same length as the Class S1 engines, but the diameter was increased to 5 feet 6 inches. The back-end of the fire-box cover was joined on an entirely new plan with the flange outwards to facilitate its withdrawal when necessary. The Ramsbottom safety-valve columns on the fire-box were arranged in a group of four encased in a large circular brass cover.

On Thursday, 10 December, 1903, Engine 532, working to York in the morning on the 9.30 express from Newcastle, returned at 1.57 on the 'Flying Scotsman', weighing over 300 tons, and gained six minutes on booked time. This was the first run of the 'Atlantic' engine on an important East-Coast Scotch express.

The Class V engines and Royalty
On the occasion of HM the King's journey from Doncaster to Balmoral, via the East-Coast Route, on Monday, 12 September, 1904, Engine 784 worked the royal train between Shaftholme Junction and Newcastle. Here the engines were changed, and Engine 742 took His Majesty's train to the Scottish capital.

No. 649 was the first of this class painted green. Gold lining was substituted for the usual white bands.

List of Class V engines:

Engine No.	Date	Engine No.	Date
532	November, 1903	742	July, 1904
649	January, 1904	753	July, 1904
784	May, 1904	1776	September, 1904
295	June, 1904	1792	October, 1904
1680	July, 1904	1794	October, 1904

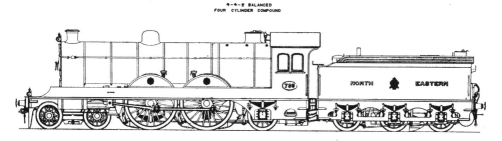

Diagram of **No. 730.** Four-cylinder Balanced Compound. Built in 1906.

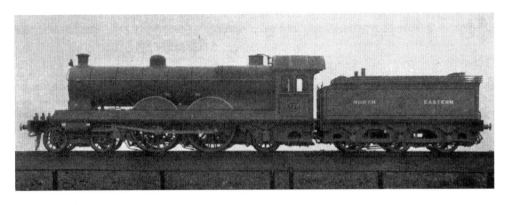

Above: No. 730. The first of the four-cylinder 'Smith' Compounds.

730 and 731
(4-C.C. Class). Built 1906. Four-cylinder balanced compounds. Belpair fire-boxes. Wilson Worsdell, Chief Mechanical Engineer.

Weights and Dimensions

Driving and coupled wheels, 7-foot-1¼-inch diameter; 7-foot-6-inch centres. Bogie wheels 3-foot-7¼-inch diameter; 6-foot-6-inch centres. Trailing wheels, 4-foot diameter; 7 feet 6 inches from coupled wheels. Total wheel base of engine, 28 feet 9 inches. Wheel base of engine and tender, 52 feet 9¾ inches. Cylinders: two high-pressure (outside), 14¼-inch diameter by 26-inch stroke; two low-pressure (inside), 22-inch diameter by 26-inch stroke. Piston valves are used with Walschaert's valve gear in the case of No. 731, and Stephenson's link motion in No. 730. Only two sets of valve gear are used for all four cylinders. Boiler contains 242 tubes 2-inch diameter. Barrel is 5-foot diameter. Heating surface: fire-box, 180 sq. ft; tubes, 1,916 sq. ft. Total, 2,096 sq. ft. Grate area, 29 sq. ft. Steam pressure, 225 lbs per sq. in. Tank capacity, 3,800 gallons. Coal space, 5 tons. Weight, full: engine, 73 tons 12 cwt; tender, 42 tons 12 cwt. Total, 116 tons 4 cwt.

These two engines were designed on the late W. M. Smith's four-cylinder compound system. Being chief draughtsman at Gateshead he was able to exercise considerable latitude from the standard practice of the Company in carrying out his ideas. Belpair fire-boxes were adopted, a new safety-valve casing was designed, and larger domes fitted than the Class V 'Atlantics'. The small narrow splashers upon a platform of the frame have since been adopted as regular standard practice by the Company.

Smith's designs were accepted entirely on their merits. He already had compounds running on the NE, Midland, and GC Railways, and his is the only system that has survived modern strenuous conditions. Unfortunately he was seized with a fatal illness, and barely lived to see these two magnificent 'fliers' on regular duty after their initial trials.

Engine 730 came out in April, 1906, and after being 'run in' began on 1 May regularly to work on the East-Coast Scotch expresses between Edinburgh and Newcastle, being on the 10 a.m. to King's Cross that day. No. 731 soon followed, and these two engines have continued on the principal main line trains ever since.

On the occasion of King Edward's visit to Scotland on 17 September, 1906, Engine 730 hauled the royal train from Newcastle to Edinburgh. His Majesty having expressed a wish for an early arrival the driver, Charles Gill, made a record run in 2 hours 18 minutes. Berwick was passed 8 minutes early and Edinburgh reached 15 minutes early.

On 1 October, 1906, the King Edward Bridge was opened, which enabled Engine 730 to perform a feat otherwise impossible. When HM Queen Alexandra travelled from Balmoral to Sandringham on 17 October, 1906, No. 730 worked the royal train from Edinburgh to York, with a stop of 6 minutes at Newcastle, being the first engine to cover the entire distance of 204½ miles without turning.

The second occasion on which an engine worked the whole distance between York and Edinburgh was on 16 September, 1907, when King Edward VII travelled from Doncaster to Perth for his autumn visit to Scotland. The engine was No. 731, driven by T. Blades. The fastest express speed was maintained, and the journey was only 3 minutes slower than the record run of No. 730 in 1906. The same engine and driver repeated the performance in 1908 with the royal train, weighing over 200 tons.

During the summer of 1908 Engine 731 was run experimentally on the NBR 'Waverley Route' with heavier loads than are usually taken by one engine, and time was kept.

A record run by No. 731 on the 9.13 p.m. York to Newcastle dining-car express is recorded in *Railway and Travel Monthly* for January, 1913. The driver was C. Gill and the load 195 tons behind the tender. Darlington arrival time was 9.55.35 p.m., the average speed, start to stop, being 62.1 miles an hour. Sir Vincent Raven has fitted both Nos 730 and 731 with superheaters, still further enhancing their efficiency and usefulness.

Class Rl
Four-coupled bogie express engines. First engine built Darlington Works, 1908. Wilson Worsdell, Chief Mechanical Engineer.

Weights and Dimensions

Cylinders, 19 inches by 26 inches. Diameter of driving wheels, 6 feet 10 inches. Diameter of bogie wheels, 3 feet 7 inches. Centres of coupled wheels, 9 feet 6 inches apart. Total engine wheel base, 27 feet. Centre of boiler from rail, 8 feet 11 inches. Length of barrel, 11 feet 6½ inches. Diameter, outside, 5 feet 6 inches. Thickness, 5/8 inch. Tube-plate, copper. Length of fire-box, outside, 9 feet; breadth, at bottom, 3 feet 11 inches. 254 copper tubes, 2-inch diameter. Diameter of variable blast pipe nozzle, from 4¾ inches to 7 1/8 inches. Height of chimney from rail, 13 feet 3 inches. Heating surface: tubes, 1,579 sq. ft; fire-box, 158 sq. ft. Total, 1,737 sq. ft. Area of fire-grate, 27 sq. ft. Weight of engine, in working order: on bogie wheels, 17 tons 10 cwt; on driving wheels, 42 tons. Total, 59 tons 10 cwt. Tender wheels, 3-foot-9¼-inch diameter. Tank and well capacity, 4,125 gallons. Coal space, 5 tons. Total weight, in working order, 41 tons 2 cwt.

The Class R engines, first introduced in 1899, having proved so thoroughly satisfactory, the plan now adopted was to design similar engines with bigger and longer boiler and

firebox, so as to provide a much increased heating surface to meet the more exacting demands of the traffic department.

One of the noteworthy facts in connection with these engines was their being constructed at Darlington Works. This intelligent anticipation of the transference of the locomotive headquarters of the Company back to the famous North Road Works was naturally a great disappointment to Gateshead.

The first engine of the class, No. 1237, came out in November, 1908, and after being painted ran from Newcastle to Edinburgh on the morning of 23 November, returning on the afternoon 'mail', as a preliminary canter, with the unexpected result that it was taken into the Gateshead Works and its motion re-assembled.

The amusing sequel was that Gateshead sent assistance through to Darlington to aid the completion of the remaining eight engines, the second one of the class having meanwhile made its appearance.

The smoke-box rests on a saddle and is recessed a trifle into the boiler barrel. By the side of the smoke-box, on the right-hand side, is placed the air brake pump. The safety-valves, dome, chimney, etc., are similar to those fitted to the Class V 'Atlantics'. The engines have piston valves 10 inches in diameter, with outside admission. The variable blast-pipe was designed to relieve the back-pressure on the pistons and to eject the ashes from the smoke-box.

Two of these engines, Nos 1242 and 1244, were at first stationed at Leeds for working the morning Scotch expresses as far as Newcastle. The others were located at York shed.

The Class R1 engines never seemed quite to come into their stride until Sir Vincent Raven fitted them with superheaters in 1913, but they are now remarkably fine and handsome engines and capable of high speeds.

An enormous boiler-pressure of 225 lbs was originally adopted. This was later reduced, when superheated, to 170 lbs.

Numbers of Class R1 engines:

Engine No.	Date built
1237	October, 1908
1238	November, 1908
1239	January, 1909
1240	February, 1909
1241	April, 1909
1242	May, 1909
1243	May, 1909
1244	June, 1909
1245	June, 1909
1246	June, 1909

Opposite page, from the top: No. 1238, Class R1. Built at Darlington Works, 1908. No. 797, Class S2. One of the big-boilered Express Engines built in 1911. No. 696, Class V1. One of the second batch of two-cylinder 'Atlantics'.

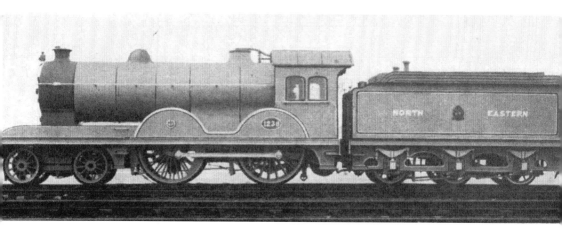

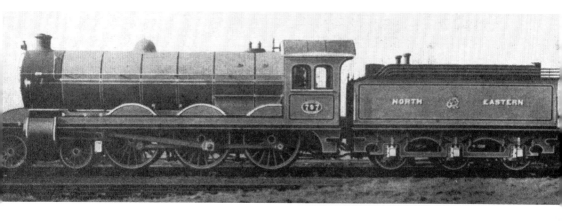

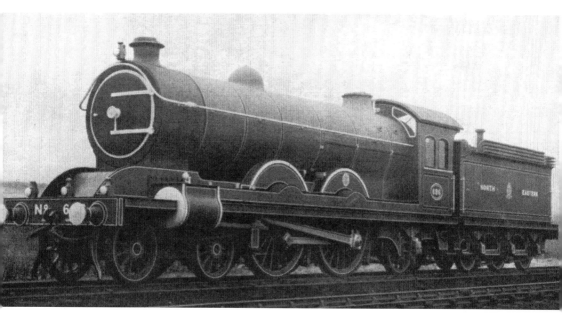

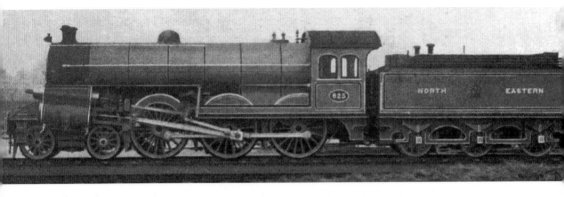

Above: No. 825, Class S2. With 'Stumpf' arrangement of cylinders.

Class VI (2-Cylinder 'Atlantics')
Built at the Darlington North Road Works, 1910. Ten engines in the class.

These engines were designed during Wilson Worsdell's tenure of office but were the first new engines to appear under Raven on his appointment as Chief Mechanical Engineer.

Darlington now became the headquarters of the Chief Mechanical Engineer and was the principal locomotive building centre of the Company in place of historic Gateshead, adding to the loss which Newcastle had already experienced in a similar way from the removal of the pioneer locomotive business in the world.

The principal difference between these new 'Atlantics', numbered from 696 to 705 (inclusive), and No. 532 of the Gateshead series, was the reduction of ½ inch in the cylinder diameter and strengthening of the main frames, and consequently slight additional weight of the engines.

The boiler pressure also was reduced to 180 lbs in accordance with the prevailing practice with all the express engines on the line, and has considerably added to the economic life of the boilers. This practice was soon extended on the almost universal introduction of superheating.

The class was originally located at York and Leeds. Those from the former town working on the Newcastle and Carlisle line to make up their mileage. As this section is a very secondary one compared with the main line there is probably something in the statement that Sir Vincent Raven sent them to uphold the honour of the line at that great cosmopolitan junction – the Citadel Station, Carlisle.

It will be noticed the numbers of Class VI displace the early four-coupled passenger engines by Stephenson and Beyer, Peacock of 1870. They are as follows:

698 700 702 704
699 701 703 705

No. 700 drew the royal train from Edinburgh to Newcastle on the occasion of HM the King's journey from Scotland on 21 July, 1911.

Class S2

Built at Darlington Works. Sir Vincent Raven, Chief Mechanical Engineer.
Twenty six-coupled bogie engines for fast freight traffic and passenger trains.
First one built in 1911.

This class is similar to the Class S engines except that they have larger boilers and are therefore heavier. The boiler is 15 feet long by 5-foot-6-inch diameter. Boiler pressure, 180 lbs. Total heating surface, 1,821 sq. ft. Total weight of engine and tender in working order, 109 tons 19 cwt. The first six engines were originally painted green, but they have all long since been re-painted black with red lining, like 797 came out in 1911.

No. 825 of this class is well known and has been described by all the technical journals on account of its arrangement of cylinders on the Stumpf system, in which the steam is exhausted by the pistons uncovering a grating at the end of the stroke.

The following are the numbers of the Class S2 engines:

Built 1911	Built 1912
782	813
786	815
787	817
788	819
791	820
795	821
796	822
797	823
798	824
799	8-3

Classes Z and Z1

Sir V. L. Raven, Chief Mechanical Engineer. Three-cylinder 'Atlantics'. First one built 1911.
(Originally Class Z was without superheater but had same dimensions.)

Weights and Dimensions

Three cylinders, 16½-inch diameter by 26-inch stroke. Driving and coupled wheels, 6-foot-10-inch diameter. Trailing wheels, 4-foot diameter. Bogie wheels, 3-foot-7¼-inch diameter. Wheel base: bogie, 6 feet 6 inches; centre of bogie to driving wheels, 10 feet 8 inches. Coupled wheel base, 7 feet 7 inches. Coupled wheels to trailing wheels, 8 feet. Total wheel base of engine, 29 feet 6 inches. Boiler contains 149 tubes 2-inch diameter and 24 flue tubes. Heating surface: in tubes, 2,329 sq. ft; fire-box, 180 sq. ft. Total, 2,509 sq. ft. Fire-grate area, 27 sq. ft. Boiler, 15ft. 10½ inches long by 5-foot-6-inch diameter outside; 8 feet 11 inches from rail to centre of boiler. Fire-box, 9 feet long. Working pressure, 180 lbs; when superheated, 160 lbs per sq. in. Piston valves, outside admission, 7½-inch diameter. Stephenson's link motion to all cylinders. Tender wheels, 3-foot-9½-inch diameter.

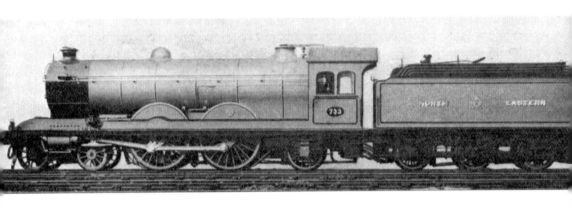

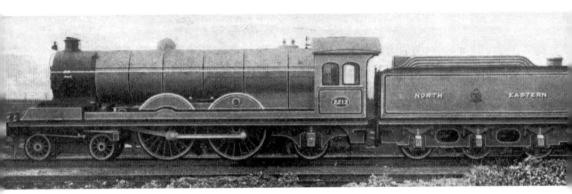

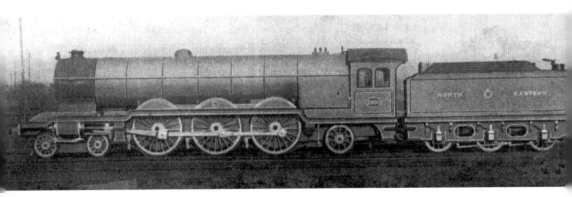

From the top: No. 733, Class Z1. Built in 1911 by the North British Locomotive Co. Ltd. No. 2212, three-cylinder 'Atlantic' Uniflow Express Passenger Engine. No. 2400, the first of the monster 'Pacific' express engine.

Wheelbase, 12 feet 8 inches equally divided. Capacity, 4,125 gallons. Coal space, 5 tons. Total wheel base, engine and tender, 53 feet 3 7/8 inches. Weight: on bogie wheels, 18 tons; on driving axle, 20 tons; on coupled axle, 20 tons; on trailing axle, 19 tons. Weight of tender, 45 tons 6 cwt. Total weight of engine and tender in working order, 122 tons 6 cwt.

In designing the original twenty fine Class Z 'Atlantic' express passenger engines Sir V. L. Raven continued the same general policy as his predecessor, only introducing such modifications and improvements as were found necessary. They had three high-pressure cylinders as a compromise between the 2- and 4-cylinder systems already in use, and owing to the setting of the cranks they have a very even blast on the fire owing to the more continuous exhaust from the overlapping of working strokes, and slipping is almost entirely absent. With an increased total wheel base of 29 feet 6 inches this gives the engines a remarkable steadiness in running combined with good acceleration. Their fire-box dimensions remained the same; a reduction in total heating surface and, more especially, in boiler pressure has added considerably to their economy in maintenance and repair over the similar type of earlier 'Atlantics'. As in the 4-cylinder compounds the leading coupled wheels are the driving wheels for all cylinders. This plan also enables the outside connecting rods to be brought nearer the driving wheels than would be the case were the trailing wheels used, where the coupling rod necessarily comes in between. (See Class V engines.)

The three cylinders and piston valves are all cast in one piece. The whole of the twenty engines in 1911 were built by The North British Locomotive Co. Ltd., Hyde Park Locomotive Works, Glasgow, and as already mentioned only the first ten designated Class Z1 had Schmidt patent superheaters, but the second ten are now likewise converted.

These 1911 3-cylinder 'Atlantics' can be distinguished from the later ones of the class by their large brass safety-valve casings, enclosing two sets of Ramsbottom safety valves. They have Wakefield's mechanical lubricator, the tender frame is different, having the semi-circular slots, and they had not the Lockyer regulator originally.

The numbers of these engines are tabulated overleaf.

Ten of the Z1 Class were built at the North Road Works, Darlington, in 1914, with some modifications in size of boilers and other details and different safety valves. These comprised Timmis springs for the bogie to add resilience to the leading wheels of the engine, Ross muffled 'pop' safety valves (now adopted as standard on all classes), and Stone's forced-feed lubricators. The Darlington series have a total heating surface of 2,005.9 sq. ft. Sir V. L. Raven designed entirely new tenders of a much improved type, for self-trimming, and a stronger frame of new pattern. However, the general dimensions remained unaltered from the first twenty built at Glasgow. In 1915–16 twenty additional engines were added, making a grand total of fifty of the 3-cylinder superheater Class Z engines.

A truly remarkable feature of the Class Z engines when ably handled is their weight-pulling capacity which they frequently display, but the palm goes to No. 732 for an example during the 'strike' of 1911, instanced in the *Railway Magazine*, 1912, where Engine 732, Driver Glass, conveyed the 'Flying Scotsman', weighing 545 tons, from York to Darlington in 50¼ minutes, start to stop!

As showing their adaptability to varying conditions, Cecil J. Allen timed No. 2195, Driver Young, over the Darlington to York section at 79 miles an hour *on the level*, a truly remarkable performance even for so huge an engine as the Z1s are!

No. 709 was the engine on the new East-Coast royal train between Newcastle and York on 21 July, 1911, when His Majesty the King travelled from Scotland by the East Coast route.

No. 2212, with its three 'Uniflow' cylinders, holds the best coal consumption record of the entire series.

Complete list of the Class Z engines:

Built in 1911 by N. B. Loco. Co. Ltd.		Built 1914 at Darlington	Built 1915 at Darlington	Built 1916 at Darlington
Class Z	Class Zl Superheaters	Class Z1		
706	722	2163	2193	2203
709	727	2164	2194	2204
710	728	2165	2195	2205
714	729	2166	2196	2206
716	732	2167	2197	2207
717	733	2168	2198	2208
718	734	2169	2199	2209
719	735	2170	2200	2210
720	736	2171	2201	2211
721	737	2172	2202	221 2

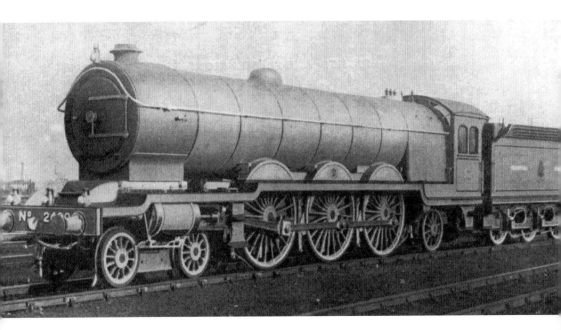

Above: No. 2400, 'Pacific' Express Engine (end view).

The Pacific express passenger engines (Class 4-6-2)
First one built November, 1922. Designed by Sir Vincent Raven, KBE, MICE, MIME.

We have literally described the whole of the passenger locomotives of the NER from A to Z, so that there is no letter left to be allotted to the monster 'Pacific' type, of which Nos 2400 and 2401 are the first to be built. They had neither finished their trials nor were they painted green at the beginning of 1923 when the Company ceased to exist, but No. 2400 was finished in gray with lettering for photographing, and No. 2401 has since been painted in North Eastern green and the old name on the tender.

Weights and Dimensions

Coupled wheels, 6-foot-8-inch diameter. Rigid wheelbase, 15 feet. Leading bogie wheels, 3-foot-1¼-inch diameter. Trailing wheels, 3-foot-9¼-inch diameter; 8-foot centres from coupled wheels. Total wheel base of engine, 37 feet 2 inches. Tender wheels, 3 feet 9¼ inches; 6-foot-4-inch centres. Total wheel base of engine and tender, 61 feet 11¾ inches. Total length over buffers, 72 feet 4 3/8 inches. Three cylinders, 19-inch diameter; stroke 26 inches. Boiler, 6-foot diameter; length, 26 feet. Fire-box 8 feet long, 6 feet 5 inches wide. Grate area, 41.5 sq. ft. Heating surface: fire-box, 200 sq. ft. Total heating surface of engine, 2,874.6 sq. ft. Boiler pressure, 200 lbs per sq. in. Self-trimming tender capacity, 5½ tons of coal and 4,125 gallons of water. Weight of engine in working order, 97 tons. Total weight of engine and tender in working order, 148 tons 2 cwt.

This arrangement of a wide fire-box spread out over a pair of trailing wheels on a radial axle is, of course, new on the NER. The first two Darlington 'Pacifics' have had very exhaustive trials, and not until 23 April, 1923, did No. 2400 run a final test with the dynamometer car and 500 tons behind the tender between Newcastle and Edinburgh before being finally put into regular service.

There is no doubt these huge 'Pacific' engines will be a distinct acquisition to the locomotive stock of the London & North Eastern Railway, and the author will not be surprised to see No. 2400 and her sisters working on other sections of the line than that for which they were built. They are almost certain to be seen south of York before very long.

No. 2400 has already been running experimentally in comparison with a GN 'Pacific' between Doncaster and King's Cross. It was reported to be more powerful but not quite so fast as the latter.

At the time of the publication of this chapter No. 2400 is painted in the new London & North Eastern green and new lettering, while No. 2401 is in the old NER colours and lettering.

Three more of these 'Pacific' engines are to be built at Darlington. These will have trailing wheels arranged with outside axle-boxes and bearings as in the Class Z 'Atlantic' engines.

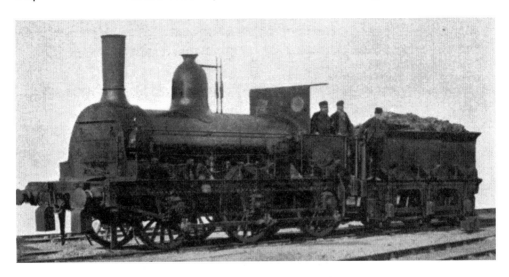

Above: No. 390. Double-framed goods engine built by R. Stephenson & Co. in 1855.

Main Line Goods Engines

The North Eastern Railway was the largest mineral carrier in the United Kingdom, and naturally their goods and mineral engines far exceeded the passenger engines in number. In addition to this many express goods trains are regularly worked by passenger engines.

One or two goods engines were illustrated and described in Parts I and II, so the earliest engines we need illustrate are the outside-framed 388 Class, built by R. Stephenson & Co. between 1855 and 1857. Their driving wheels were 5 feet in diameter and cylinders 16 inches by 24 inches. E. B. Wilson & Co., Leeds, built a very similar lot for the NER at the same time. They are interesting, for they were the first real NER type built after the formation of the Company in 1854.

398 Class
Single-framed long-coupled engines. Number of engines in the class, 324. First one built 1872. Fletcher, Locomotive Superintendent.

Original Dimensions

Engine wheels, 5-foot diameter. Tender wheels, 3-foot-6-inch diameter. Wheelbase: engine, 16-foot-6-inch diameter; tender, 12 feet 3 inches. Total, 37 feet 3½ inches. Cylinders, 17-inch diameter; 24-inch stroke. Boiler, 206 tubes 1¾-inch diameter. Barrel, 4 feet 3 inches. Grate area, 17 sq. ft. Heating surface: fire-box, 110 sq. ft; tubes, 1,028 sq. ft. Total, 1,138 sq. ft. Tank capacity, 2,200 gallons. Coal space, 3 tons. Weight, empty: engine, 34 tons 16 cwt; tender, 15 tons 2 cwt. Total, 49 tons 18 cwt. Weight, full: engine, 37 tons 6 cwt; tender, 28 tons 18 cwt. Total, 66 tons 4 cwt. The boiler, 10 feet 7 inches in length, 16 feet 5 inches with the fire-box, was the type fitted to the 1463 Class passenger engines. There were many slight variations in both cylinder dimensions and wheel diameters, but the foregoing were standard.

It is worth noting that the five engines Nos 100, 283, 292, 488, and 805 came out new with round-topped domes and Ramsbottom valves in McDonnell's time and never had Fletcher's fittings.

Complete list of the 398 Class engines, built by private firms:

No. Built	Engine Nos.	Date	Builders	Makers' Nos.
19	781–799	1872	Stephenson & Co.	2051–2069
11	813–823	1873	"	2070–2080
20	824–843		Hawthorn & Co.	1561–1580
19	879–897	1874	Stephenson & Co.	2151–2169
11	913–923	1874–5	"	2170–2180
10	934–943	1874	Neilson, Reid & Co.	1809–1818
10	984–991		Hawthorn & Co.	1623–1632
20	1370–1389	1875	Stephenson & Co.	2261–2280
20	1390–1409	1875–6	Sharp, Stewart & Co.	2540–2559
20	1410–1429	1875	Dübs & Co.	863–882

708 Class
Double-framed long-coupled engines.

Same general dimensions as 398 Class, but had double frames. Built 1870 by R. Stephenson & Co. Numbers ran from 706 to 775 inclusive.

Total weight of engine, empty, 37 tons; tender, 11 tons 14 cwt. Weight of engine, full, 39 tons 10 cwt; tender, 25 tons 10 cwt. Engine and tender in working order, 65 tons. These are illustrated by No. 774, shown because it had a different shaped safety valve from the standard design. No. 737 had cylinders 17½ inches by 24 inches.

59 or 1480 Class
Number of engines in the class, forty-four. First one built 1883.
McDonnell, Locomotive Superintendent.

Chief Dimensions

Engine wheels, 5-foot diameter; 7-foot-9-inch and 8-foot-3-inch centres. Tender wheels, 3-foot-8-inch diameter. Wheelbase: engine, 16 feet; tender, 12 feet 6 inches. Total, 36 feet 5¾ inches. Cylinders, 17-inch diameter; 26-inch stroke. Boiler, same as Class 901 engines. Tender capacity, 2,500 gallons. Coal space, 3½ tons. Weight, empty: engine, 33 tons 18 cwt; tender, 14 tons 7 cwt. Weight, full: engine, 36 tons 16 cwt; tender, 27 tons 14 cwt. Total, 64 tons 10 cwt.

The two engines Nos 498 and 606 had wheels 5-foot-6-inch diameter. The Darlington engines, built in 1885, had their numbers painted on the side of the cabs like the 'Tennant' engines, but were afterwards given number plates.

Complete list of 59 class:

Engine No.	Date	Works	Engine No.	Date	Works
208	1883	Darlington	681	1884	Darlington
235	,,	,,	682	,,	,,
440	,,	,,	812	,,	,,
455	,,	,,	1141	,,	,,
497	,,	,,	192	1885	,,
506	,,	,,	232	,,	,,
59	1884	,,	422	,,	,,
78	,,	,,	491	,,	,,
131	,,	,,	1102	,,	,,
142	,,	,,	1106	,,	,,
369	,,	,,	1480	,,	Stephenson & Co.
388	,,	,,	1481	,,	,,
446	,,	,,	1482	,,	,,
498	,,	,,	1483	,,	,,
502	,,	,,	1484	,,	,,
508	,,	,,	1485	,,	,,
522	,,	,,	1486	,,	,,
565	,,	,,	1487	,,	,,
567	,,	,,	1488	,,	,,
571	,,	,,	1489	,,	,,
606	,,	,,	1490	,,	,,
620	,,	,,	1491	,,	,,

Class C

(Originally two-cylinder Compounds.) 171 Engines in the class. First one built 1886. T. W. Worsdell, Locomotive Superintendent.

Dimensions

Engine wheels, 5-foot diameter; 8-foot and 8-foot-6-inch centres. Tender wheels, 3-foot-9-inch diameter. Wheelbase: engine, 16 feet 6 inches; tender, 12 feet 8 inches. Total, 37 feet 9¾ inches. Cylinders: high pressure, 18-inch diameter; low pressure, 26-inch diameter; 24 inch stroke. Boiler: 203 tubes 1¾-inch diameter Barrel, 4-foot-3-inch diameter. Grate area, 17¼ sq. ft. Heating surface: fire-box, 110 sq. ft.; tubes, 1,016 sq.ft. Total, 1,126 sq. ft. Tank capacity, 3,038 gallons. Coal space, 5 tons. Weight empty: engine, 38½ tons; tender, 17½ tons. Total, 56 tons. Weight, full: engine, 41½ tons; tender, 34½ tons. Total, 76 tons.

These engines were designed by T. W. Worsdell between 1886 and 1892. Only one, No. 16, was built the first year. They were spoken well of by those who had charge of them, and enjoyed a much longer run of success than the corresponding express engines. The coal consumption of eleven of these engines for a period of six months was reported to average 35¼ lbs per mile. Engine No. 107, fitted with patent piston valves, in the same period consumed 32½ lbs per mile.

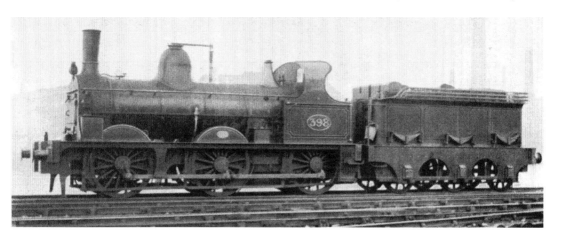

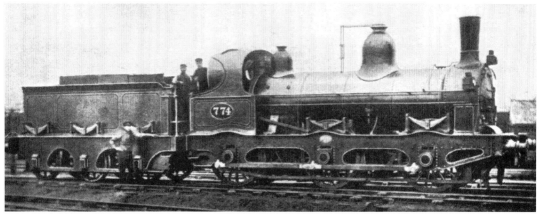

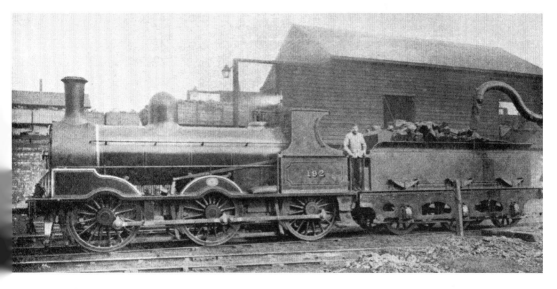

From the top: No. 398. Fletcher's standard Main Line Goods Engine in 1872. No. 774 of the 708 Class, with double frames, built 1870. No. 182, 59 Class, built in 1885, showing the reversing lever on the left-hand side of engine.

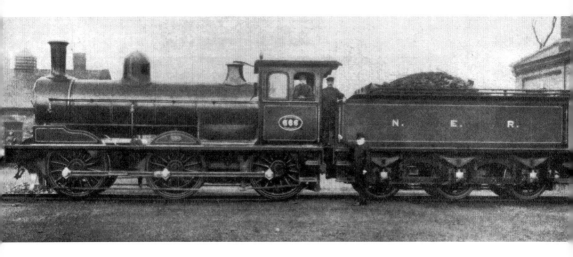

Above: No. 666, one of the Class C two-cylinder Compounds. Built 1887.

Class Cl
Thirty engines in the class. First one built 1886.

Dimensions

Same as Class C, but two 18-inch high-pressure cylinders. All these engines were built at Gateshead. Complete list:

Engine	Date	Engine	Date	Engine	Date	Engine	Date	Engine	Date	Engine	Date
4	1886	360	1886	1801	1894	1806	1894	1811	1894	1816	1894
22	"	480	"	1802	"	1807	"	1812	"	1817	"
86	"	539	"	1803	"	1808	"	1813	"	1818	"
152	"	558	"	1804	"	1809	"	1814	"	1819	"
182	"	667	"	1805	"	1810	"	1815	"	1820	1895

Class P
Six-coupled goods. Seventy engines in the class. First one built in 1894.
Wilson Worsdell, Locomotive Superintendent.

Dimensions

Engine wheels, 4-foot-6-inch diameter; 7-foot-9-inch and 8-foot centres. Tender wheels, 3-foot-9-inch diameter. Wheelbase: engine, 15 feet 9 inches; tender, 12 feet 8 inches. Total, 37 feet 0¾ inch. Cylinders, 18-inch diameter; 24-inch stroke. Boiler, 206 tubes 1¾-inch diameter. Barrel, 4-foot-3-inch diameter. Heating surface: fire-box, 98 sq. ft; tubes, 999 sq. ft. Total, 1,097 sq. ft. Grate area, 15 1/6 sq. ft. Tank capacity, 3,038 gallons. Coal space, 4 tons. Weight, empty: engine, 35½ tons; tender, 18 tons. Total, 53½ tons. Weight, full: engine, 38½ tons; tender, 34¼ tons. Total, 72¾ tons.

List of Class P engines:

Eng	Date	Eng	Date	Eng	Date	Eng	Date	Eng	Date	Eng	Date	Eng	Date
1821	1894	1841	1895	1851	1895	1891	1896	1931	1897	1941	1897	1951	1898
1822	"	1842	"	1852	"	1892	"	1932	"	1942	"	1952	"
1823	"	1843	"	1853	"	1893	"	1933	"	1943	"	1953	"
1824	"	1844	"	1854	1896	1894	"	1934	"	1944	1898	1954	"
1825	"	1845	"	1855	"	1895	"	1935	"	1945	"	1955	"
1826	1895	1846	"	1856	"	1896	"	1936	"	1946	"	1956	"
1827	"	1847	"	1857	"	1897	"	1937	"	1947	"	1957	"
1828	"	1848	"	1858	"	1898	"	1938	"	1948	"	1958	"
1829	"	1849	"	1859	"	1899	1897	1939	"	1949	"	1959	"
1830	"	1850	"	1860	"	1900	"	1940	"	1950	"	1960	"

The last twenty engines were built at Darlington Works.

Class P1, first built in 1898, with cylinders 18¼ inches by 26 inches, is an enlargement of the above engines, the boiler and wheel base being the same as Class C. There are 140 engines in this class.

Class P2
Six-coupled goods engines. First one built in June, 1904.

The dimensions are similar to Class P engines as regards the frame and motion, but the size of the boiler is enormously increased. The total heating surface is 1,658 sq. ft made up from 127 in the fire-box and 1,531 in the tubes. The outside diameter is 5 feet 6 inches and grate area 20 sq. ft. The centre of the boiler is 8 feet 1 inch above rail level. The total weight of engine and tender in working order is 83 tons. The original working pressure of 200 lbs has been reduced in all of this class to 180 lbs per square inch.

The safety-valve columns are arranged in a group of four in a similar manner to those on the 'Atlantic' passenger engines. The chimneys are not fitted with brass caps as the Class T engines, and are of cast iron.

List of class P2 engines:

Engine No.	Darlington Works No.	Date	Engine No.	Date Built	Engine No.	Date
132	466	1904	1043	1904	67	1905
243	467	1904	1057	1904	233	
342	468	1904	1098	1904	379	Built at
442	469	1904	1130	1904	406	Gateshead
434	470	1904	1369	1904	816	
543	471	1904	1671	1904	1139	
554	472	1904	1672	1904	1360	
555	473	1904	1674	1904	1670	
1159	474	1904	1676	1904	1673	
1172	475	1904	1678	1904	1698	

Since 1906 another hundred engines have been built by various makers, designated Class P3, having modified boiler dimensions and heavier total weight. Their numbers nearly all replace old 1001 Class engines which had been broken up. Cylinders, 18½ inches; stroke, 26 inches. Coupled wheels, 4-foot-7¼-inch diameter. Grate area, 20 sq. ft. Boiler pressure, 180 lbs per sq. in. Total heating surface, 1,589.36 sq. ft. Weight of engine in working order, 49 tons 7 cwt. Tender tank capacity, 3,000 gallons. Coal space, 5 tons. Weight of tender in working order, 37½ tons.

Class T
Eight-coupled mineral engines. First one built 1901.

Leading Dimensions

Engine wheels, 4-foot-7¼-inch diameter. Tender wheels, 3-foot-9¼-inch diameter. Wheel base: engine, 17 feet 2 inches; tender, 12 feet 8 inches. Total, 41 feet 11 7/8 nches. Cylinders, 20-inch diameter; 26-inch stroke (piston valves). Boiler, 193 tubes (steel) 2-inch diameter Barrel, 4-foot-9-inch diameter. Grate area, 21.5 sq. ft.

Heating surface: fire-box, 125 sq. ft; tubes, 1,550 sq. ft. Total, 1,675 sq. ft. Tank and well capacity, 3,701 gallons. Coal space, 5 tons. Weight, empty: engine, 52 tons 6 cwt 1 qr; tender, 20 tons. Total, 72 tons 6 cwt 1 qr. Weight, full: engine, 58 tons 6 cwt; tender, 38 tons 12 cwt. Total, 96 tons 18 cwt. Note. – The tender is fitted with a water scoop.

These engines were designed to haul trains of 60 loaded wagons of coal, but this number is frequently exceeded in practice.

The Engineer in 1901 described an experiment at Tyne Dock where one of these engines hauled a train-load of 1,326 tons, whose total length was 569 yards, the longest the Company had ever hauled. Similar trials were carried out at Blyth with Engine No. 651 on 29 July, 1903.

The first ten engines were constructed without sand-boxes on the leading wheel splashers. They had brass-capped chimneys.

Roll of Honour

The following fifty engines of Class T1 were sent overseas during the war

130	652	669	783	1177
527	653	764	789	1178
578	654	767	793	1215
642	655	769	794	1320
643	656	770	939	1700
644	657	771	1002	1704
645	658	772	1031	1708
646	659	773	1032	1709
647	660	774	1054	1717
648	661	781	1062	1729

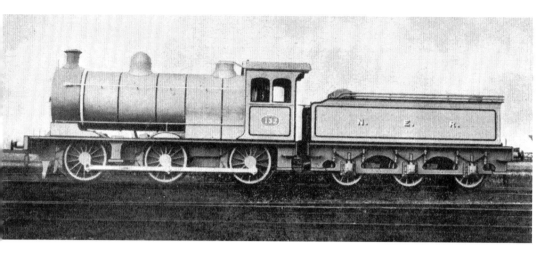

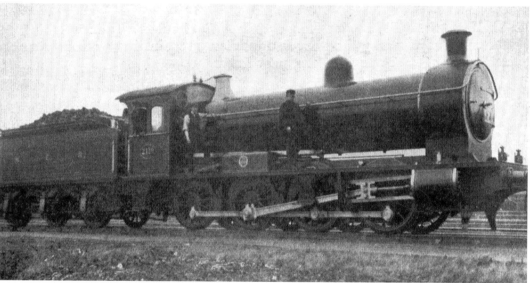

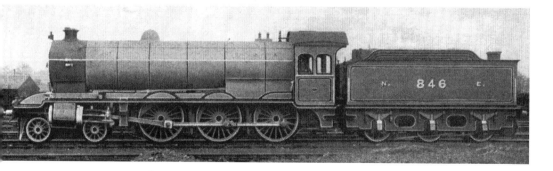

Top to Bottom: No. 132, Class P2 Mineral Engine, with big boiler, built in 1904 by Wilson Worsdell. No. 2119, Class T. One of the first of the eight-coupled Mineral Engines. No. 846, Class S3, Main line Express Goods Engine.

Class T3

The latest variation of the eight-coupled mineral engines known as Class T3 were built in 1919 at Darlington, their chief features being three cylinders, 18½ inches with a stroke of 26 inches, and self-trimming tenders holding 4,125 gallons of water and 5½ tons of coal. They have the Schmidt superheater and a minor alteration in the setting of the cab windows. The engine weighs, in working order, 71 tons 12 cwt, and the tender 44 tons 2 cwt.

On 28 August, 1921, Engine No. 903, Class T3, hauled a train weighing 754 tons 16 cwt on a gradient of 1 in 75 and covered 6 miles 53 chains in 33 minutes on the NB line between Bridge of Earn and Glenfarg, near Perth.

Class S3
Three-cylinder six-coupled bogie goods engines. Built 1919–20.

Class S3, for fast freight traffic, designed by Sir Vincent Raven, KBE, MICE, MIME, have leading bogies with wheels 3-foot-1¼-inch diameter and six-coupled wheels 5-foot-8-inch diameter, with a wheel base of 13 feet 6 inches. Total wheelbase of engine, 27 feet 8 inches. Tender wheels, 3-foot-9¼-inch diameter; 6-foot-4-inch centres. Wheel base of engine and tender, 52 feet 5 7/8 inches. The boiler is the same pattern as for the Class T3 engines and superheated. The three cylinders are 18½-inch diameter by 26-inch stroke. Diameter of boiler, 5 feet 6 inches; length, 16 feet 2 5/8 inches between tube plates; containing 102 tubes 2-inch diameter and 24 superheated tubes 5¼-inch diameter. Boiler pressure, 180 lbs per sq. in. Heating surface: fire-box, 166 sq. ft. Total heating surface, 2,094 sq. ft. Grate area, 27 sq. ft. The tenders are self-trimming, with a coal capacity of 5½ tons, and hold 4,125 gallons of water. Total weight of engine, in working order, 77 tons 14 cwt, of which 58 tons 14 cwt are on the coupled wheels. Tender, 46 tons 2 cwt. Total weight of engine and tender, 123 tons 16 cwt. Schmidt type of superheater is fitted.

The numbers of the Class S3 engines run from 840 to 849 inclusive.

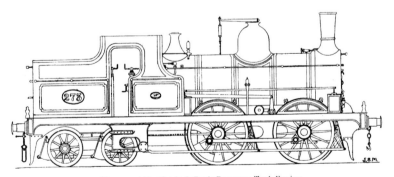

Diagram of Mr. Fletcher's Bogie Passenger Tank Engine.

Class BTP
Built by Fletcher in 1874.

A number of these engines were fitted with brake blocks on the bogie wheels.

Class O
110 engines in the class. First one built in June 1894.
Wilson Worsdell, Locomotive Superintendent.

Class U
Consisting of twenty engines with trailing radial axles.

Class D
Three-cylinder 4-4-4 passenger tank engines. Forty-five engines in class. First one built 1913. Sir Vincent L. Raven, Chief Mechanical Engineer, Darlington Works.

Weight and Dimensions

Coupled wheels, 5-foot-9-inch diameter; 8-foot centres. Bogie wheels: 3-foot-1¼-inch diameter, 6-foot-6-inch centres, 28 feet between centres of bogies. Three cylinders, 16½-inch diameter by 26-inch stroke. Boiler, 11 feet 4 1/8 inches between tube plates; 4-foot-9-inch outside diameter. Fire-box, 8 feet long. Grate area, 23 sq. ft. Boiler pressure, 160 lbs per sq. in. Total heating surface, 1,331.8 sq. ft, of which the fire-box contributes 124 sq. ft. Coal space, 4 tons. Tanks, 2,000 gallons of water. Length over buffers, 42 feet 10 inches. Steam reversing gear. Weight on coupled wheels, 39 tons 15 cwt. Total weight in working order, 84 tons 15 cwt.

North Eastern tank engines have always possessed a symmetry peculiarly their own, and these handsome double-bogie passenger tank engines are no exception to the general rule. A more compact and better proportioned engine for its size it would be difficult to find.

Cecil J. Allen timed No. 2145 when new at over 71 miles an hour between Northallerton and Stockton. This seems a record for an engine with driving wheels of 5-foot-9-inch diameter.

List of Class D passenger tank engines:

2143–2152 inclusive, built 1913.
2153–2162 inclusive, built 1914.
1326–1330 inclusive.
1499–1503 inclusive.
1517–1531 inclusive.

Class W. 'Whitby Tanks'
Originally six-coupled bogie engines. Built at Gateshead. Now 4-6-2 Type.
Designed by Wilson Worsdell. Altered by Sir Vincent L. Raven at Darlington Works.

These powerful tank engines were designed for the Whitby line in 1907, but pending the

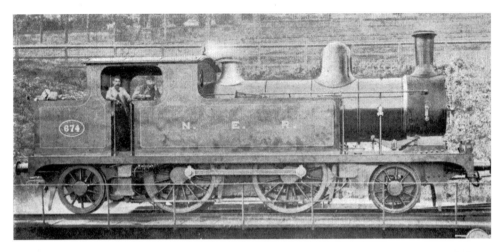

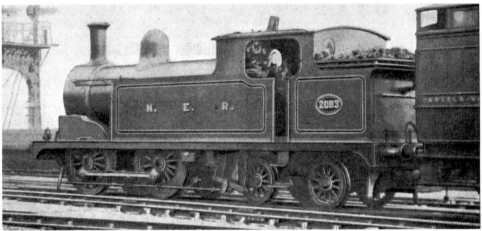

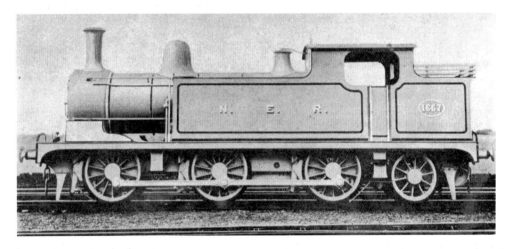

From top to bottom: No. 674, Class A, built in 1886. No. 2083, Class O, Passenger Tank Engine. No. 1667, Class U. For goods and mixed traffic. Built in 1902 by Wilson Worsdell.

strengthening of some of the underbridges on that section they were mostly located at Starbeck and ran on the Leeds–Harrogate line, another hilly stretch. One or two also went to Blaydon shed at first.

The first five originally had extended smoke-boxes, and No. 695 had a larger bunker holding 3 tons of coal, and had a fire-box 141 sq. ft., tubes 1,169.32 sq. ft., and total heating surface of 1,310.32 sq. ft.

The other numbers had dimensions as follows:

Fire-box, 130 sq. ft; tubes, 1,182 sq. ft; total, 1,312 sq. ft. Grate area, 23 sq. ft. Boiler, containing 225 tubes 1¾-inch diameter, was 11 feet long and 4-foot-9-inch diameter. Grate area, 23 sq. ft. Fire-box, 8 feet long. Boiler pressure, 170 lbs per sq. in. Two cylinders, 19 inches by 26 inches. Tank capacity, 1,500 gallons. Coal space, 2¼ tons. Six-coupled wheels, 5-foot-1¼-inch diameter. Bogie wheels, 3-foot-1¼-inch diameter. Bogie wheelbase, 6 feet 6 inches. Coupled wheel base, 12 feet 6 inches. Total wheel base of engine, 26 feet 3 inches. Weight on bogie wheels, 17 tons; on driving wheels, 17 tons; and intermediate and trailing coupled wheels, 17 tons 10 cwt each. Total weight of engine in working order, 69 tons. The combined variable blast pipe and ash ejector was fitted, being standard on all engines.

A fine coloured plate of No. 695 appeared in the *Locomotive Magazine*, in July, 1908.

Numbers and dates of Class W:

Engine No.	Built	Engine No.	Built
686	December, 1907	691	January, 1908
687	December, 1907	692	January, 1908
688	December, 1907	693	January, 1908
689	December, 1907	694	January, 1908
690	December, 1907	695	January, 1908

Their work calling for a generous supply of coal, it is not surprising that Sir V. L. Raven has recently altered these engines by enlarging their bunkers to carry 4 tons of coal and given them an extra pair of small trailing wheels.

Class X
Eight-coupled bogie (3-cylinder) Shunting tank engines.
Wilson Worsdell, Chief Mechanical Engineer.

These engines were built by Wilson Worsdell at Gateshead in 1909 for marshalling goods trains over 'humps' at sorting sidings. The boilers have similar dimensions to the Class W six-coupled bogie tanks already mentioned. The three cylinders are 18-inch diameter by 26-inch stroke and have a common steam-chest. The cranks are set at an angle of 120 degrees. The three piston valves are 8¾-inch diameter. The boiler barrel is 11 feet long and 4 feet 9 inches in diameter outside, containing 225 tubes 11 feet 4 1/8 inches long by 1¾-inch diameter. The fire-box is 8 feet long outside, with a grate area of 23 sq. ft. They had originally 'Seros' regulators and the now standard variable blast pipe and ash ejector. They have both steam and hand brakes. Heating surface: fire-box, 141 sq. ft; tubes, 1,169 sq. ft.

Total, 1,310 sq. ft. Capacity of tanks, 2,500 gallons. Coal space, 4¼ tons. Weights: on bogie wheels, 17 tons 16 cwt; on leading coupled wheels, 17 tons 19 cwt; on driving wheels, 17 tons 7 cwt; on intermediate coupled wheels, 16 tons 4 cwt; and on trailing coupled wheels, 15 tons 7 cwt. Total, 84 tons 13 cwt.

Numbers of Class X: 1352, October, 1909; 1353, October, 1909; 1354, November, 1909; 1355, December, 1909.

Class Y (1113 Class)
Three-cylinder 4-6-2 mineral tank engines. Consisting of twenty engines. First built 1910. (Now Sir) V. L. Raven, Chief Mechanical Engineer.

These notable mineral engines were the first class V. L. Raven designed on his accession to power as Locomotive Chief, and were all built at the Darlington works of the Company.

They were designed with a specially flexible wheel base to meet the requirements of colliery sidings, and their wheel arrangement avoids the necessity of a turn-table, enabling them to run bunker first.

The three high-pressure cylinders give them a remarkably steady motion when hauling even the heaviest loads, and the continuous exhaust, giving six beats to one revolution, is less destructive on the fire than the more usual 2-cylinder plan and consequently more economical of fuel. The following are the leading dimensions of Class Y: Three cylinders, 16½-inch diameter by 26-inch stroke. Diameter of bogie wheels, 3 feet 1½ inches; driving wheels, 4 feet 7¼ inches; trailing wheels, 3 feet 9¼ inches. Rigid wheel base, 14 feet 6 inches. Boiler: length, 11 feet; outside diameter, 5 feet 6 inches. Length of outside fire-box, 9 feet. Working pressure, 180 lbs per sq. in. Heating surface: fire-box, 140 sq. ft; tubes, 1,508 sq. ft. Total, 1,648 sq. ft. Grate area, 23 sq. ft. Capacity of tanks, 2,300 gallons. Bunker space, 5 tons. Weights: on leading bogie, 20 tons 16 cwt; on the six-coupled wheels, 55 tons 12 cwt; and on the trailing wheels, 11 tons. Total weight of engine in working order, 87 tons 8 cwt. The engines have 7½-inch piston valves operated by Stephenson's link motion.

The Class Y tank engines were officially stated to have been designed to haul a gross load of 1,000 tons exclusive of the engine on the level at 20 miles an hour, which they have proved themselves fully capable of doing.

Built 1910 Engine No.	Built 1911 Engine No.
1113	1180
1114	1181
1126	1182
1129	1183
1136	1185
1170	1190
1174	1191
1175	1192
1176	1193
1179	1195

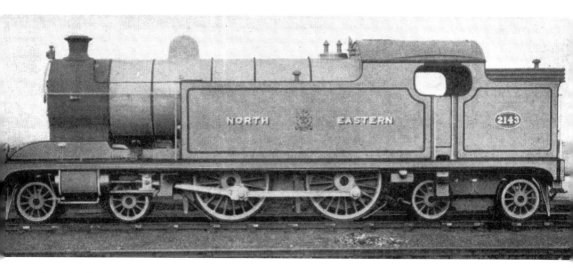

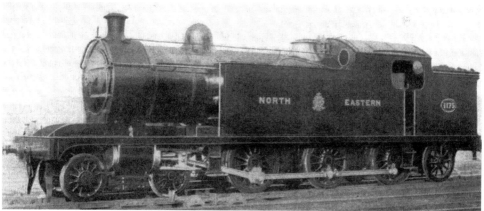

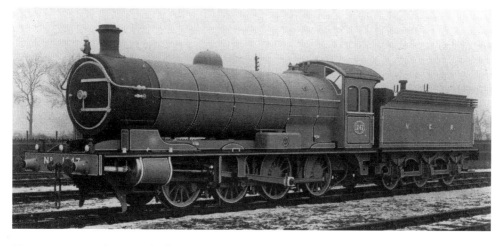

Top: No. 2143, Class D. The first one of the Double-Bogie Tank Engines. *Middle:* No.1775, Class Y. Three-cylinder 4-6-2 Tank Engine, built in 1910. *Bottom:* No. 1247, Raven 0-8-0 built at Darlington in 1913. LNER 3340 and British Railways 63340, withdrawn 1963. *(CMcC)*

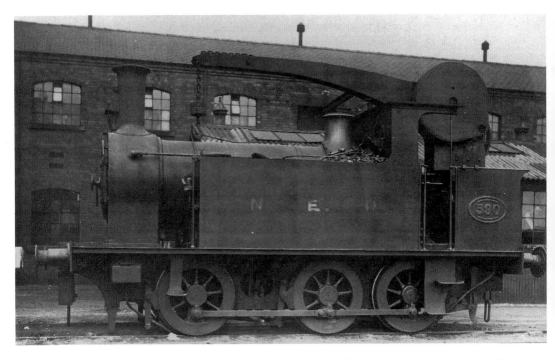

A pair of NER steam curiosities: *Above*, No. 590 is a Worsdell Class H1 0-6-0 Crane Tank. Two of these were built in 1888 for their Gateshead Works. By 1907 No. 590 was working at West Hartlepool. *Below*: Londonderry Steam Wagon No. 4 in NER livery. The company was based at Seaham Harbour, County Durham, and built the steam lorries up until 1906. *(CMcC)*

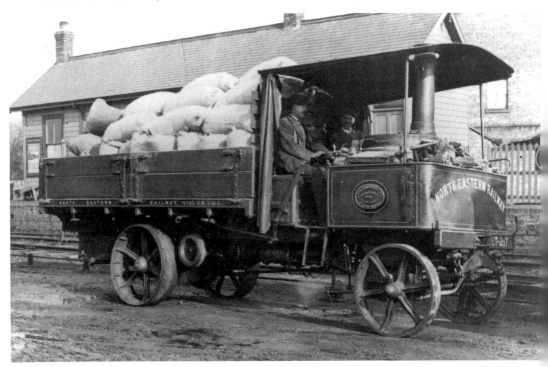